Picasso exhibition at the Galerie Louise Leiris, 1957. Photo David Douglas Duncan.

THE DOCUMENTS OF 20TH CENTURY ART

DIALOGUES WITH MARCEL DUCHAMP

by Pierre Cabanne. Translated from the French by Ron Padgett, with an editor's note by Robert Motherwell, a preface by Salvador Dali, and an appreciation by Jasper Johns. Bibliography and chronology by Bernard Karpel. Illustrated.

ROBERT MOTHERWELL,
GENERAL EDITOR

BERNARD KARPEL,
DOCUMENTARY EDITOR

ARTHUR A. COHEN,
MANAGING EDITOR

MY GALLERIES AND PAINTERS

BY
DANIEL-HENRY KAHNWEILER
WITH FRANCIS CRÉMIEUX

TRANSLATED FROM THE FRENCH
BY HELEN WEAVER
WITH AN INTRODUCTION BY
JOHN RUSSELL
NEW YORK THE VIKING PRESS

Contents

Introduction by John Russell

People still think of art dealing predominantly as a matter of bluff and counterbluff, midway between gangsterdom and the artificial comedy of Sheridan and Goldoni. The great art dealer, in this context, is a flamboyant and imperious figure: a man who hires Bernard Berenson the way an outraged husband hires Louis Nizer, goes through the great country houses as Nebuchadnezzar went through Jerusalem, lives better than many a Head of State, and ends up in London with a seat in the House of Lords.

At the bottom of all this is S. N. Behrman's dazzling *Duveen*. Duveen was a great dealer—no doubt about that—and *Duveen* is as pretty a book as has been put together since the war. But there are other ways of being a great dealer, just as there are paintings other than the Titians and Gainsboroughs in which Duveen dealt, and clients other than Andrew Mellon and Henry Clay Frick. Were this not so, Daniel-Henry Kahnweiler would soon have run through the small capital sum with which his family provided him in 1907; and no one would have come, in any case, to the tiny shop in Paris near the Madeleine which he had taken over from a derelict Polish tailor.

Kahnweiler's methods were, after all, the opposite of Duveen's. He dealt only in artists of his own age whom nobody else was after. (Already in 1907, for instance, Matisse seemed to him too old and too grand to bother with.) He bought cheap, and he sold cheap. He never advertised, never did anything to get his gallery talked about, and

never went out of his way to court a rich client. Duveen dealt in reassurance as much as in works of art: buying a Bellini was the next best thing to buying a presentable ancestry. But there was nothing to be reassured about in the purchase of paintings by an unknown artist from a dealer born in Mannheim, Germany, apprenticed to the stock market in London, nicknamed "the little Japanese" by his acquaintances in Paris, and just twenty-three years old.

Had the unknown painters not been Picasso, Braque, Gris, Léger, Derain, and Vlaminck, the venture would, in fact, have been a desperate one for all concerned. Kahnweiler knew nothing about the art trade. When he bought his first fauve paintings by Derain and Vlaminck at the Salon des Indépendants in 1907, he paid the full asking price, not realizing that, in the first place, everyone bargained, and that as a dealer he was entitled to a further reduction. He knew no other dealers, no collectors, and no critics. He didn't even know any artists, although he soon made it his business to call on the ones he liked. "People told me," he said recently, "that I ought to learn 'the tricks of the trade.' Well, I still don't know what they are. No one ever told me. I just had five or six clients, after a while, who came in from time to time. I showed them what was on the wall, and either they bought or they didn't. That was all there was to it."

From this it will be clear that if ever a deutero-Behrman tries to make a deutero-Duveen out of Kahnweiler he will have a hard job of it. Kahnweiler in conversation is one of the great uncomplicators. Never will he admit to the inner conflicts, the ups and downs of fortune, the moments of irresolution, and the brusque changes of intention which afflict the rest of us. "I've always known what I wanted to do" is the message that comes across quietly and lucidly in French, German, and English, "and I've always managed to do it." Even the tribulations which came to him as a result of World Wars I and II are passed off with a deft and unrancorous irony.

What Kahnweiler invented in 1907, and what has been practiced ever since by the dealers who count for something in the history of living art, was a new kind of art dealing. In the nineteenth century the dealer employed a liveried doorman to keep the artists at bay; potted plants and a Moorish fountain reminded the client that this was a palace of art, not a common shop; formal dress and the dropping of august names reminded him, also, that his host was not so much a trader as a senior human being of style and substance. Behind and beneath all this, acknowledged by all though never stated openly, was the fact that in the last resort the dealer was there to satisfy an estab-

lished need and for no other reason. Kahnweiler substituted for this an informal, unpretentious relationship in which a profound emotional commitment was the thing that mattered most. Where the old-style dealer did his artists a favor by inviting them to luncheon, Kahnweiler lived with Picasso, Braque, Gris, Derain, and Vlaminck on a day-to-day, hour-to-hour basis. The important thing was not so much that they should sell as that they should be free to get on with their work; and Kahnweiler, by making this possible, helped to bring into being what now seems to us the last great flowering of French art. Once again, his account of all this is a masterpiece of uncomplication. "My painters just wanted to get on with their work," he said not long ago in a radio interview. "They weren't like the Futurists, who were always getting into fights. They didn't even want to draw attention to themselves by holding exhibitions.

"My painters were quite certain that what they were doing would triumph in the end, and all they wanted to do was to live quietly and get on with it.

"It's a curious thing, but today, when I have a large staff in my gallery, I never have a moment to myself. Before 1914 I had nobody, and yet I had all the time in the world. I could play chess in the afternoon with Derain and Vlaminck, and at five o'clock Braque and Picasso would walk down from Montmartre, and we'd have dinner and go to the circus, or to the Lapin Agile, and on Sundays I'd go out on the Seine in one of the boats I shared with Vlaminck. . . ."

Picasso said once that neither he nor Braque could have done singlehandedly what they did between 1907 and 1914: "It took team-work." That Kahnweiler got the team together was a triumph of intuition and fine judgment. That he kept it together was also a triumph, and one owed as much to a sense of human quality as to an inherited sense for business.

The "five or six clients" of whom he speaks so casually included Hermann Rupf, thanks to whom Bern is taking its place among the world's foremost modern museum cities; Roger Dutilleul, one of the last of the great French collectors; and Serge Stchoukine, who built up, almost on his own, the twentieth-century French collection which makes such an effect at the Pushkin Museum in Moscow and the Hermitage in Leningrad.

Until the outbreak of war in 1914, these people were as much a part of "the team" as were the painters themselves; and it was thanks to Kahnweiler's dedicated management that the painters were able to live a little better, year by year. "Not that they cared about luxury,"

Kahnweiler said. "Picasso got it exactly right when he said to me, 'What I want is to be able to live like a poor man with plenty of money.'" Kahnweiler first came to know Picasso at the lowest moment of his fortunes, when "Les Demoiselles d'Avignon" hung, derided, on the easel, and the studio in the rue Ravignan was in an indescribable state of dilapidation, chaos, and decay. "And the curious thing is that Picasso has always remained homesick for that studio. No matter how many houses he buys, he's always delighted when a bit of the ceiling falls down and he can say, 'Just like the rue Ravignan.'"

Kahnweiler's position is based today, as it was in 1907, on the fact that he has first call on Picasso's production. For one reason or another the other painters in the team dropped away after 1918 (with the exception of Gris, who died in 1927); but from the heroic epoch there remain not merely some of the most beautiful canvases painted in the twentieth century but an enormous fund of reminiscence. Kahnweiler at eighty-six is interested in everything, as he always has been, and if he has charge of the conversation, it is as likely to turn on Italian opera or on anthropology as on his own career. He keeps up with the new books in several languages and in half a dozen disciplines. In August, when the temperature is in the high eighties and his younger colleagues lie flat on their private beaches, Kahnweiler thinks only of how to be up and away: bowling across the Hungarian plains on a journey of exploration, conjuring the ghost of Verdi from the corridors of the Grand Hotel in Milan, holding court in sardonic and lapidary style after *Tristan und Isolde* in the rebuilt Munich opera house. And just occasionally, as in these interviews, he gives a measured and unsentimental account of life when the "team" was in full activity. In writing about the period, he has so far been more interested in evolving for himself a neo-Kantian aesthetic than in *la petite histoire*, but the reader of this book can learn how Vlaminck once made himself a wooden necktie; how Derain was dressed "American-style," in checked tweeds, derby hat, and brightly colored tie; and how Braque's elegance was so discreet that only the connoisseur could take note of it, while Picasso was the only one who wore the artist's classic corduroys and velveteens.

Such concessions apart, Kahnweiler is more interested in characteristics that throw light on the inner life of the team. Picasso, for instance, is rarely seen with a book in his hand, and yet on examination he turns out to have read everything with the most perceptive attention. "Even in the early days, when he hardly knew French," Kahnweiler says, "he had an unfailing ear for French poetry."

And Kahnweiler, in this context, knows what he is talking about, for

he has had an auxiliary career, and an immensely distinguished one, as a publisher. Once again his activity does not follow any accepted pattern, in that none of his books was published in editions of more than a hundred copies; but it should be remembered that he was the first person anywhere to publish Apollinaire, the first Frenchman to publish Gertrude Stein, the first publisher of André Malraux, and the initiator of books which count for a good deal in the careers of Picasso, Braque, Gris, Léger, Derain, Marie Laurencin, André Masson, Raymond Radiguet, and Antonin Artaud.

Kahnweiler the musician (as a boy he dreamed of becoming a conductor) published Erik Satie's one-act operetta *Le Piège de Méduse* with colored wood engravings by Braque; Kahnweiler the inspired traveler published André Masson's *Voyage à Venise*; and Kahnweiler the lifelong reader published in 1957 Picasso's eight lithographed portraits of Balzac with a text by Michel Leiris. These books were not commercial enterprises, although many of them are now very valuable; they were ventures put together in moments of high enthusiasm. (Kahnweiler as a young man knew much of Apollinaire by heart.) The French cult of the *beau livre* applies as a rule to reprinted classics for which illustrations have been commissioned: Kahnweiler worked only with texts never before published, and, often enough, with authors now famous who had never before been published at all. The tradition was kept up even during the German occupation of 1940–1944, for it was in Kahnweiler's Paris apartment, while he himself was in hiding near Limoges, that Picasso's play *Desire Caught by the Tail* was given its first reading, with Albert Camus as producer.

There is, in fact, no escaping Picasso where Kahnweiler is in question, even if it would be an illiteracy to speak of him primarily as "Picasso's dealer." At the entrance to his country house near Étampes a fourteen-foot-high sculpture by Picasso greets the visitor. In the gallery in Paris which since the Occupation has borne the name of his sister-in-law Louise Leiris, the great event of each season is, beyond a doubt, the arrival of the new Picassos: sometimes a complete series, such as the variations on "Las Meninas," on "Les Femmes d'Alger" by Delacroix, or on the "Rape of the Sabines," sometimes a miscellaneous group, sometimes an isolated sculpture to remind the visitor of Picasso's fantastic inventiveness in that domain.

Kahnweiler in old age has become, in self-protection and in spite of himself, someone who can be seen only by appointment; and the volume of business transacted by his gallery can hardly be less than that of the stockbrokers and the private banks with which he did business in the

days of his apprenticeship. The forms of that business are, however, simplified as far as is possible: "If someone likes a picture, I look up the price, and he either pays it or he doesn't. No one bargains here, and I never make anyone a reduction."

You don't get to be where he is, and stay there, without a certain relish for the trade. One eminent colleague of Kahnweiler's once said to me, "I always know when he's really interested—his ears go just a little more pink." He is still tremendously active when the occasion warrants it. Toward most other dealers his mind was made up once and for all, I think, when his entire stock (it would now be worth around a hundred million dollars) was sold at auction by the French government after 1918. As a German national, he had his gallery and its contents confiscated during the war. "One or two painters helped me," he once said, "and one or two collectors did their best. But my colleagues in the trade manifested an absolute hostility."

But if there have been dark moments in Kahnweiler's career, there is nothing forced or affected about the equanimity with which he regards past, present, and future. I know of few properties in France more uniformly agreeable than the one which he found a few years ago. White doves tumble in the air above the long white Directoire house, the huge Picasso sculpture stands against the ruins of a thirteenth-century abbey, there is a touch almost of pedantry about the perfectly kept kitchen garden; the gravel in the courtyard could not be more elegantly raked if it were a Japanese sand garden, and in the center of it all is the master of the house: spry, beaky, amused, and undeceived.

His uncles were baffled when, in 1907, he passed up the chance of concerning himself with the gold and diamond mines which one of them had pioneered in South Africa. But somewhere behind that equanimity is the knowledge that, mine for mine, Daniel-Henry Kahnweiler's discoveries can compare with anyone's.

Chronology

1884: Daniel-Henry Kahnweiler born at Mannheim on June 25.

1889: His father, who is a broker, moves the family to Stuttgart, where Daniel-Henry spends his infancy and childhood.

1902-1905: D.-H. Kahnweiler, for whom his parents have planned a banking career, goes to Paris, where he works as a stockbroker. He meets and marries Lucie Godon, and begins to collect prints by Manet, Lautrec, Cézanne, Signac, Vuillard, and Bonnard.

1905-1907: Goes to London to work for an uncle, a financier with investments in South African gold and diamond mines.

1907: After refusing an assignment to South Africa, returns to Paris in February. Some weeks later, opens his first gallery at 28 rue Vignon. Buys some paintings by Derain and Vlaminck at the Salon des Indépendants and meets the two painters; also buys the work of Van Dongen and Braque. Meets Picasso, whose studio (at 13 rue Ravignan) he visits to see a strange picture ("Les Demoiselles d'Avignon"), which he mentions to his friend Wilhelm Uhde. Meets Braque.

1908: Exhibits pictures by Braque rejected by the Salon d'Automne, in reference to which the word "cubes" is used for the first time. Meets Juan Gris.

1909: Publishes his first book: *L'Enchanteur pourrissant*, by Guillaume Apollinaire, illustrated by André Derain.

1910: Meets Fernand Léger.

1912: Begins to purchase the works of Manolo, the Spanish sculptor.

1912–1914: Makes contracts with Manolo and with the four great cubist painters: Braque, Gris, Léger, and Picasso.

1914: Makes a trip to Italy, where he is caught by the war. Lives in Switzerland from 1914 to 1920 with his wife, where he works on his first aesthetic essays, *Der Weg zum Kubismus*, which remain unpublished as a whole until 1920; the first four chapters are published in 1916 (in *Die Weissen Blätter*, Zurich-Leipzig, September 1916).

1920: Returns to Paris in February. Opens a new gallery at 29 rue d'Astorg and names it for his friend and partner, André Simon. Louise Godon (whom Michel Leiris marries in 1927) becomes his collaborator.

1921–1923: Kahnweiler's property, sequestrated during World War I, is put up for public auction at the Hôtel Drouot in four sales spread over three years.

1920–1929: The sculptor Henri Laurens and the painters Elie Lascaux, André Masson, Suzanne Roger, Eugène de Kermadec, and André Beaudin join the Galerie Simon.

1927: Death of Juan Gris.

1930: Memorial exhibition of Juan Gris' work at Galerie Flechtheim, Berlin.

1937: Kahnweiler becomes a French citizen.

1940: Death of Paul Klee.

1940–1944: The German occupation and the anti-Semitic laws of the Vichy regime force Kahnweiler to leave Paris with his wife. They live, legally but clandestinely, in the Southern Zone. Kahnweiler is deprived of French citizenship by the Pétain government.

In 1943 Gallimard (Paris) publishes Kahnweiler's major monograph, *Juan Gris* (revised London and New York editions, 1947).

Kahnweiler returns to Paris in October 1944. He immediately resumes his activities, this time with the Galerie Louise Leiris; formerly the Galerie Simon, it was bought by Louise Leiris in 1941, when it was considered a Jewish enterprise and liquidated.

1949: Editions du Chêne (Paris) publishes Kahnweiler's *Les Sculptures de Picasso*, with photographs by Brassaï.

1945: Death of Manolo.

1952: Kahnweiler's conversations with Picasso (1933–52) are published in *Le Point*, October 1952 (German edition: *Acht Gespräche*, Zurich, 1954).

1953: Kahnweiler makes an exclusive agreement with the painter Yves Rouvre.

1954: Death of Henri Laurens. Death of André Derain.

1955: Death of Fernand Léger.

1956: Limited edition of *Letters of Juan Gris: 1913–1927* published in

London (letters collected by Kahnweiler, translated by Douglas Cooper). Maurice Jardot joins Galerie Leiris as its director.

1958: Death of Vlaminck. Revised edition of *Der Weg zum Kubismus* issued by Gerd Hatje Verlag, Stuttgart. Marlborough Fine Art organizes a Juan Gris exhibition as homage to Kahnweiler's fifty years in the world of art, with an essay by John Russell.

1959: Galerie Louise Leiris (Paris) exhibits "50 ans d'édition de D.-H. Kahnweiler." Kahnweiler is the first publisher of Apollinaire, Max Jacob, André Malraux, Antonin Artaud, Armand Salacrou, Michel Leiris, Georges Limbour, and others. Under the names of the three galleries he has directed to the present time, Kahnweiler has published nearly forty titles.

1960: Kahnweiler makes an exclusive agreement with the painter Sébastien Hadengue.

1961: *Mes galeries et mes peintres: entretiens avec Francis Crémieux* published by Gallimard (Paris). Portions are broadcast in France from May to June. Translations are issued in German, Czech, Swedish, and Polish.

1963: Death of Braque. *Confessions esthétiques* published by Gallimard (German edition, 1968).

1965: *Pour Kahnweiler*, a monumental homage in celebration of Kahnweiler's eightieth birthday, is published in Stuttgart by Gerd Hatje Verlag and distributed in New York by George Wittenborn, Inc. Limited edition contains original lithographs by Picasso, Lascaux, Beaudin, Masson, Roger, de Kermadec, Rouvre, and Hadengue. It also includes an extensive bibliography of writings by and about Kahnweiler in French, German, and English.

1966: "Self-Portrait" series, organized by Hannes Reinhardt for German television, presents Kahnweiler on the Süddeutscher Rundfunk.

1968: Kahnweiler's *Aesthetische Betrachtungen* is published by Dumont Schaubert Verlag, Cologne. Death of Lascaux.

1969: Third edition of Kahnweiler's *Juan Gris* is issued by Hatje (Stuttgart), Niggli (Teufen), Gallimard (Paris), Thames and Hudson (London), and Abrams (New York).

1970: The Viking Press (New York) publishes American illustrated edition of revised text of *Mes galeries et mes peintres* in the series Documents of 20th Century Art.

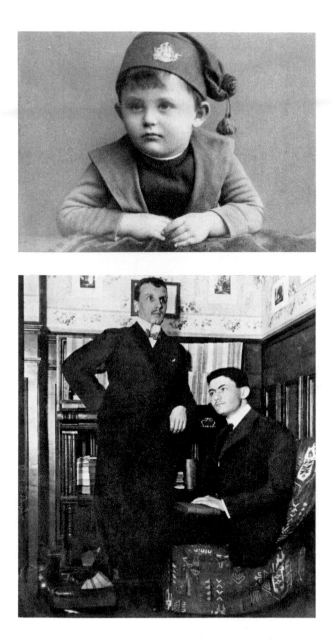

Top: Daniel-Henry Kahnweiler at the age of four. Bottom: Kahnweiler (seated) in Paris, 1903, four years before he became an art dealer. With him is the collector Hermann Rupf, a lifelong friend and one of Kahnweiler's first clients.

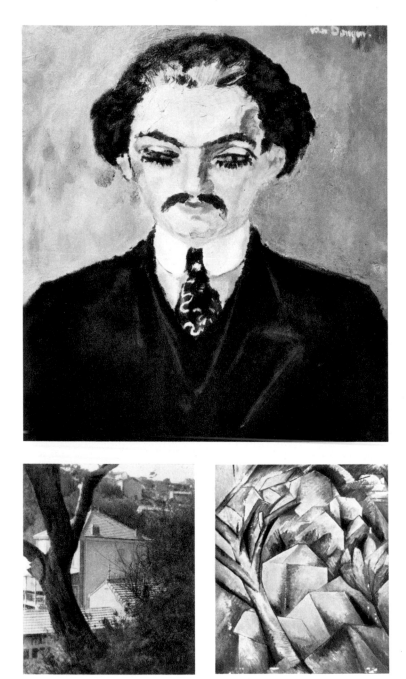

A Henry Kahnweiler

Vous êtes le premier, Henry qui m'éditâtes ;
Il faut qu'il m'en souvienne, en chantant votre los.
Que vous célèbrent donc les vers et les tableaux
Au triple étage habité par les trois Hécates !

Guillaume Apollinaire.

28 novembre 1910

Above: "To Henry Kahnweiler" from Guillaume Apollinaire. (Translation
follows bibliography.)

Opposite, top: Portrait of Kahnweiler by Kees Van Dongen (Modern Art
Foundation, Geneva). The picture was painted in 1907, the year Kahnweiler
opened his first gallery. Bottom: Houses at l'Estaque, photographed by Kahn-
weiler and painted by Braque in 1908, the year of Kahnweiler's first Braque
exhibition which inspired Vauxcelles to coin the word "cubism." The painting is
now in the Kunstmuseum in Bern, a gift of Hermann and Margrit Rupf.

Top: Picasso, photographed by Kahnweiler in the artist's studio, 11 Boulevard de Clichy. Bottom: Kahnweiler, photographed by Picasso in the studio, 1912.

18 Décembre 1912

Mon cher ami

je vous confirme notre conversation comme suit nous nous sommes convenus pour une période de trois ans à partir du deux 30 Décembre 1912. Je me engage pendant cette période à ne rien vendre à qui que ce soit en dehors de vous [...] seuls exceptés de cette condition certains [...] et dessins anciens qui me restent. J'aurai le droit de accepter des commandes de portraits et des grandes décorations [...] pour un emplacement donné. Cet exempté [...] entendu que le droit de tous les tableaux que d'ici vous seuls pourra appartenir je me engage à vous vendre de [...] prix [...] mon entière production de tableaux et sculptures, dessins gravures, en me gardant au maximum que cinq tableaux par an. J'aurai le droit en outre de garder ce nombre de dessins que je jugerai nécessaire pour mon travail. Vous vous en remettrez à moi pour décider si un tableau est terminé. Il est bien entendu que pendant ces trois ans je ne aurai pas le droit de vendre les tableaux et dessins que je produirai pour moi.

Vous vous engagez de votre côté pendant ces trois ans à acheter au prix fixés tout ce que je produirai de tableaux et de gouaches ainsi que au moins vingt dessins par an. Voici les prix que nous avons fixés pour la durée de notre traité

dessin	— 100	frcs
guaches	— 200	"
tableaux jusqu'à y compris 6	— 250	"
x 8 10 12 15 20	— 500	"
x 25	— 1000	"
x 30 40 50	— 1500	"
x 60 et au dessus	3000	"

prix des sculptures et gravures à discuter

Bien à vous

Picasso

Letter from Picasso serving as a contract between artist and dealer—the only formal agreement ever made between them. (Translation follows bibliography.)

Top: Derain in his studio, 1914. Bottom: Portrait of Kahnweiler by Derain, 1913. (Galerie Louise Leiris)

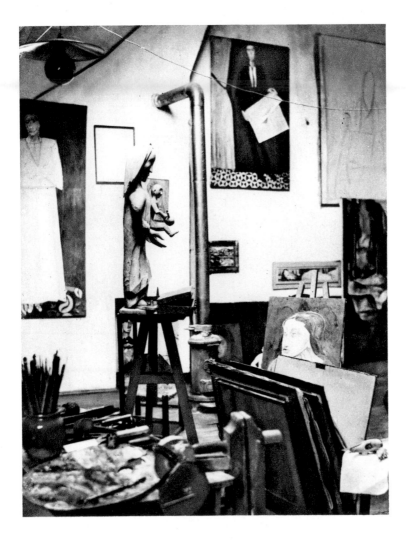

Derain's studio, 1914.

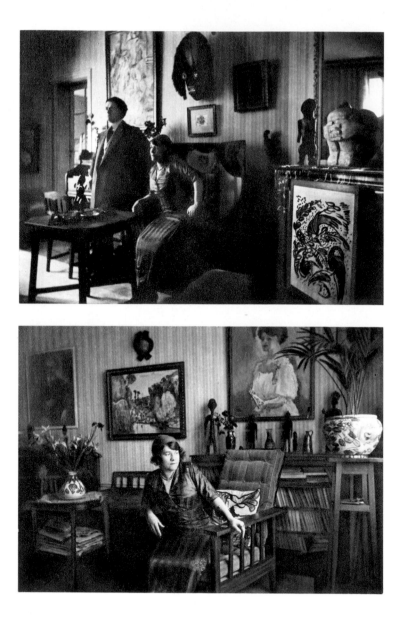

Views of M. and Mme. Kahnweiler at home, rue George Sand, 1913.

A drawing of Kahnweiler by Juan Gris, 1921. (Galerie Louise Leiris)

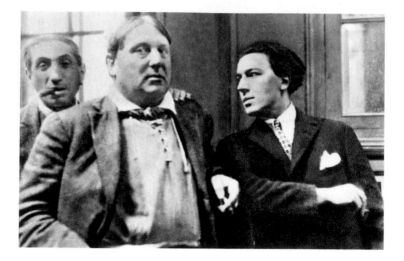

André Breton, Maurice de Vlaminck, and Alfred Flechtheim (right to left) in Paris in 1927. Flechtheim was a well-known German art dealer, whose gallery assistant at one time was Curt Valentin.

Top left: Kahnweiler and Braque on the beach at Lecques, 1924. Top right: Braque at Lecques, 1924. Middle: Kahnweiler and Picasso at Juan-les-Pins, 1925. Bottom: Mme. Kahnweiler, Olga Picasso, Picasso, and Bob (clockwise) at Bois Geloup. 1932.

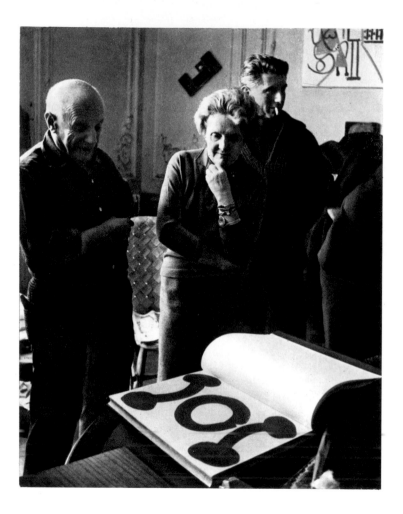

Picasso, Louise Leiris, and Paul Picasso at La Californie in 1956. (Photo Edmund Quinn)

"Pour D. H. K. Son ami Picasso Le 8.12.66" (Photo Alexander Liberman)

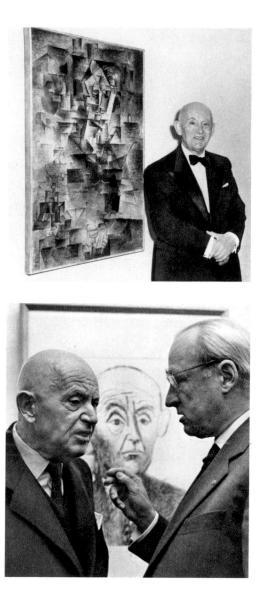

Top: Kahnweiler standing in front of Picasso's 1910 portrait of him at the Picasso 75th Anniversary Exhibition, The Museum of Modern Art, New York, 1957. Bottom: Kahnweiler talking with collector Bernhard Sprengel in front of Picasso's 1935 portrait of Kahnweiler, Hanover, 1965. (Photo Wilhelm Hauschild)

Picasso's fourteen-foot sculpture "Woman" of 1962 at the entrance to Kahn-weiler's country house near Etampes. (Photo Copyright © 1965 by Snowdon)

Top: Henri Laurens exhibition at the Galerie Louise Leiris, 1958.
Bottom: Kahnweiler with André Malraux in Helsinki, 1963.

Preface

I have often been asked to write my memoirs. For a long time I resisted out of some kind of modesty, but now it seems to me that what I had to tell, more about my traveling companions than about myself, did perhaps deserve to be recorded.

So when Francis Crémieux suggested the idea of these interviews, I accepted, thinking that in this way I could give my listeners—and readers—a sort of outline of the memoirs that I may not have time to write.

D.-H. K.

Saint-Hilaire, March 26, 1961

I.

FRANCIS CRÉMIEUX: Monsieur Kahnweiler, it was fifty-four years ago—in 1907—that you opened your first gallery in rue Vignon. You have been an art dealer for fifty-four years. Did you decide to become an art dealer when you were still a young man, were you passionately interested in painting, and what were your childhood and adolescence like?

DANIEL-HENRY KAHNWEILER: Do you want me to begin at the beginning?

CRÉMIEUX: Yes, with your family, with your birth.

KAHNWEILER: Well, there are some people who claim to have memories of early infancy; I have very few. I was born June 25, 1884, in Mannheim, where my father had moved after leaving the Palatinate, and I have only two absolutely uninteresting memories of that period. I can see myself in a large courtyard sitting astride a huge dog, probably a Saint Bernard; and I see another scene, in which I am with a boy my own age, when I was about three or four. The boy's name was Poldi. I am showing him a toy train made of wood and saying, "I'm not allowed to play with you because we broke the other train I had." Not much, you see, in the way of memories of early childhood. Well, my parents left Mannheim when I was five and moved to Stuttgart, and it is Stuttgart that is really my home town, around which I have all my memories of childhood and youth. At that time Stuttgart was a kind of big village; there were the local bourgeois, the "natives" of the area, as it were, each of whom had a vineyard on the surrounding hills. People went there in the fall, for the grape harvest, to set off fireworks. It was not at

all the big city we think of today. It was there that I went to school, it was there that I grew up.

My parents lived a little outside the center of the town, which is in a kind of hollow surrounded by hills, a little like Florence, they say. Personally I don't see a great similarity. . . . At that time there was still a little brook running through Stuttgart, which is now buried in the sewers, but never a river like the Arno.

In Germany in those days, parents used to send their children to the local elementary school for two years. So I went there for two years. One thing I remember is that there must have been a certain amount of anti-Semitism at this school. I, a little Jewish boy, was in a milieu that was almost entirely Protestant. There weren't any more Catholics than there were Jews at the school, maybe even fewer. I can see myself walking down the street one day, followed by a whole troop of little hoodlums my own age screaming, "*Judenbub*!" which means "little Jew." I mention this incident because afterwards, at boarding-school, nothing like that ever happened. In fact, I was something of a leader, liked and respected by my classmates, and sometimes even admired.

I was a pretty good student, although not a very industrious one, and I think I must have had some ability. In German schools in those days, there were two examinations a year, one at Easter and another in the summer, which was a final examination. By studying hard right before the examinations, I had no trouble passing them.

My parents were respectable middle-class people. My father was in finance; he was a broker's agent and represented one of my uncles, who was a stockbroker in London. At this time, many people were speculating on gold mines, and the market was booming. This is how my father made his living.

CRÉMIEUX: So you come from a family of well-to-do financiers, not big businessmen.

KAHNWEILER: Precisely, but there was a big businessman in my family at the time, the oldest of my uncles, who lived in London. He had been one of the founders of the gold and diamond mines in South Africa. He was a very big businessman; the others were well-off bourgeois, but not really rich.

This uncle, my mother's brother, had left Germany when he was very young and had settled in England. His two brothers had moved there too. One of them later left England and moved to Mannheim, which he then left for Munich. The other remained in England, where he also made a lot of money, but not on the same scale as his older

brother.

CRÉMIEUX: On your mother's side of the family, in Germany in the late eighteenth century, you had some grandparents who specialized in the sale of precious metals. Do you think this explains the appeal of South Africa for your uncle?

KAHNWEILER: It's possible, but there is very little similarity between that profession and the gold mines, where it is actually other people who must extract the ore! This was something that attracted a great many people, you remember. It was also the time of the great migrations in America. People rushed to California to dig themselves, which my uncles obviously did not do.

CRÉMIEUX: I understand that on your father's side your ancestors in the Palatinate were importers of colonial produce.

KAHNWEILER: That's right; they imported coffee and other exotic products. I must confess that my father's ancestors have a great appeal for me.

CRÉMIEUX: So, as an adolescent you lived in this well-to-do family, and you had an easy time at school. Had you had any contact with painting or with the arts in general? What was your home life like between the ages of ten and fifteen?

KAHNWEILER: Naturally, my parents had put pictures on the walls, but these pictures were poor things. I don't know whether the name Defregger means anything to you. Defregger was much admired by the late Adolf Hitler; he was a person who painted the Tirolese. Well, the paintings my parents had were somewhat in that genre; they were very bad paintings. My parents had much better taste in furniture and rugs— the ones in our house were very beautiful—but they had no taste when it came to pictures. But there was someone in my family who had a great deal of influence, I think, on the little boy I was then. This was a brother of my maternal grandmother, whose name was Joseph Goldscheider. He did not want me to call him "Uncle Joseph"; he wanted me to call him "Uncle Amico," the Italian word for friend, or even *amico* by itself. This alone gives you an idea of what he was like. He was the image of the forty-eighter, a man who was passionately devoted to freedom, literature, and music, who even loved the theater and actresses—a really interesting man. He wrote too; unfortunately, as is the way with families, nobody saved the poems he wrote, which I would like to have read. When I was a boy, we used to take walks together. Stuttgart was and still is surrounded by large forests. The long walks we took must have given me a passion I've had all my life: a passion for walking and for the mountains.

CRÉMIEUX: In those days, when someone asked you, "What do you want to do when you grow up?" what did you answer?

KAHNWEILER: To tell the truth, I really hadn't decided yet—I mean, at the time when that great-uncle was still alive. Later, at the age of about sixteen, I did have an idea, but I don't believe I even told it to my parents, who would have set up a howl.

There really wasn't any good painting to be seen in those German towns. There was old painting, of which the museum in Stuttgart does not have an outstanding collection, but which is good German painting of about 1500. There was no modern painting at all, except very bad painting. What I was more enthusiastic about was music; at that time I thought I wanted to be an orchestra leader. But I don't think I said anything about it to my parents. When I thought it over, I said to myself, "It's impossible! To do that, I would have to play the piano much better than I do." I had had a fine teacher, whom my parents had found for me and who almost made me lose interest in music; fortunately he did not, but I realized very quickly that it was hopeless. I got as far as buying scores and taking them to concerts, and shortly afterwards, I gave up the idea. Curiously, I think the same impulse was behind this that made me become an art dealer: an awareness that I was not a creator but rather a go-between, in a comparatively noble sense of the word, since I was not a composer myself. Later, when I became interested in painting, I found an opportunity to help those whom I considered great painters, to be an intermediary between them and the public, to clear their way, and to spare them financial anxieties. If the profession of art dealer has any moral justification, it can only be that.

CRÉMIEUX: Does being an intermediary imply that one is prepared to fight for these artists or this painting? Are you a fighter?

KAHNWEILER: Yes, I always have been, even for music; my greatest pleasure was to applaud a piece of music I like in the face of hissing adversaries. The same is true of painting: I adore defending what I love.

CRÉMIEUX: Well, by 1900, your adolescence was almost over; you were sixteen, you had passed your examinations for secondary school, and you didn't know what you wanted to do. What happened then? Did you stay in Germany?

KAHNWEILER: What happened is that my parents were completely convinced that there was only one salvation: the career followed by most members of their family, namely, banking and the stock exchange. So, my parents stuck me in banks in Germany. Then, in 1902, when I was eighteen, they sent me to Paris, where, on the recommendation of my uncles, I got a job working—so to speak—for a stockbroker named Tardieu.

CRÉMIEUX: Did you speak French? Had you learned French in school?

KAHNWEILER: Yes, we had always had French governesses, and I spoke French.

CRÉMIEUX: You began earning your living at the age of eighteen?

KAHNWEILER: Oh, no ... I wasn't paid, I was there as a volunteer. My family gave me a monthly allowance, enough to live on very decently.

CRÉMIEUX: So you were alone in Paris, you didn't know anyone. Were there any relatives or friends of the family?

KAHNWEILER: No, there were only the friends of my uncles. There was a banker who was very famous then, named Jacques de G——. As soon as I arrived, he and his friends very kindly invited me to share their box at the Opéra, where *Romeo and Juliet* was being presented. I heard them talking during the singing, while the orchestra was playing. I heard them running down Wagner, who was my idol at the time, as in fact he still is. I didn't care for this, and I carefully avoided these people afterwards. I left my card with the corner turned down, as one did in those days, to get it over with, and I never saw them again.

CRÉMIEUX: Were you active in politics? Did you have definite political and social ideas at the age of eighteen? You had to put up with some anti-Semitism as a child, but I suppose that in Paris your German citizenship must have presented problems in this very nationalistic period of 1902?

KAHNWEILER: No, that was no problem. Around the Bourse, people kidded me, but that was all. I was respected, and no one ever held my German nationality against me. My co-workers made references to Alsace-Lorraine and the Five Thousand, and similar pleasantries, to which I replied in the same vein, but it wasn't really ill-natured, far from it. As for my political ideas, I was a leftist. For example, I took part in a demonstration on the grave of Zola, who had just died.

CRÉMIEUX: What form did your interest in politics and current history take around 1903 and 1904?

KAHNWEILER: I was still, you remember, a very young man, so the only way I could show my interest was to participate in demonstrations and meetings, which I did. I heard Jaurès, Pressensé, all the great socialists of the day. I took part in demonstrations. The Dreyfus case was fairly recent, and the political atmosphere was still very unsettled. The right wing was very restless, and the left wing was full of enthusiasm.

CRÉMIEUX: In France at that time, the events in czarist Russia were very important and had considerable impact on public opinion, didn't they?

KAHNWEILER: Yes, but remember that everything the *petite bourgeoisie* of

the time possessed was lent to the **Russians**. The banks had committed the monstrous error of garnishing **the** portfolios of all these good people with Russian bonds. It was understandable, therefore, that any disturbance in Russia worried them, and that in the Russo-Japanese war, for instance, they were entirely on the Russian side. Personally, I don't know exactly why—maybe out of hatred of czarism—I was for the Japanese, which at the Bourse was almost unheard-of, and I remember that in my neighbourhood, which was near the Bourse, they used to call me "*le petit Japonais.*"

CRÉMIEUX: From 1902 to the end of 1905 you lived in Paris, but you don't seem to have been a very active apprentice stockbroker. What did you do?

KAHNWEILER: Believe me, an apprentice stockbroker doesn't have to do much. That profession has always struck me as simplicity itself, and the few things there were to know I learned in a very short time, if I ever learned them at all. What I actually did was this: I got to the office in the morning and did what absolutely had to be done. Then—I don't know whether it's still like this—we would have lunch right in the office, which was at 28 boulevard Haussmann, where now there is the continuation of boulevard Haussmann, which at the time had not been extended to the great boulevards. After that, we went to the Bourse, where Monsieur Tardieu would stand with the other stockbrokers around what they call *la corbeille*, with his staff gathered around him. I put in an appearance at noon. When the bell announced the beginning of the session I would disappear, not to return until the bell rang again at three o'clock.

I would go to the Louvre. At that time I always spent those three hours at the Louvre. A little later I discovered the Luxembourg, which did not interest me at all, except for one little room that intrigued me very much. This room contained, or so I understood, a collection that had been left to the government, called the Caillebotte Collection. The painters who were represented in it were called the impressionists. I must say that at first this room upset me very much. This proves that the comprehension and even the reading of a new kind of painting is difficult for everyone. As a matter of fact, at first I found these paintings illegible, like so many blobs of color, and only gradually did I realize that I was in the presence of a world that was new to me, new to everyone, a world where clouds floated, where the light looked like the light I saw outdoors, where the shadows were blue and not black, as in previous painting—in short, the world that was created for us (for painters create the visual universe of mankind) by the impressionists.

Thus, after old painting, I discovered the painting of the age, the living painting of the time.

CRÉMIEUX: Were you an art lover? Did you read the few art magazines that came out at the time? Had you already made contact with critics and friends who were interested in painting, or were you isolated?

KAHNWEILER: I hadn't read many magazines, for the simple reason that there weren't any. There were very few reviews at that time, and those that did exist paid very little attention to contemporary painting. Even the impressionists did not have many defenders, and Cézanne, Van Gogh, Seurat, and Gauguin had none to speak of.

CRÉMIEUX: At least they had enemies. There were some extremely violent articles written against them.

KAHNWEILER: Yes, but I didn't read them. I didn't know any critics, but I did have a friend, a man who also worked in Tardieu's office, to whom I owe an eternal debt of gratitude. His name was Eugène Reignier. He was the cashier for stock certificates and a very remarkable man. Unfortunately, life did not give him the opportunities he deserved, perhaps because he didn't take the plunge. You'll see what I mean. He was a very good friend of Lugné-Poë and his admirers. Lugné-Poë: The name probably doesn't mean much to you. . . .

CRÉMIEUX: On the contrary, it means a great deal; it means *Le Sot du Tremplin,* the Théâtre de l'Œuvre.

KAHNWEILER: Bravo! Well, personally, I shall always maintain that people like Antoine or Gémier, whom people still talk about, are nothing in comparison with Lugné-Poë. He was the man who played everything at that time that was worth playing. It is impossible to name a single role that is worth something in the theater that Lugné did not play. Even Henri Bataille was played by Lugné at first. Of course, I don't have to tell you that it was Lugné who directed *Ubu Roi.* It was Gémier who played the part of Ubu in the play. Well, Reignier stayed with Tardieu as a broker, instead of taking his chances, giving it up and working for Lugné as bookkeeper, accountant, or whatever. . . .

CRÉMIEUX: Did you also go to concerts and the theater?

KAHNWEILER: Yes, indeed. For one thing, my friend Eugène Reignier was extremely fond of books, the theater, art, and music. In regard to music, I had nothing to learn, to tell the truth. I could perfect my musical education, but at least I had one to begin with. As for literature, I knew German literature, but almost no French literature. I came to know French literature through Reignier, and through him, of course, I was able to see all Lugné's performances. I also saw what was being given in the theaters on the boulevards. It was a period when at least

the acting was excellent—much better than it is today, I think. One recalls the names of Sarah Bernhardt, Mounet-Sully, Réjane, and a thousand other actors and actresses. It was really an extraordinary flowering of the theater, although fundamentally the plays were very weak, since almost none of them have survived. So I went to the theater often. I also went often to concerts, to the Opéra, which was as bad as it is today, and to the Opéra Comique, which was infinitely better. I did not go to the premiere of *Pelléas et Mélisande*, but I did go the second or third night, and after that I went to every performance. In an obituary on Kemp,[1] I read that he had done this. Well, I too attended sixteen performances of *Pelléas et Mélisande*!

CRÉMIEUX: Even so, you were a very serious young man. You are a man who loves work and who loves art. You're not a man who is particularly fond of light entertainment or empty pleasures?

KAHNWEILER: Alas, I'm even a puritan! I have never enjoyed night life. Much later, I used to go with Picasso to the night clubs in Montmartre, but that was more to be with Picasso, and Picasso also went there for very different reasons. Perhaps we'll have occasion to talk about it later.

CRÉMIEUX: He loved spectacle, and in a sense a night club is a spectacle, too.

KAHNWEILER: Yes, and even a sad one. He loved the sadness of this spectacle, I think. I myself had never gone. I didn't go to dance halls. Later, I used to go with Gris, who loved to dance. But in those days I didn't go at all; I was excessively "serious" in the sense we have been talking about. And I had very modest tastes—I lived very simply. I went to the cheapest restaurants, ones which served dinner for twenty sous, and which weren't bad, as I remember. So I had quite a lot of money left over for the kind of pleasures I just mentioned and also for traveling. On Sunday, I used to take the train from Paris to see Chartres, the châteaux of the Loire, Reims, everything you can think of; and I used to take very short trips to places outside France.

This friend Reignier whom I mentioned had a habit that was unusual for those days. He would take the train Saturday evening, say to Marseille, and come back Monday morning. I adopted these habits to a certain extent myself. In 1904, I was married at the age of twenty—it was the fifth of November—and immediately my wife and I began to travel. She had exactly the same tastes as I. Our marriage has been extremely happy. We were close in a way that few couples are. We went to Spain and Italy. As you can imagine, the Bourse suffered con-

[1] Robert Kemp was a literary critic who wrote for *Le Monde* and other newspapers.

siderably. ... Since I was an unpaid trainee, they gave me all the vacations I wanted, but they must not have thought me very serious.

CRÉMIEUX: I have a clear picture of what your life was like. What strikes me is that the first part of it seems to have been an existence without material difficulties, without conflicts with your employers, without inner drama: a pleasant, happy life.

KAHNWEILER: I think it was. Basically, I have never had any inner conflicts in my life. I have done what I wanted to do. The only conflict—which was not very serious—is one that I will tell you about presently: when I announced to my family my plan of being an art dealer. But this was the one and only time that there was any conflict, and today I realize that my family was very understanding.

CRÉMIEUX: Monsieur Kahnweiler, who were your idols in 1903 and 1904? At this time you were given to often irrational enthusiasms. What men would you have liked to know, to meet? Were you a calm person? Did you have enthusiasms of this kind?

KAHNWEILER: I had enthusiasms, but not in that sense; as I just said, I adored the impressionist painters, some of whom were still alive; I adored Cézanne, and I even liked Gauguin more than I do today, but I had no idea that I would ever know them, and I didn't even have the desire to know them. When I decided to become an art dealer, it would never have occurred to me to buy Cézannes. It seemed to me that the period for that was over, for me at least, and that my role was to fight for the painters of my age. I knew and defended the painters of my age.

CRÉMIEUX: We can now cross the Channel at the end of the year 1905 and follow you to the home of another of your relatives. Was it through one of your uncles that you got a job in England?

KAHNWEILER: I worked in the offices of one of my uncles, who was named Sigmund Neumann and who was later made a baronet. He was a man of enormous wealth. My parents' mistake lay in the fact that this man was an international financier, but he had no "business," properly speaking. The business, which involved perhaps twenty employees, consisted solely of the administration of my uncle's fortune, his investments, his mines, and so forth. It didn't take me long to realize that there was no career to be made for a young man working for this uncle. I don't think it was this that drew me away from this profession, but it certainly played a part. I saw the complete futility of all this activity, which I disliked and which could never lead to anything.

CRÉMIEUX: And yet there was a career: inheritance, at least partial inheritance.

KAHNWEILER: This uncle had a great many children, and consequently there

was no question of my being his heir. That mercenary idea did not occur to me; I really didn't think about money. Anyway, it was impossible. He had two sons and several daughters. At the most, I could have been some kind of underling. You'll tell me that I could have founded a big company myself if I had been a great businessman, which I absolutely was not. The whole thing was distasteful to me, and I led exactly the same life as in Paris. I didn't go to the Bourse—it was not a brokerage in that sense. We used to go out for lunch. I would have a cup of coffee and go off to the National Gallery, the British Museum, or the Wallace Collection, exactly as I had done in Paris.

CRÉMIEUX: You have always resisted the temptation of power, wealth, and high finance, for you must have seen fortunes or half-fortunes being made around you. Money for the sake of money did not interest you?

KAHNWEILER: Not in the slightest, to be completely honest. I should add, however, that I was, as we noted earlier, moderately well-off; I received a small allowance and I didn't have to worry about earning my daily bread, but the idea of harnessing myself to a business and becoming an enormously rich man never occurred to me. I simply don't have the taste for luxury. Nothing about it appealed to me.

CRÉMIEUX: This brings us to the year 1907, the year of what you say was the only conflict in your life, the year in which you decided to leave the stock exchange, business, and offices, and to open a gallery. What were the circumstances of your crossing the Rubicon?

KAHNWEILER: It was like this. One fine day my uncles decided that I had nothing more to learn in London, which was very amiable of them, and that it was now necessary that I get to know the business in South Africa. My uncle Sigmund had an office in Johannesburg, so I was to go there. I could not refrain from telling them about an idea that had been germinating for a long time. I did not want to go to South Africa, not for anything in the world. I did not want to go on doing a type of work that did not suit me. I asked to have a serious talk with them and I told them, "You see, what I'm doing here, what I did before, I'll never be any good at. What I want to be is an art dealer." "An art dealer," they answered, "but what do you want to sell?" They had a friend who was an art dealer in London, a very big art dealer. He sold the paintings that they themselves collected. I didn't tell you that they both had collections that were fine and valuable of their kind. They had quite a few pictures of the great eighteenth-century English portrait painters—Gainsborough, Reynolds, Lawrence, etc. I didn't like those paintings; I still don't like them very much, although I recognize that Gainsborough has certain qualities, that he was something of a pre-

cursor in landscape painting. But at that time, I regarded their work as no more than fashionable illustration, and I looked down on it. Since my uncles were serious people, they said, "All this is very well, but we'll have to look into it. You will go and visit one of our friends (the art dealer I just mentioned, Wertheimer); he'll give you a little test."

This Mr. Wertheimer was certainly an excellent art dealer, and I suppose he had good pictures in his field. He was rather at a loss when confronted by me. He asked me questions such as, "At the National Gallery, what do you like?" I knew perfectly well what he would have liked me to say. He would have liked me to say, "I like the great English portrait painters of the eighteenth century." He would even have accepted it if I had said Rubens, for example, or even Velàzquez, but some demon made me give him names that I knew in advance would displease him or that at least would not mean to him what they did to me. I told him, "What I like best is El Greco." At that time, El Greco was just beginning to emerge from an obscurity of several centuries to become the great name he is today. He seemed rather astonished, and when I added the name of Vermeer van Delft, he muttered, "Of course, of course," but the examination was not a success. Still, he must have been a kind man. He overlooked my young man's follies. Then he asked me, "What do you intend to sell in Paris?" Of course you realize that at this time in London, nobody knew anything about contemporary French painting. The impressionists were barely known. There had been some sort of exhibition in a little gallery called the New Gallery, which had shown the impressionists and some works by the artists who are today called the nabis. I said to myself, "If I mention the painters I really have in mind, he won't know them. Perhaps he will have heard of Vuillard and Bonnard?" Those were the names that came to me. He said, "I don't know them." But even so, he must have given my uncles a relatively favorable report, and as for my uncles, I must give them credit for being rather open people, for they made the following proposition: "All right. You'll go to Paris. You'll open a gallery, since that's what you want to do. We'll give you a thousand pounds and one year. If after one year this gallery has gained a foothold, that is, if you can keep it going and make a living for yourself and your wife, you can continue; if not, you'll come back and work for us."

CRÉMIEUX: How do you explain this provocative side, this anticonformity that you showed in your answers to Mr. Wertheimer's first questions? Was he the kind of art dealer that you did not want to be?

KAHNWEILER: Precisely. He was the kind of art dealer who provided his customers with the merchandise they desired. I wanted to be an art

dealer who would offer for public admiration, if I may say so, painters whom the public did not know at all, and for whom it would be necessary to clear the way.

CRÉMIEUX: Weren't you afraid of jeopardizing the result of Mr. Wertheimer's report to your uncles in being slightly insolent, as you were?

KAHNWEILER: That's why I said that some demon possessed me. To this day, I do not know why I wasn't clever and didn't tell Mr. Wertheimer exactly what he wanted to hear. Perhaps I couldn't have done that.

CRÉMIEUX: So you demonstrated, in this little examination, a total lack of opportunism.

KAHNWEILER: That's true.

CRÉMIEUX: So you opened the door to this profession at the same moment you opened the door of your gallery. Before we discuss what hung on the walls of this gallery in rue Vignon, do you mind if we consider your drawings? What did you buy in the days when you spent three hours at the Louvre or the National Gallery? What did you already own?

KAHNWEILER: That is very simple, and it's important, now that I think of it, because it shows that from the beginning I was not interested in making money. I bought reproductions of the paintings I liked. That was what I put on the walls at first. It wasn't until later, when I passed shops selling prints, that I realized that the modern painters I liked had also made prints, that these prints were not very expensive, and that I could buy them.

I haven't mentioned my visits to the Salons, for after a short apprenticeship at the Louvre and then at the Luxembourg, I was no longer satisfied with what was in the museums. I wanted to see what was being done. I went to the Salons, all the Salons: at first, of course, the Salon des Artistes Français and the Salon de la Société Nationale des Beaux-Arts, later also the Salon des Indépendants, and then, after its founding, which was right around this time, the Salon d'Automne. It was especially at the Salon des Indépendants that I saw the living painting of the time. Except for Picasso, who did not exhibit there, I found the painters there whose friend and defender I later became.

CRÉMIEUX: So you had lithographs and etchings by Bonnard, Vuillard— who else?

KAHNWEILER: Well, the great masters whom I admired. I had both of Cézanne's lithographs, quite a few lithographs by Lautrec, a very fine lithograph by Manet, "La Barricade," to name a few. I tried to collect the prints of painters whose paintings I liked. I also had one of Renoir's lithographs; you can see it from here. There is a little lithograph by Sisley that I owned, as well as the prints of those who were

later called the neo-impressionists, the pointillistes. Seurat didn't do any, but I had works by Signac and Cross. This gives you the tone of the little collection I had put together.

CRÉMIEUX: Did you go to Vollard's before you . . .

KAHNWEILER: I would never have dared to cross the threshold of a gallery. I used to go to see a little print seller named Le Véel, who was in rue Lafayette at the time, but I would never have dared to walk into a gallery. I didn't know that it could be done, that one could go and visit a gallery; I didn't know any, not one. I had seen public exhibitions at Durand-Ruel—for instance, the 1904 exhibition of Monets from London, the Thames series—but I would never have dared to walk into a gallery cold, where there wasn't a public exhibition. I was a shy young man.

CRÉMIEUX: You were a man in 1906 and 1907—you were twenty-two.

KAHNWEILER: It was not until I was twenty-three that I opened my little gallery.

CRÉMIEUX: In the days when you used to haunt the Louvre, did you have a mentor whose articles you read? I'm thinking of Salomon Reinach, who taught at the Louvre school at that time—did you have a guide, or were you a kind of autodidact of all that painting in the Louvre?

KAHNWEILER: I had read quite a few serious works on classical painting. But this literature could not furnish me with aesthetic guidance. It gave me historical and scientific guidance, if you will, but aesthetically, I had to find my own way, and I think that I am a man who has hardly changed at all. What I regarded very highly then, with minor exceptions, I still regard very highly today, especially Rembrandt. Today, as then, I consider Rembrandt's "Bathsheba" at the Louvre one of the most beautiful paintings in the world.

CRÉMIEUX: You did not dare to walk into a gallery that was not presenting a public exhibition, but in 1907 the number of galleries could be counted on the fingers of one hand.

KAHNWEILER: Let's say two hands, if one includes people who were art dealers who lived in the back of their shops; but if one speaks of galleries in the sense that we use the word today, they were almost non-existent. For example, there was the house that later became the Galerie Paul Rosenberg and that of Léonce Rosenberg—I mean the house of the father of those two art dealers, in avenue de l'Opéra. The others were clustered in rue Laffitte and rue Le Peletier, which were then the center of the commercial art world; but those people sold the most popular merchandise of the period: Roybet, Meissonnier, things of that sort. It was only gradually that the impressionists obtained access to those

galleries. Then there were the more short-lived galleries, like that of Le Barc de Bouteville, which did not last. But above all, there were the two great art dealers, whom I respect very much and whom I think of as my masters, Durand-Ruel and Vollard.

Vollard had a funny little hole in the wall with nothing but an old frame in the window, whereas Durand-Ruel had fine showrooms. His gallery gave onto rue Laffitte on one side and rue Le Peletier on the other, with a big showroom between them, in which he gave exhibitions. In 1904 he exhibited Monet's London paintings, the Thames series. I remember something interesting about this show, which was also a lesson in modesty for the future. I saw two cab drivers standing in front of Durand-Ruel's window, rigid with hatred and rage, their fists clenched, yelling, "Any place that shows such rubbish should have its window bashed in!" Now, you know as well as I do that one of those London paintings of the Thames is today generally regarded as the most natural, the most realistic, and at the same time the most poetic representation imaginable. At that time, people must have seen something they recognized, but they must have seen it "distorted," so that it shocked them. And this, too, is very significant. This modern painting, which calls itself abstract or *tachiste*, is not outrageous at all; it cannot be, because it is not figurative. Painting has a very noble function. Painting is a kind of writing. Painting makes us see the external world. It *creates* the external world of men, and when this creation is new, when the signs invented by the painters are new, there arises this constraint, this conflict, the result of which is that people see the objects, but do not see them as they are accustomed to seeing them. This is what creates the outrage. When a way of painting is purely hedonistic, when it tries only to arrange agreeable colors on a canvas, it cannot be shocking. This is what makes me think that the abstract and *tachiste* painting of today is simply a replacement for the painting of Bouguereau and the other "masters" of the Salon des Artistes Français who wanted to charm the spectators with the beautiful thighs of women. Today we see painters who want to charm by agreeable arrangements of colors (even a disagreeable arrangement of colors can be agreeable in certain circumstances). In any case, we no longer have the conflict that was born with the impressionist painters and those who came after them.

Returning to the subject of art dealers, I recently realized that, fundamentally, it is great painters who create great art dealers. Each great period of painting has had its dealer. There was Durand-Ruel for the impressionists. There was Vollard for those who came afterwards—

Cézanne, Gauguin, then the nabis and many other painters—for we must remember that it was Vollard who first showed things by Picasso, a very young and unknown Picasso, in 1901.

CRÉMIEUX: Do you see a causal relationship between the proliferation of places where painting is sold today in Paris and the situation of painting in 1961? Do you think this multiplication of galleries implies a certain lack of progress in artistic creation?

KAHNWEILER: No, I don't think so. I see it as a purely economic phenomenon.

2.

FRANCIS CRÉMIEUX: What time of year was it when you came back to France in 1907?

DANIEL-HENRY KAHNWEILER: It was February 22.

CRÉMIEUX: You remember the exact date.

KAHNWEILER: It is strange, but I remember it because of the date of another return to France, in 1920. It was also on February 22, in 1920, that I came back to Paris after the First World War.

CRÉMIEUX: When did you open the gallery in rue Vignon?

KAHNWEILER: Not immediately, for even in those days, when you could find apartments and shops, we had to look first. My wife and I looked for and found an apartment at 28 rue Théophile Gautier (today called avenue), which in those days was charming, for there weren't many houses in Auteuil. From our sixth-floor flat you could still see the whole left bank. Then I had to look for a shop. The commercial art center, after having been for dozens and dozens of years in rue Le Peletier and rue Laffitte, was in the process of shifting into the neighborhood of the Madeleine. The house of Bernheim-Jeune, which had been in rue Laffitte, had opened one shop at the corner of boulevard de la Madeleine, in the place where the store Madélios is now, and a second shop (which communicated with it), for more modern painting, in rue Richepanse. It was Félix Fénéon who managed the second. Druet, who had been in faubourg Saint Honoré, was moving to rue Royale, and it was in the same area that I found a little shop at 28 rue Vignon.

It was occupied by a Polish tailor. His business must not have been going very well; he was eager to let it go. I'm sure he was delighted to see me coming, for he rented it to me for 2400 francs a year, and it had only cost him 1800.

CRÉMIEUX: Having found the shop, you had to find painters. Whom did you know?

KAHNWEILER: No one. I knew no one in Paris except the people at the Bourse, the people I had seen when I was working there. I knew one or two print sellers, from whom I had bought prints. That's all; I knew no art dealers, collectors, painters, or critics.

CRÉMIEUX: What did you do?

KAHNWEILER: Well, it's simple. Every year I had visited the Salon des Indépendants, which in those days was truly the nursery of modern art, where everyone, with the single exception of Picasso, exhibited. So, on the twenty-first of March, I went to the Indépendants. It was always open in those days, and there I began buying paintings by Derain and Vlaminck. This was the middle of the fauve period. After going to the secretary's office and asking the prices of the paintings, in my naïveté I accepted the prices demanded. I found out later that, not only did everyone bargain, but also that an art dealer, even a future art dealer, was entitled to a considerable reduction. I knew nothing about this. I bought the pictures at exactly the prices demanded. After the Indépendants closed in April, Derain and Vlaminck came to my little apartment in rue Théophile Gautier to deliver the paintings. This is how I met Derain and Vlaminck.

CRÉMIEUX: Did you tell them that you had decided to be an art dealer?

KAHNWEILER: Naturally, I told them at once, and I told them that I wanted to buy more of their paintings. In short, everything was arranged very quickly. There is a very curious thing, which I did not find out about until much later. About seven years ago, Vlaminck published the letters that Derain wrote him between 1904 and 1915, adding a few notes of his own. In these notes Vlaminck says that he had told Vollard about what I wanted to do. I had told Vlaminck that I wanted to buy his entire production. Vollard supposedly answered, "Do it; it will get your painting known." This brings out the very special psychology of Vollard. I can see myself! If a painter from whom I was buying and from whom I was prepared to buy everything he did had told me that, I would have jumped at him and said, "You're mad, my friend—I'm buying your work; what do you need with some young man who just came to Paris?" Vlaminck concluded, "And so it was that a young German of twenty-five came to possess the work of the

greatest French painters of the day." He was my senior by three years; I was only twenty-two.

CRÉMIEUX: When you made contact with these painters, what kind of contracts did you make with them? What does it mean to "buy someone's whole production"?

KAHNWEILER: At that time I really did have written contracts, something I no longer do. When I do business with painters now, the important thing is absolute good faith on both sides (and actually, I have never been disappointed), but nothing in writing. Then I really did make contracts. The painter promised to sell me his whole production, I promised to buy it, and the prices were determined by the dimensions, as it has always been done.

CRÉMIEUX: What were your first contacts with customers, for after you bought the canvases at the Indépendants and the work of the painters in whom you have exclusive rights, you showed them. How did this come about?

KAHNWEILER: Well, I hung the pictures on the walls. Of course, the original collection was enlarged rather rapidly with the work of other painters. Immediately afterwards, I also bought from Van Dongen and Braque, who exhibited in the same Salle des Fauves. So I already had those four painters, and I hung their pictures. As I told you, there were not many galleries in Paris; there were perhaps a dozen that were interested in painting that was not purely commercial, and even so! A new gallery, therefore, however small, attracted attention, and people came to see me.

CRÉMIEUX: Were there cocktail parties in those days?

KAHNWEILER: My God, no! Good heavens, no!

CRÉMIEUX: Publicity campaigns?

KAHNWEILER: There was nothing—no publicity campaigns, no cocktail parties, nothing at all. And I'll tell you something even stranger: I didn't spend a cent on publicity before 1914, not one cent. I didn't even put announcements in the papers; I didn't do anything.

CRÉMIEUX: Didn't you celebrate the opening of the gallery?

KAHNWEILER: No, there was no opening.

CRÉMIEUX: One day, suddenly, the Polish tailor . . .

KAHNWEILER: I sent for a decorator, who tried to rob me because he thought I was a kid. This decorator laid rugs. He put sackcloth on the walls, as I asked him to do. The ceiling was repaired after a fashion. We even kept a frightful gas chandelier with three burners, which were simply replaced with Auer burners, the great innovation of the day. And one fine day, when everything was ready, I rolled up the iron screen,

I hired a boy named Georges, who was a bit feeble-minded, and I opened my gallery.

CRÉMIEUX: Weren't you excited at the idea of your first customer? What was he like?

KAHNWEILER: I can't remember, but I think my first real customer was a very dear friend, who is still my friend today, fifty years later: Hermann Rupf of Bern, whom I had known a few years before, and who had lived with me for a year in Paris. We had rooms in the same apartment house, and we were together from morning to night. It was he, I think, who was my first buyer. He acquired an admirable collection.

CRÉMIEUX: Who were your other customers?

KAHNWEILER: One of the very first was someone who is also known as a very great collector: Roger Dutilleul. He died three or four years ago, and his admirable collection is now in the hands of his nephew, Jean Masurel of Roubaix. It was really he who was my first customer in Paris, I think.

CRÉMIEUX: Were these people well-to-do?

KAHNWEILER: Dutilleul was rich, I think. Rupf wasn't very rich then; he was a very young man. But the pictures were very cheap. You must remember that, when you multiply by two hundred or whatever to find the true value today, it isn't completely correct. After all, if a picture cost a hundred francs, that still wasn't an enormous sum in relation to the cost of living, in relation to the price of lunch.

Shortly afterwards, a very rich man who became my customer began to buy: Serge Stchoukine, the great Russian collector. He was extremely wealthy. He bought an enormous number of pictures.

CRÉMIEUX: When was your first visit from Picasso?

KAHNWEILER: Well, I'll tell you about it. One day I was in my shop when a young man came in whom I found remarkable. He had raven-black hair, he was short, squat, badly dressed, with dirty, worn-out shoes, but his eyes were magnificent. Without a word, this young man began looking at the pictures. He made a complete tour of the little shop, which was about twelve feet square, and left. The next day he came back in a carriage with a gentleman who seemed quite elderly to me—for I was very young—but who could not have been over forty-five at the time, a rather stout gentleman with a beard. Still without saying a word, the two of them walked all around the gallery and left.

I had made the acquaintance of a man who is no longer alive and whom I remember very fondly: Wilhelm Uhde, the German writer and art historian. Wilhelm Uhde had been living in Paris steadily since 1900. He knew everyone, including a great many painters, and it was he

who first told me about a strange picture that the painter Picasso was working on. A picture, he said, that looked Assyrian, something utterly strange. I wanted to see it. I did not know Picasso, but I had heard his name, and I had seen many of his drawings in the front window of the shop of an art dealer named Clovis Sagot, in rue Laffitte; he was a really courageous old man, who did the best he could with slender resources.

So one day I set off. I knew the address, 13 rue Ravignan. For the first time I walked up those stairs on the place Ravignan, which I tramped up and down so many times later, and entered that strange structure that was later named "the laundry boat" because it was made of wood and glass, like those boats that existed then, where housewives used to come to do their washing in the Seine. You had to speak to the concierge of the adjacent building, for the house itself had none. She told me that he lived on the first flight down, for this house, hanging on the side of the hill of Montmartre, had its entrance on the top floor, and one walked down to the other floors. Thus I arrived at the door that I had been told was Picasso's. It was covered with the scrawls of friends making appointments: "Manolo is at Azon's . . . Totote has come . . . Derain is coming this afternoon. . . ."

I knocked on the door. A young man, barelegged, in shirt sleeves, with the shirt unbuttoned, opened the door, took me by the hand, and showed me in. It was the young man who had come a few days before, and the old gentleman he had brought with him was Vollard, who, of course, made one of his characteristic jokes about their visit, telling everyone he knew that there was a young man whose parents had given him a gallery for his first communion.

So I walked into that room, which Picasso used as a studio. No one can ever imagine the poverty, the deplorable misery of those studios in rue Ravignan. Gris' studio was perhaps even worse than Picasso's. The wallpaper hung in tatters from the unplastered walls. There was dust on the drawings and rolled-up canvases on the caved-in couch. Beside the stove was a kind of mountain of piled-up lava, which was ashes. It was unspeakable. It was here that he lived with a very beautiful woman, Fernande, and a huge dog named Fricka. There was also that large painting Uhde had told me about, which was later called "Les Demoiselles d'Avignon," and which constitutes the beginning of cubism. I wish I could convey to you the incredible heroism of a man like Picasso, whose spiritual solitude at this time was truly terrifying, for not one of his painter friends had followed him. The picture he had painted seemed to everyone something mad or monstrous.

Braque, who had met Picasso through Apollinaire, had declared that it made him feel as if someone were drinking gasoline and spitting fire, and Derain told me that one day Picasso would be found hanging behind his big picture, so desperate did this enterprise appear. Everyone who knows the picture now sees it in exactly the same state it was in then. Picasso regarded it as unfinished, but it has remained exactly as it was, with its two rather different halves. The left half, almost monochrome, is still related to the figures from his rose period (but here they are hacked out, as they used to say, modeled much more strongly), whereas the other half, very colorful, is truly the starting-point of a new art.

CRÉMIEUX: Did you discuss "Les Demoiselles d'Avignon" with Vollard?

KAHNWEILER: Oh, I hardly ever saw Vollard in those days. I did not meet him until later. Vollard very rarely came to Picasso's studio. But I know that at that time Vollard did not appreciate what Picasso was doing, since he did not buy from him any more, which is the best proof that he didn't like his work. Vollard had certainly seen "Les Demoiselles d'Avignon," which he must have disliked excessively, as did everyone else at the time.

CRÉMIEUX: Do you remember your first conversation with Picasso in front of that picture?

KAHNWEILER: No, I don't; I only remember that I must have told him immediately that I found his work admirable, for I was overwhelmed.

CRÉMIEUX: Did this first meeting mark the beginning of your unwritten contract with Picasso?

KAHNWEILER: Oh, no, that came much later. Picasso was and still is, for that matter, much too suspicious a man to make a deal immediately with some young man who appeared out of the blue, and whose business—which might well seem mad—he had no way of knowing would last. No, I immediately bought some of Picasso's pictures, for which, if I may say so, there was no competition. There was no need to draw up a contract or anything of the sort, since no one else was buying from him any more. So I bought and I kept on buying, and it was not until several years later that we actually signed a contract. In the meantime, Vollard bought more paintings in 1909 and even in 1910.

CRÉMIEUX: But then the state of poverty in which Picasso was living must have changed, since you were buying paintings from him.

KAHNWEILER: Let's not exaggerate. As Picasso later told me, very correctly, "In order for paintings to be sold at high prices, they must first have been sold very cheaply." Well, I sold Picasso's pictures very cheaply,

like the rest, and I bought them very cheaply too. In other words, it was no longer poverty, but it wasn't prosperity either.

CRÉMIEUX: Did your connection with Picasso, like your connections with Derain and Vlaminck, go beyond a pure business relationship?

KAHNWEILER: Yes, our friendship was very genuine and very deep. We were very close. Vlaminck and I had two boats on the Seine that we owned together, a sailboat, and a motorboat. Picasso and I would spend long evenings in Montmartre; we would go to the Cirque Medrano on Friday and afterwards to the night clubs, one of which was called Le Rat Mort. This was a sordid place, and he must have liked it for that reason; I think it reminded him of the bordellos of Barcelona. We trusted each other completely, as is clear from all the letters that still exist from that period.

CRÉMIEUX: Is it true that there was a group, a gang of friends made up not only of painters, but also of poets, essayists, and others?

KAHNWEILER: Absolutely. There were Apollinaire and Max Jacob, very intimate friends of Picasso's, and at that time there was also Salmon, who was very close to us.

CRÉMIEUX: And did they have arguments, intellectual battles, aesthetic battles among themselves?

KAHNWEILER: No, it can't be said that there were aesthetic battles, because all these innovations, discoveries, or whatever you want to call them were not formulated in words. It was not until much later that first the minor cubists formulated them and that Apollinaire wrote *Les Peintres cubistes*,[1] in which he too tried to advance some ideas, which owed more, I think, to the minor painters than to the truly great painters.

CRÉMIEUX: Who are the minor cubists?

KAHNWEILER: That's easy. There are some who are forgotten, or almost, like Le Fauconnier, and there are some who are less forgotten, like Gleizes or Metzinger. There were still others at the time.

CRÉMIEUX: And did the minor cubists show in the Salons?

KAHNWEILER: Yes, they did, and there's something I wanted to say about that. People always think that an art dealer "launches" painters with a lot of fanfare or publicity. I didn't spend a cent, not even for announcements in the papers, as I've already told you. The last exhibition I had before 1914 was Braque's, in November 1908—that was when the word "cube" appeared for the first time from the pen of Vauxcelles. After

[1] *The Cubist Painters*, translated by Lionel Abel, was published in the United States in 1949 in Robert Motherwell's series *The Documents of Modern Art* (New York, Wittenborn).

that, the painters from whom I bought, in accordance with an agreement with me, no longer exhibited in the Salons, nor did we have any more exhibitions in rue Vignon. All I did was hang their pictures. You understand, the painters worked in peace; I advanced them money so that they could live. They brought pictures, we kept the books, we hung the canvases, and the people who were interested in them came to see them. I must say that after a certain point the few people interested in these painters—for there were five or six—came immediately to see the new paintings, and painters and art lovers unable to buy came too; but we never again exhibited publicly, which shows you the absolute contempt in which we held not only the critics, but also the general public. It is impossible to imagine these things today, because with this pseudopainting that abounds in the Salons today, with this pretentious applied art that is called abstraction and *tachisme*, there's nothing to laugh at or to get mad at.

In the old days, people went to the Indépendants to get mad or to laugh. In front of certain pictures, there would be groups of people writhing with laughter or howling with rage. We had no desire to expose ourselves either to their rage or to their laughter, so we stopped showing the pictures.

CRÉMIEUX: You were talking about cubism. I have before me a quotation from an article by Apollinaire that appeared in the *Mercure de France* of October 16, 1911. He writes, "The name cubism was invented by the painter Henri Matisse, who used it in connection with Picasso," and he continues, "The first cubist paintings were the work of Georges Braque."

KAHNWEILER: This, like much of what Apollinaire wrote about the arts, is completely untrue. Apollinaire was an admirable poet. I can say so because I was his first publisher; but in the first place, he knew nothing about painting, and in the second place, he had a kind of compulsion to say things that were not so. In fact, it was one of his axioms that "what is true is never interesting." It is possible that Matisse (I used to say so myself at the time, but it has never been proved) did play a very small role in the sense that he talked about little cubes, not in connection with Picasso, but in connection with some paintings by Braque that had been shown at the Salon d'Automne in 1908. He was a member of the jury, and it was reported at the time that he had said that Braque "was making little cubes." When these pictures were refused, it was I who exhibited them in 1908. But the person who invented the word "cubism" without any doubt—one has only to consult the documents—was Louis Vauxcelles, the art critic of *Gil blas*,

who had already invented the ridiculous name "fauves" for the painters of the preceding generation. In connection with my Braque exhibition in November 1908, he wrote, "Braque is painting little cubes"; six months later he was talking about "cubism," and consequently the name was entirely his own invention from the beginning, and it was invented not in connection with Picasso, but with Braque.

CRÉMIEUX: At the time of the birth of cubism, at which you were, shall we say, the midwife, were you aware of the importance of cubism in the history of painting?

KAHNWEILER: Absolutely. I was completely aware of it, and I did not have the slightest doubt as to either the aesthetic value of these pictures or their importance in the history of painting, for although I did not know about the commercial aspect of painting, I did know painting and had been going to museums religiously from a very early age.

CRÉMIEUX: Did you think there would be something after cubism, or that cubism would last for a long time? Would cubism have been enough for you?

KAHNWEILER: That question seems curious, since there is always something after. The history of painting had shown me that painting was in continual transformation. Real painting expresses something essential about the time, but times change, and consequently painting changes too. What I wrote then and what I shall always maintain is that after cubism, painting will never be the same. There will always be something of the influence of cubism, but already, in the succeeding generation—let's say among the surrealists, if you like, to give it a name—there are certainly traces of the influence of cubism, but the ends are completely different.

CRÉMIEUX: You make it sound as if these painters were primarily workers—less provocative, less quarrelsome than the surrealists.

KAHNWEILER: Around 1914 there were some who were more quarrelsome than the surrealists who came after them, namely, the futurists, who actually had fist fights with their enemies at all their meetings; but this was exactly the opposite of what we wanted. My friends asked only to work; they had no wish to provoke, they knew what they were doing, and they only wanted to do their work. If they had wanted to create a scandal, they would have exhibited, but this did not interest them at all. What's the use of a scandal if one wants to work? They worked quietly, but, as I have said, with absolute conviction.

I remember a certain letter from Picasso that is surely the most astonishing thing a painter ever wrote to an art dealer. It was in answer to a letter from me, in which I told him that one of our most faithful

customers did not like his latest work. Picasso wrote, "That's fine. I'm glad he doesn't like it! At this rate we'll disgust the whole world."

CRÉMIEUX: We haven't yet talked about your meeting with Braque. Was it after you got to know Picasso?

KAHNWEILER: Very shortly afterwards. I began buying Braque's paintings in the summer of 1907. Then Braque went to the Midi, and on his return he brought the series of paintings that we have already mentioned several times in our conversations, the Estaque series, which I showed in November 1908.

CRÉMIEUX: Does the intimate friendship between Braque and Picasso date from this period?

KAHNWEILER: It developed after 1909, yes.

CRÉMIEUX: Who was the spokesman, the littérateur, the formulator, let's say, of the cubist theory?

KAHNWEILER: The theory? No one really formulated it, for the simple reason that there was no theory. Picasso carefully avoided all theory in what he said. Perhaps you have heard about Picasso's various jokes on this subject? For example, when Metzinger asked him something about feet, Picasso answered, "There are no feet in nature."

CRÉMIEUX: He was asking him whether he saw feet as round or square, wasn't he?

KAHNWEILER: Something like that—I don't know exactly what. I remember other answers that were even better, such as "Do not talk to the driver." This was a little sign that used to be in Parisian boats. In regard to arguments in *bistros*, it was the other cubists who had them; as for theory, it was Metzinger who expounded it, and it was, let me hasten to say, a theory that had nothing to do with what Picasso and Braque were doing.

CRÉMIEUX: Yes, the newspapers of the period—we've already come to 1912—had widely used a sort of manifesto signed by Metzinger explaining what cubism was.

KAHNWEILER: There was that book, *Du cubisme*, by Gleizes and Metzinger, but it absolutely must not be regarded as the bible of Picasso and Braque, for it expresses a completely different point of view, which has no relation to what Picasso and Braque were trying to do.

CRÉMIEUX: But there were also polemics in the press, and there were enemies of cubism.

KAHNWEILER: Yes, but in a way these enemies were tilting against windmills, the windmills being the minor cubists. The others, the great ones, were invisible.

CRÉMIEUX: Still, they recognized Picasso as a leader.

KAHNWEILER: In the eyes of the public, you know, Picasso had the advantage of his past. There had been his blue period. During this blue period, his pictures had not sold very well, but it existed. Then there was his rose period. In the eyes of the public, this was the proof that he "knew how to draw."

CRÉMIEUX: Of course, but there were battles. I asked the question to try to get some background on the battle of ideas, the battle of friends and foes, and to name the champions, even if it was a question of unimportant articles by these champions.

KAHNWEILER: The champions were incontestably in the first place Apollinaire, to a lesser degree Max Jacob—a lesser degree because he did not write as much. He never wanted to get involved in journalism, in which he was right. There was Salmon, then a little later, Maurice Raynal.

CRÉMIEUX: Good. Now we must ask you some questions about what was said at the time about Braque—and Picasso, if you will, but mainly about Braque. It seems that Braque was good at dancing the jig and playing the accordion, and was an excellent wrestler.

KAHNWEILER: That can't be denied; he was a very handsome lad—he is still handsome today, a handsome old man. Yes, he used to say himself that he could play Beethoven symphonies on the accordion. He also danced occasionally and he boxed. So did Derain and Picasso, actually.

CRÉMIEUX: You mentioned Le Rat Mort, but we don't have a very clear idea of what it was like on Saturdays or Sundays, the everyday life.

KAHNWEILER: There weren't any Saturdays or Sundays; there was nothing but constant work. I should tell you that Derain and Vlaminck were located in completely different places. Vlaminck lived at that time in the Rueil section—first in the valley, then on the side of the Jonchère, and next at Saint Michel. As I told you, we jointly owned two boats on the Seine. I used to spend Sunday with him and his family. Derain, on the other hand, lived at this time in rue de Tourlaque; later, he moved to rue Bonaparte. Picasso and Braque, of course, were still in Montmartre. Braque lived across from what was then the Théâtre Montmartre, which is now L'Atélier. They would work; then they would meet at five o'clock and come down to my gallery in rue Vignon, and we would talk. There's something I don't understand: Now I have a gallery with a lot of people working for me, and I never have a minute to myself. In those days, my freedom was complete: In the morning I would visit painters, and in the afternoon I would play chess with Braque, Derain, and Vlaminck. . . . Probably not many people came, but still, enough came so that business went on, the painters could live, my wife and I could live, we could keep the gallery going, and the painters could have

a little more money every year. The prices of their paintings were going up. It's very hard to imagine this now. I didn't even have a telephone. It was a very strange business, really. Well, at the end of the day, they would arrive. We would make jokes. I remember one day—it was at the end of a month, and they were coming to get their money. They arrived, imitating laborers, turning their caps in their hands: "Boss, we've come for our pay!" You can't imagine how friendly, how full of trust our relationship was, not at all as you would imagine the struggle between the painter and the dealer. On the contrary, it was the most open-hearted collaboration. To give you a better idea of what we did for amusement—at that time there was also Le Lapin Agile. Picasso and Braque went often, and I went with them.

We would go to Le Lapin Agile—in the winter, to that smoky cave where Freddie, with his long beard, would play the guitar and sing, in the summer, in the open air. I remember those warm summer nights with Paris illuminated at our feet. That was our life; it was simple and carefree because, as I said before, we were sure of victory, we were sure of ourselves.

CRÉMIEUX: In short, for the painters, it was painting and relaxation; for you, the gallery and relaxation.

KAHNWEILER: Precisely.

CRÉMIEUX: Very simple.

KAHNWEILER: And then there were the summers when the painters went to the Midi. You know, no doubt, that Picasso spent several summers at Céret and another summer at Sorgues, as did Braque. Derain, too, almost always went to the Midi. Then there was Vlaminck, who left the suburbs of Paris only for short trips. As for Van Dongen, whom I mentioned a little while ago, my relations with him did not last very long because his painting took a completely different direction, namely, fashionable portraiture.

CRÉMIEUX: You mentioned Céret. Wasn't it at Céret that, in the course of a rather long period of cohabitation, Braque and Picasso painted side by side and decided to stop signing their canvases? What's the truth about this?

KAHNWEILER: On this point there is absolute confusion. They never painted side by side, and they never wanted their canvases to be confused; the proof of this is that they are always signed. However, they are signed in back instead of in front, because all the painters with whom I collaborated felt that a signature on the canvas could, in fact necessarily must, disturb the construction, the architecture of the painting, which they wanted to be so strong and solid that even a signature would

disturb it. But the pictures are always signed in back, so there was never any question of a Picasso being able to pass for a Braque. Anyway, in spite of the very close connection between the ideas, it is easy to tell them apart.

CRÉMIEUX: Of course, but still there is some truth to this friendship that was perhaps even more intimate between Picasso and Braque than with other painters.

KAHNWEILER: True. It was a fraternal friendship and truly a daily collaboration, at least when it came to ideas.

CRÉMIEUX: Did you see it begin?

KAHNWEILER: Yes, I saw it begin, I saw it continue, and it ended, as did everything else, in 1914. Picasso told me many years later, "On August 2, 1914, I took Braque and Derain to the Gare d'Avignon. I never saw them again." This was a metaphor, of course. He did see them again, but by this he meant that it was never the same.

CRÉMIEUX: Besides Picasso, Braque, Vlaminck, and Derain, what were your first contacts in Paris in 1907? Can you tell us how you made contact with men like Fernand Léger, Manolo, and especially your great friend Juan Gris?

KAHNWEILER: Gladly. It all happened through painting. I met Léger in 1910. He had exhibited his great picture "Nus dans la forêt" at the Indépendants, and it had caused a sensation, even at that time. Vauxcelles, who had invented the term cubism, had talked about "tubism" in connection with this picture, and Picasso had told me, "You see, this boy must have something new, since they don't even give him the same name as to us."

It was at this time that I started going to Léger's studio, and shortly afterwards I signed a contract with him, of which I still have the original. Many years later, Léger used to tell how he had shown this contract to his mother, who was an old peasant from Normandy, to prove to her that he was capable of doing something, of making money. His mother had absolutely refused to believe that it was real and had submitted the document to an uncle who was a notary (for there was an uncle who was a notary), who had confirmed that it was a bona fide contract. Even so, his mother didn't really believe it. So, Léger became one of the painters of rue Vignon, and Gris, whom I had known much longer, followed very soon afterwards.

Gris also lived in a laundry boat. He lived in the studio to the left of the entrance. His two windows gave onto the square, and I used to see him at work when I went to see Picasso. Through Picasso I soon met him. He had not done any painting yet, except at Madrid as the

student of an academic painter. He did drawings for newspapers: "L'Assiette au beurre," "Le Charivari," and later, "Le Témoin." It wasn't until 1911 that he began painting by doing a series of still-life water colors. Soon afterwards came the first oils.

CRÉMIEUX: Did Juan Gris start right out with cubism?

KAHNWEILER: Yes, he has explained that very clearly. He arrived in Paris in 1906, so he was there at the beginning of cubism, the cubism of Picasso and Braque, which seemed to him the normal and natural way of painting. It was in this atmosphere that he began to work.

CRÉMIEUX: Yes, when he was in Paris, his first consideration was to earn a living. He did this by selling his drawings to satirical newspapers.

KAHNWEILER: Precisely.

CRÉMIEUX: And there aren't, in Juan Gris, as there are in Picasso, those rather fleshy pre-cubist periods, are there?

KAHNWEILER: Absolutely not; the only pre-cubist periods are the drawings for the newspapers, which, as far as I'm concerned, do not represent the real Juan Gris. I am sorry to say that more and more of them are turning up at auctions, because the descendants of the people who published those papers had a pretty good supply of them. They command prices that, in my opinion, they do not deserve. Gris himself repudiated those things completely; they were really out-and-out potboilers. It's possible that they may also have been drawing exercises for him, but in any case, they have nothing to do with the art of Juan Gris.

CRÉMIEUX: Did Villon work for these papers too?

KAHNWEILER: Yes, Villon, Galanis, Van Dongen ...

CRÉMIEUX: What about Léger? Didn't he ever do drawings for newspapers?

KAHNWEILER: No, never, nor did Picasso or Braque, but there were quite a few other painters who did.

CRÉMIEUX: In short, Juan Gris was, let's say, not the first painter to adopt cubism, but the first painter to begin with cubism; the others had different backgrounds, especially the minor cubists.

KAHNWEILER: Oh, not really. Metzinger had a short pointillist period behind him, for example. Gleizes too had already done some painting, as had Le Fauconnier, but their valuable work begins with cubism. There were many others of which the same thing is true.

CRÉMIEUX: What about Manolo? Tell us about Manolo. Your friend Juan Gris had some serious quarrels with him, didn't he?

KAHNWEILER: Later at Céret, yes. They were very good friends, but in regard to ideas, they didn't get along at all. Manolo was marked for life by what has been called the "Romanesque school." He had been a friend of Moréas, who had always been his idol. You probably know

the line by Moréas that begins, *"De Don Caramuel Manolo suit la trace. . . ."* Cubism has always been quite alien to him. He was an intelligent, shrewd man, but he lacked a certain philosophy. . . . He always saw things with the good sense of the peasant. There is a famous remark by him, which he really made to Picasso in front of one of his paintings: "What would you do if your parents met you at the station in Barcelona looking like that?" This is childish; there is this common confusion between the sign and the thing signified.

Nevertheless, Manolo was an absolutely extraordinary person. In my opinion, he was a great sculptor who is not yet fully appreciated, but being an optimist, I am convinced that he will be some day. His sculpture was distinctly classicist, like the Romanesque school, like Moréas, who remained his intellectual master. He was a man who had suffered years of frightful poverty, but he had a picaresque style, which I never knew in anyone else. The petty swindles of Manolo—they are legion—are sometimes very amusing. One of the least of these was selling tickets to a lottery in which the prize was one of his sculptures, which did not exist and which, naturally, nobody ever won. There was another one that happened much later—after Manolo had moved to Spain—at Caldes de Monbuy. I used to send a certain sum of money every month for him and his wife to live on. One day he wrote me that he intended to make some very large sculptures, but that in order to do so, he would have to have an additional sum every month, since they would entail additional expenses. I agreed, and for months—six, eight, or more, I don't remember—I sent the additional money every month. Manolo kept me informed about what he was doing, and one day I got a letter saying, "I have just sent you a large sculpture. It is a kneeling woman, who, if she stood up, would be five feet tall.' In reality, of course, she was about fifteen inches high. Of course, if she had stood up . . .

CRÉMIEUX: You must have been the first to laugh.

KAHNWEILER: I had a good laugh, and that was that. Yes, that was Manolo, but in his work he was a very serious man and not at all eccentric, and I think his art is a great art, fresh and close to the earth, much more so than that of the other Catalan, Maillol.

CRÉMIEUX: You published the work of the poets who were friends of these painters. How did this need to publish arise? You had no vocation as a publisher.

KAHNWEILER: I must have had one, since I did some publishing. You must understand that we lived in an atmosphere of euphoria, youth, and enthusiasm that can hardly be imagined today. The work of the poets, Apollinaire and Max at that time (Reverdy didn't come until later),

was very important in our lives: My wife knew the "Chanson du mal aimé" by heart, all of it, and so did I. Besides, these poets had no publisher at that time. So it occurred to me to publish editions of these poets, illustrated by their painter friends. The admirable editions of Vollard were all new editions of old texts, whereas I always published first editions, generally of writers who had never been published before.

CRÉMIEUX: But even so, didn't you publish books that are now considered de luxe editions?

KAHNWEILER: I never published anything but editions of one hundred copies.

CRÉMIEUX: Editions of one hundred copies could not do much to circulate the poetry of your friends.

KAHNWEILER: It gave it a little exposure, and above all it encouraged other publishers to put out larger editions later. Apollinaire or Max had published books to show, which might persuade the *Mercure de France*, for example, to publish Apollinaire.

CRÉMIEUX: Hadn't Apollinaire already published a lot of prose things under a false name?

KAHNWEILER: No, his editions of Sade and other authors of the same kind, Nerciat, for example, came later, after 1911, 1912, whereas *L'Enchanteur pourrissant* was published in 1909.

CRÉMIEUX: Did the painters know and love these poets?

KAHNWEILER: Absolutely. Picasso had a very keen sense of French poetry. Apollinaire once told me, "Even several years ago, when he could hardly speak French, he was completely able to judge, to appreciate immediately the beauty of a poem." In fact, Picasso has written some admirable poems in Spanish and French.

CRÉMIEUX: There was beginning to be a slight difference in generations. Weren't Reverdy and Léger a little younger than you?

KAHNWEILER: No, Léger was six months older than Picasso. Reverdy was a few years younger.

CRÉMIEUX: All these men left to go to war, and I'd now like to turn to the period from 1914 to 1918. We left Picasso on the platform of the Gare d'Avignon, where he had gone with Derain and Braque. Wasn't this at about the time that Apollinaire took the train from Nice to Nîmes?

KAHNWEILER: Yes, but he was in Paris when the war broke out, because there is that very beautiful poem about his return from Trouville or Deauville with Rouveyre on the night war was declared.

CRÉMIEUX: So war broke out for all these men. Where were you? You were a German subject, so things weren't simple. What happened to you and your friends during those four years?

KAHNWEILER: Well, to begin with me, on the day war was declared, August 2, I was in Rome. I still remember it. I was staying at the Hotel Eden, which still exists, and I would go down into the street every ten minutes to buy the special editions that came out one after another. For me the war was absolutely unspeakable and caused an indescribable anguish, because obviously, to fight for Germany was absolutely impossible for me. I did not consider it for a moment. I asked myself whether I should go to France and enlist, and in the end I dismissed that idea too. I have profound pacifist convictions; I had them at that time, and I still have them today. This war seemed to me insane; even today it still seems madness. I think it was a war that had no reason, that was ...

CRÉMIEUX: Unjust, shall we say.

KAHNWEILER: Yes, unjust, but above all, senseless. Both sides got into it inadvertently. Later, I thought I might go to France as a hospital attendant. Some friends talked me out of it, saying, "What's the point? The little good you'll do ..." So we stayed in Italy, my wife and I. We went to Siena because, in the first place, it was on the return half of our round-trip tickets, and in the second place, there was a hotel there that I knew very well. We lived there until December.

CRÉMIEUX: Did you have any news of your friends? What was happening at rue Vignon?

KAHNWEILER: I had news. There was censorship, and letters took longer than usual, but people could write, and my friends, the ones who weren't drafted, wrote me. My very dear friend Reignier, who died in 1918 of Spanish flu, wrote almost every day. Gris wrote very frequently. So I had news of rue Vignon. I behaved stupidly, out of respect for the law, as I did at other times in my life. At that point I could easily, if I had wanted, have had my things moved out of rue Vignon by friends. Brenner, my representative in America in those days, had a gallery in New York, the Washington Square Gallery. He was begging me to let him take some of the pictures to America. Stupidly I refused, saying, "No, no, we mustn't do that, we must leave them where they are. Anyway, nothing will happen to them!" So I left the pictures there, with very bad consequences, as you know.

CRÉMIEUX: Was the shop closed, or did you have a manager?

KAHNWEILER: The shop was locked up. I was paying the rent; I paid the rent throughout the war, which was madness, but ...

CRÉMIEUX: And did any of your friends have a chauvinistic reaction toward you? Did anyone call you a "dirty German"?

KAHNWEILER: Not a one, not a one. . . . No, it just didn't come up, either for them or for me.

CRÉMIEUX: But the government automatically regarded you as an enemy subject, and we'll talk about that a little later.

KAHNWEILER: Precisely. So I was in Siena, not really knowing what to do, when my friend Rupf of Bern, whom I have mentioned as an art lover and a friend of long standing, invited me to come to Bern. He wrote me, saying, "But after all, in the first place, Italy is going to get into the war," which of course happened. Later: "Why don't you come and stay in Switzerland? I would find you a furnished apartment, you would live there, and you could be more usefully occupied than you could be in Italy." He finally convinced me, and we arrived in Bern around December 15, 1914.

CRÉMIEUX: When you got to Switzerland, did you resume your activities as an art dealer?

KAHNWEILER: Not at all. In the first place, I had no paintings and I didn't even think about it. No, in Switzerland I devoted myself to study, especially the study of philosophy. I felt that my philosophical education was incomplete. This is what I did during the five years I lived in Bern. I also wrote some books at this time, one of which is called *Der Weg zum Kubismus*.[2]

CRÉMIEUX: Has it been translated into French?

KAHNWEILER: It has just been reissued in German, and it is going to be published in French.

CRÉMIEUX: Is it customary for you to write during periods of war?

KAHNWEILER: Alas, yes. The rest of the time I am so busy that I don't get much writing done, whereas then I had the time. I wrote this book and quite a few essays (which are also about to be republished in book form in Germany and in France), in which I tried to explain to myself and to others what had happened, what cubism was.

CRÉMIEUX: These were the first serious books on cubism, because until then spokesmen had been rather rare.

KAHNWEILER: I agree. There was the book by Gleizes and Metzinger, which expresses opinions that one can like or dislike, but which are, in any case, the private opinions of Gleizes and Metzinger and have nothing to do with the activities of those whom I shall call the four great cubists: Picasso, Braque, Gris, Léger.

CRÉMIEUX: In Switzerland, did your fundamental pacifism bring you together with men like Romain Rolland or the Russian, German,

[2] *The Rise of Cubism*, translated by Henry Aronson, published in the United States in 1949 in Robert Motherwell's series, *The Documents of Modern Art* (Wittenborn); now out of print.

and even French socialists who were at Kiental? Did you meet these men?

KAHNWEILER: It so happened that, through Rupf, I became a close friend of Robert Grimm, the great Swiss socialist leader of the time, who was one of the organizers of Zimmerwald and Kiental, and through him I may have met, for example, Radek and other Bolshevik leaders, but I did not know them personally. Much later, when he gave a lecture before leaving Bern after October 1917, I learned that for years I had worked beside Zinoviev at the university library. He was a young man, but extremely fat. I heard a lecture that he gave before leaving for Russia, and this is how I found out who he was.

CRÉMIEUX: Did you meet the originators of the dada movement, who were more from Zurich than from Bern, in 1917–1918?

KAHNWEILER: Yes, I went to Zurich once or twice, and they came to see me too. I saw Tzara and Arp several times.

CRÉMIEUX: Did they want to enlist you in the movement?

KAHNWEILER: Oh, no, not at all, they just wanted to meet me. I already knew Arp quite well. I did not know Tzara, because he had just arrived from Rumania; he hadn't been to Paris yet. Someone whom I also saw rather often was the German, or to be precise, the Lorrainian poet, who later wrote in French, Yvan Goll, and his wife Claire Goll.

CRÉMIEUX: What did you think of dada?

KAHNWEILER: It seems to me now that I immediately saw the destructive, nihilistic side of this movement, which I nevertheless found sympathetic. Of course, this nihilism was pretty much in the spirit of the time, and I could well understand how people could give way to this kind of despair.

CRÉMIEUX: The dadaists preceded you to France, for you did not return until well after the armistice. Why?

KAHNWEILER: That's true, Tzara did arrive earlier. Since Arp was a native of Strasbourg, and Yvan Goll of Lorraine, in Metz, they had become French citizens by the armistice. They arrived well before me. This is understandable; the peace treaty was not signed until December 1919 or January 1920, and it was not until after this that one could submit a request to return to France. Actually, I was lucky—and I am grateful to the French embassy in Bern—that they let me into France when they did.

CRÉMIEUX: Yes, because to the Germans you were a draft dodger and to the French you were an enemy subject, which was an awkward situation.

KAHNWEILER: Yes, but I should tell you that in Germany there was am-
nesty—the Republic pardoned me.

CRÉMIEUX: You could have returned to Germany, but you preferred to return to France.

KAHNWEILER: Yes, I could have done as I liked; it was a closed case, completely over and done with, but I wanted to return to France. You understand: Then, as now, I felt capable of doing only one thing, and I was absolutely determined to go on doing it.

CRÉMIEUX: The war left some empty spaces in your group; you never got to see Apollinaire, who died in 1918, on the ninth of November.

KAHNWEILER: There were many others; my dear friend Reignier was one of the first victims of the flu in 1918. One of my wife's sisters also died of the flu. There were so many victims!

CRÉMIEUX: And you must often have been worried, for some of the painters who went to war were wounded—Braque, for example.

KAHNWEILER: Yes, we trembled for those we loved. Braque, as you know, was wounded at Carency, and after a long convalescence, resumed painting. Léger was gassed at Verdun and could not paint again until 1917. Then there was Vlaminck, who was called up to work in a munitions factory. I have never been able to understand how a pacifist, for he was one, could feel any better working in a munitions factory than at the front, where the risk is much greater, which seems to me nobler. Derain was called up, and he served throughout the war. He got out intact.

CRÉMIEUX: Was there a halt in production?

KAHNWEILER: Yes, on the part of all those who were at the front; but there were the neutrals who were in Paris—the Spanish, for example. And there was an art dealer—unfortunately, the poor man did not understand what he should do, but he still deserves a lot of credit—Léonce Rosenberg, who really took over the painters whom I was unable to take care of, helping and supporting them during the war.

CRÉMIEUX: What was the state of rue Vignon when you returned?

KAHNWEILER: Rue Vignon was locked up, but at a certain point the sequestrator moved the paintings to a ground-floor apartment in rue de Rome, which was damp, and the paintings suffered. Fortunately, they did not stay there long.

CRÉMIEUX: And how did you find the painting of those who had not been drafted because they were foreigners? What changes did you find in their work?

KAHNWEILER: It had changed considerably. For instance, there was that extraordinary change in Picasso's painting. That change, which led Picasso at least partially toward a classicist painting, worried me greatly at that time. Since then I have realized a great many things, and I have

understood the reasons for this change. Picasso still tells me quite often today that everything that was done in the years from 1907 to 1917 could only have been done through teamwork. Being isolated, being alone, must have upset him enormously, and it was then that there was this change. Furthermore, I must tell you that in the spring of 1914 Picasso had shown me two drawings that were not cubist, but classicist, two drawings of a seated man. He had said, "Still, they're better than before, aren't they?" This proves that this idea must already have been germinating in him then, but it had not reached the stage of painting.

CRÉMIEUX: When he said, "They're better than before," did he mean, "They're better than what I did before cubism"?

KAHNWEILER: Precisely: "Better than the classicist, or, if you will, the naturalistic drawings I did before." That's all he meant. He never really "abandoned" cubism; he did both things concurrently. Next, there was another rather important event: his meeting with Cocteau, the Ballets Russes, and Olga Kokhlova, one of the dancers in the Ballets Russes, who was to become his wife.

CRÉMIEUX: When we talk about Cocteau, we are already in a new generation.

KAHNWEILER: Yes, and there was also Satie, dear Erik Satie, our good master, as we used to call him, who was older; meeting him certainly didn't do Picasso any harm, far from it. Satie was an admirable man. In him, too, a certain classicism was beginning to appear.

CRÉMIEUX: Satie is a great friend of Braque.

KAHNWEILER: He hadn't been until then.

CRÉMIEUX: In what year would you put it?

KAHNWEILER: Oh, during the war, when Braque came back from the war. Before, we didn't know Satie; he was a whole different world. Satie was a musician who had first known the people in the Rose–Croix, and next the people in Montmartre. He had been in love with Suzanne Valadon. It simply wasn't our world. And the meeting with him really came about through *Parade*.[3]

[3] In 1915 Diaghilev commissioned Satie to write the music for the ballet *Parade* (in collaboration with Jean Cocteau, Massine, and Picasso). [Editor's note.]

3.

FRANCIS CRÉMIEUX: I'd like to talk about cubism. We have reached 1920, and we have some distance. I wish you would explain what cubism is and what its sources are, because we have been talking painters and memories, but very little theory.

DANIEL-HENRY KAHNWEILER: That's true. Well, it's difficult to put it in a few sentences, but I'll try. In the first place, we must recognize a constant phenomenon, the revolt of the sons against the fathers. It is evident that the cubists were revolting in the first place against impressionism; they were revolting against its momentary vision of the external world, its fleeting aspects. On the other hand, it is also evident that there was an ancestor whom they recognized and loved: Cézanne. He had been imitated to an enormous extent in the years after 1900, but with absolutely no understanding. Painters painted Cézannesque subjects, "a plate with three apples on a lopsided table," as they said in those days. But they had not understood the point of Cézanne's painting.

Picasso said to me not very long ago in a conversation at which Pignon was also present: "Pignon, even though he is a painter, can't know, but you, Kahnweiler, who lived through that period, you know what Cézanne meant to us. Cézanne was to us like a mother who protects her children." What had the cubists learned, what had they seen in Cézanne? In the first place, they had seen the construction of the painting, the idea that the painting is not, as the impressionists said,

a slice of nature served with art, or a window opened onto the outside world, but that it is first of all a plane surface of a certain size, on which the painter wants to give us his sensations. The very fact of introducing colored forms that fix these sensations on a plane, rectangular surface creates a certain rhythm.

I think that what happened at that time, not only in painting, but also in literature and music, reveals a very curious phenomenon. Artists wanted to understand the true nature of each art. In music, for example, they wanted to be aware of what was really fundamental and what was merely the habit of the age. Thus they found that tonality, for example, was merely the habit of an age, and that there could be an atonal music, as they say nowadays. In painting, too, they asked themselves what painting really was. I just said that the impressionists had loved the fleeting aspects. In short, they had painted what they saw in a single glance. They had gone, if you will, as far as you can go in illusionism: to show as well as to make whatever one sees, so that the spectator reads exactly what the painter has felt or seen. You understand what I mean—for example, the impressionists would have painted a house in the distance with a blue roof that one could see simply as a blue blob. It was against this that the cubists initially rebelled. They said to themselves: But this house is a cubic construction that is turned in a certain direction. All this must be communicated to the spectator. So they immediately tried to give an image of objects that was more detailed, more precise, more true than can be seen in a single glance. In other words, they painted from then on at least partially what we know of the object, and not only what we see of it. When I say the cubists, of course you must understand always that it was Picasso who began, with his "Demoiselles d'Avignon." As I have already said, the right half of "Les Demoiselles d'Avignon" is an absolutely heroic first attempt to solve all these problems at once, for the cubists wanted to give not only the exact form of objects, but also their exact color. The impressionists had given the color as it appears to us, that is, faded by a layer of air, changed by the sun, by twilight, or whatever. The cubists wanted to give what has sometimes been called the local tone, that is, the true color of the object. They wanted to give the true form too, but at the same time they wanted what they had to say to be shown on rectangular or sometimes oval canvases, without the unity of structure being broken.

I want to point out to you here, in passing, something that I did not realize at the time, but only much later, that in psychology there was something analogous at this time, which today is called *Gestalt-theorie*,

or Gestaltism, which is, to put it crudely, the idea that the whole is always more important than the parts. Basically, this is what the cubists thought too. What was of primary importance was the painting in itself. Its rhythm could distort objects. Everything would have been simple if one could have taken a cup, a glass, or a bottle and given it an accurate, faithful image, but such was not the case.

Picasso said to me in those days, "Of course, when I want to make a cup, I'll show you that it is round, but the over-all rhythm of the painting, the structure, may force me to show this roundness as square." This, obviously, is the source of what people refer to as distortion. We must not forget something that is absolutely fundamental, in my opinion, to the comprehension of cubism and of what, for me, is truly modern art: the fact that *painting is a form of writing*. Painting is a form of writing that creates signs. A woman in a painting is not a woman; she is a group of signs that I read as "woman." When one writes on a sheet of paper "f-e-m-m-e," someone who knows French and who knows how to read will read not only the word "*femme*," but he will see, so to speak, a woman. The same is true of painting; there is no difference. Fundamentally, painting has never been a mirror of the external world, nor has it ever been similar to photography; it has been a creation of signs, which were always read correctly by contemporaries, after a certain apprenticeship, of course. Well, the cubists created signs that were unquestionably new, and this is what made it so difficult to read their paintings for such a long time.

CRÉMIEUX: Monsieur Kahnweiler, in your book on Juan Gris, you write that "the painter by his signs tries to reproduce his emotion in the spectator, to help him read his painting." How do you explain the fact that many years passed before people learned how to read cubism, whereas the writings of Pompeii, of Rembrandt, of Courbet were read very well in their own time?

KAHNWEILER: I will explain that very briefly. There was, in effect, as you very rightly point out, a very unfortunate split between the general public and the real painters. This split began in the early nineteenth century, and I think we must assign the blame to the École des Beaux-Arts, the official École des Beaux-Arts, which in France was the creation of Napoleon. This École des Beaux-Arts did not continue the old way of teaching, in which a painter took young painters into his studio to teach them the rudiments, to teach them their business—rather than to direct them toward a certain form of painting—which allowed them to develop freely afterwards. On the contrary, Napoleon's École des Beaux-Arts and the academies of all other European countries were

based on a certain style of seventeenth-century Italian painting, especially of the Bolognese school, a style that is loosely called eclectic, and they did not break away from it for almost a century. This is what people saw, not only in the Salons, which were enormously important in those days, but also in everyday life, for it was the less talented painters of the École des Beaux-Arts who did the calendars for the Postal and Telegraph Service and for the illustrated supplements to the *Petit journal* and the *Petit Parisien*. All this pseudopainting formed the public taste, and this is why, starting with the impressionists, the general public could no longer read the works of real painters. Don't believe for a minute that it started with the cubists. Remember what I told you about the two cabbies in front of Durand-Ruel's window.

If, as I maintain, painting is a form of writing, it is quite obvious that all writing is a convention. So we must accept this convention and learn to read this writing. This is what happens generally by simple habit. There is no doubt that the color reproductions that are so numerous now have done a great deal to teach people to read the work of the painters of the late nineteenth and early twentieth century.

CRÉMIEUX: Do you think that if cubism, instead of starting in 1907, started now, it would be less difficult to understand?

KAHNWEILER: But it couldn't start now!

CRÉMIEUX: I expected that answer, but you know what I mean. Do you think that if an experiment of that kind—even one less important historically than cubism—were to appear now, it would be more quickly accepted by the general public?

KAHNWEILER: I don't think so. What to me shows the inanity and weakness of what are called abstraction and *tachisme* is the fact that they are accepted by everyone. Remember that at the Salon des Indépendants, we saw people writhing with laughter or rage. Last year there was that exhibition called the Biennale des Jeunes, ninety-nine per cent of which consisted of abstract or *tachiste* pictures. I saw that exhibition; people looked at it very seriously and they liked it more or less, but it aroused neither indignation nor the desire to laugh. This is precisely because these pictures are not writing: There is nothing to read.

CRÉMIEUX: Isn't it partly the fault of cubism if people no longer dare to laugh or create a scandal? Perhaps they are aware of their own ignorance, perhaps they are terrorized by this painting.

KAHNWEILER: I don't think so. There may be critics who are terrorized and who are afraid they will be laughed at in the year 2000, but the general public does not have that fear. Do you know why people laughed? People would not have laughed if those pictures had not represented

something. People laughed because they had a vague idea of what they represented. To them they were hideous caricatures, they were monsters, as has always been said. Obviously, they saw that the leg was too long as they saw it, the nose askew. But as Picasso told me so rightly one day (I find this reflection absolutely admirable), "In those days people said that I made the noses crooked, even in 'Les Demoiselles d'Avignon,' but I had to make the nose crooked so they would see that it was a nose. I was sure that later they would see that it wasn't crooked." You see, this is what made people laugh. Now there's nothing to laugh at. The great mistake of all these people, the one that keeps their painting in the realm of decoration, is that their paintings, or what they call paintings, remain on the canvas, they remain on the wall. We must never forget that the real painting exists only in the consciousness of the viewer.

It's like music. Music is a confused sound until you find the thread, the "*melos*," if you will, which helps you to understand the intentions of the musician. Painting is the same. You must first recreate the picture yourself. But with this current pseudopainting, there is no picture to recreate, whereas with the cubists, on the contrary, it was even more difficult than with the impressionists. With the impressionists, if all else failed, one could still, by squinting at the painting, make the little particles of color blend together and thus manage to see pretty much what the painters wanted to show. With the cubists, this possibility no longer exists precisely because the construction of these pictures, which is very strong, "distorted" the forms. Thus, the round shape of a glass can become a square, which does not make the painting easy to read. But even in those days, some of the first admirers of cubism were people who were content to say, "How pretty!" Well, that's the end of everything, and that's what brought on the painting we have today. People missed the real meaning of cubism, which was a form of *writing* that was intended to be severe, consistent, and precise; they thought that it was merely a form of *decoration.*

CRÉMIEUX: You talk about abstract painting as if it occupied a very large place in contemporary art; but it seems to me that there is a great deal of opposition to abstract painting. I hear many more attackers than supporters.

KAHNWEILER: Its enemies are not as numerous, in my opinion, as you think, and besides, their attacks aren't really virulent yet. I hope they will be; I'd be delighted! I just mentioned that Biennale exhibition; well, there was another exhibition at Kassel, Germany, in 1959, under the auspices and at the expense of the government. This exhibition, too, was

ninety-nine per cent abstract. This is a very curious phenomenon; even if, as you say, this painting has many enemies, it has the support of governments. Both of these exhibitions were organized by the government. In Kassel, the American government, which partly financed the exhibition, had sent numerous abstract paintings. The fact is that this art has become an official art just as the art of the Salons once was.

CRÉMIEUX: Don't you feel that your fellow art dealers have a major responsibility for the popularization of abstract painting? Isn't there a strong commercial factor?

KAHNWEILER: My dear friend, a few months ago in Germany, in Baden-Baden, I attended a conference on painting that went on for three days, including one day in front of the television cameras, and which addressed itself to the question, "Is modern art controlled?" Obviously, the accusation was aimed primarily at art dealers, and I was given first chance to speak. This is what I said: "The business of selling paintings, like any other business, is concerned with making money. In order for a business to exist, it must have a merchandise that sells. It is true that nowadays, in certain fields, industry and business have succeeded in creating needs. In painting I don't think this is the case. I think that besides myself, there have really been only two art dealers, Durand-Ruel and Vollard, who bought paintings that did not sell or that sold poorly. To the extent that I know my colleagues, I am convinced that almost all of them buy merchandise that sells. If anyone is responsible, it is the public that buys these paintings."

These people are the grandchildren of those who bought the Bouguereaus and the Dagnan-Bouverets, all those fine painters of the Salons, like that man who used to paint pink heather, Didier-Pouget. There is the same facility in this painting, for the painter and for the spectator. They are pleasant, hedonistic works.

CRÉMIEUX: Is it really true that art dealers cannot create needs? Haven't they finally succeeded in creating a "decorative need" which corresponds to this hedonism on the part of the public?

KAHNWEILER: I don't think so. There is another factor that should not be underestimated. When the first admirers of the impressionists bought paintings, they bought these paintings very cheaply. They were almost all friends of the impressionists, and men who really had faith. Then one day it became clear that these paintings, which had been bought cheaply, were worth a lot of money. Well, there were quite a few people who bought paintings, I don't say solely for the purpose of speculating, but still with the idea that it might be a good investment. It must be said that the old style of patron has completely disappeared. A gentle-

man would go to a Salon and buy a very expensive picture—for those pictures were more expensive than the pictures of Picasso are today. Well, he would bring this canvas home, and his friends would admire this gentleman who had spent so much money, this generous patron who was supporting this painter by buying this beautiful painting. So, it was also a question of ostentation. . . . But this gentleman knew that if he wanted to sell his painting, it would not be worth very much.

Nowadays, those who buy are not people who are buying with their extra money. They are buying with the money they would once have invested in government bonds or in the market. These people ask themselves whether they will be able to sell the painting if they need money. I don't think it was the art dealers who created this need, these innumerable art dealers. You know as well as I do that there are four hundred galleries in Paris right now. Almost every week I receive an announcement of another gallery that is opening.

CRÉMIEUX: You have said that it is great painters who make great art dealers. I am tempted to say that it is great art dealers who make great customers. Since we are on the subject of speculation, do you believe there will be a decline in the prices of certain painters or a general decline in the prices of paintings within the next fifteen or twenty years?

KAHNWEILER: I can't foresee the future, and I certainly can't predict it. Obviously, we have all been through a depression, the world-wide depression of 1929 to 1936, which saw the total collapse of all prices, old painting as well as modern painting, everything. . . .

CRÉMIEUX: Leather, cotton, copper . . .

KAHNWEILER: Precisely; so we know that this can happen, but you have seen that afterwards the price immediately went back to normal. That certain painters, or that their descendants or heirs, may see their prices collapse, I am convinced is true. There are a lot of false reputations right now that will not last. On the other hand, the painting market has expanded to an inconceivable extent, especially in North America. In every town in the United States, whether it's in Minnesota or Texas, there is a museum that you've never heard of. This museum is supplied not only by its own purchases, but by gifts. Did you know that in America you can deduct gifts to charities or museums from your income tax? Consequently, a gentleman who has bought a painting, let's say a Cézanne, very cheaply in 1890 can leave it to a museum, but keep it in his home during his lifetime. He can deduct from his income not only its purchase price, but the value of the work as assessed by experts, that is, sixty million francs or more.

CRÉMIEUX: Shouldn't our government imitate this American system?

KAHNWEILER: I am convinced of it; in this way we could keep in France an incalculable number of paintings, which would attract a great many tourists and would bring in much more money than the slight loss in tax revenue. When Georges Salles was the director of museums, he tried on several occasions to persuade the Department of Finance to do this, but the Department never agreed to it.

CRÉMIEUX: Why?

KAHNWEILER: The loss in tax revenue.

CÉRMIEUX: I hope Monsieur Baumgartner is listening, because you're making money for him. In the National Assembly you can't propose expenditures unless you produce income. You're producing income because it would put an end to the art drain.

Let's get back to the theory, or system of thought of the cubists. What were its main stages? There was more than one kind of cubism. I wish you would tell us something about analytic cubism and synthetic cubism and about the end . . . well, not the end, but the turning point.

KAHNWEILER: Actually, the cubists, after trying to give as exact an image as possible of objects, found themselves confronted by so many obstacles that they tried something else.

CRÉMIEUX: What obstacles?

KAHNWEILER: Well, on the one hand, they said they wanted to give, for example, the exact color of objects. But to show their form, one had to use what is called chiaroscuro; that is, one had to paint the objects dark on one side, to put it rather crudely. This seemed to the artists first of all a dishonest method, and next, it seemed to them that in this way the true color was lost. We are too habituated to this way of showing objects and we don't realize that this is a method that has never existed in Chinese art, for example. Indeed, pictures painted in this way have always amazed the Chinese. There is the famous story of a French missionary who brought a portrait of Louis XIV to a Chinese emperor. The emperor asked him, "Is it a privilege of the kings of France to have half their faces painted black?" By means of chiaroscuro the French painter had shown the shape of Louis XIV's head. This was one of the reasons.

In defining form in this way, the cubist painters never reached the point of introducing color. Here there was a contradiction. Later, they tried to prevent this contradiction by inventing a style of painting that actually derived from their own sculpture, the sculpture that Picasso and Braque did after 1912. This was primarily a sculpture in paper, cardboard, and sheet metal, but it was distinguished by the fact that it

did not give the form as a whole. It no longer gave the skin, if I may call it that, of a given body. By the superimposition of several levels, it showed depth without giving a complete and closed form. I have written somewhere that there was a precedent for this in certain masks from the Ivory Coast, dance masks that reveal a somewhat analogous method. Picasso owned one. It is obvious that cubism owes a great debt to Negro art. It would be wrong to suppose that the cubists were led to these solutions by Negro art, but in it they found a confirmation of certain possibilities, just as the impressionists had found a confirmation in Japanese painting.

All this was accompanied by an entirely new form of representation. Instead of giving on the canvas only a single view of an object, the painter gave several views. He showed the same object—a bottle, let's say—as seen from the front, from the side, and from above. He even showed the bottom of the bottle. He really wanted to say everything he knew about this bottle. In this way, there appeared some fantastic and admirable types of constructions, primarily in tones of gray and beige, but these things became more and more difficult to read. It is possible that the cubists themselves were a little bothered by these difficulties in reading. In any case, shortly afterwards, in the work of Picasso as well as Braque and Gris, cubism changed into an entirely different manner of representing objects, one that has been called synthetic cubism. In other words, instead of imitating the forms even partially, instead of giving several views of the same object, the painter invented a single form, which synthesized, so to speak, the object in question, a sign that signified the object instead of imitating it. Gris went through analytic cubism before arriving at synthetic cubism. Léger, on the other hand, very quickly discovered synthetic cubism.

CRÉMIEUX: Thank you for this little course on the history of cubism. We have talked about the trunk of the tree, we have talked about the people who really gave cubism its roots in the history of painting. Now other painters appear, things change, we have branches, we also have surrealism, and we have, if I may say so, the descendants of Picasso, the descendants of Léger. What form did all this take in the years between 1920 and 1930?

KAHNWEILER: I am not going to use your terminology. I don't believe that there are branches. What I see is the constant phenomenon of the sons rebelling against the fathers. After all, what did we really do in the days of cubism? We rebelled against our fathers, the impressionists. And the surrealists rebelled against the cubists. This doesn't preclude the fact that cubism owes a great deal to impressionism, and surrealism to

cubism, especially in the greatest of the surrealists. But they thought they were doing something completely different. They claimed, for example, to be introducing a poetic element, which, according to the surrealists, was lacking in cubism. I think this was an error in vision, but this is what they believed.

CRÉMIEUX: Do you feel that there was the same hostility, the same break between surrealism and cubism that there was between cubism and impressionism?

KAHNWEILER: I think so. Of course, the cord was not cut, but there is this hostility, and it can be understood. Braque said and wrote, "Always remember that painting is not an art with which everything can be done." Obviously, surrealism rebelled against this idea. According to surrealism, you could do everything with painting. Remember the subjects of the cubist paintings: They were simple subjects that introduced us to a world of everyday objects that we had never looked at. The surrealists, on the other hand, introduced a thousand other new elements, the disturbing aspect, as they called it, the encountering of heterogeneous or incongruous objects. "Incongruous objects," as Picasso said at the time, "like the dove in the station master's ass?" All this is completely opposed to the ideas of the cubists.

CRÉMIEUX: So the years between 1920 and 1930 had a profound effect on both the followers of cubism and on surrealism?

KAHNWEILER: I think so, for cubism did have its followers. Of course, there was what has been called purism—including Ozenfant, Le Corbusier, for example—but those two painters were rather quick to abandon their aesthetic of that period. Other than that, there was a gradual lapse into decoration.

CRÉMIEUX: Do you mean Léger?

KAHNWEILER: Oh, no, not Léger; he is something else again. In my opinion, Léger never lapsed into decoration. Léger always said, "I cannot conceive that an easel painting could be abstract, could represent nothing or depict nothing. On the other hand, if someone gives me large surfaces to decorate, I find it natural to decorate them with forms that mean nothing."

CRÉMIEUX: The influence of Léger—his colors, his daring in the realm of everyday life—this is what I mean by a branch of cubism.

KAHNWEILER: There is no doubt that Léger influenced the appearance of our streets in the most fantastic way. With respect to signs and painted façades as well as store displays, his influence was enormous.

CRÉMIEUX: Let's go back for a moment to the period previous to 1914 before we leave it once and for all. Tell us something about that ana-

chronistic phenomenon, the Douanier Rousseau. Were you present at Picasso's famous banquet for Rousseau?

KAHNWEILER: No, I wasn't there. I heard all about it the next day, but for some reason that I've forgotten I did not attend. I knew Rousseau, of course; I used to see him at the Indépendants and other places, but that was all. But that banquet . . . here you see the ambivalent quality of all this, especially in Apollinaire. On the one hand, of course, Rousseau's painting was regarded as an absolutely astonishing popular painting and even the work of a genius, if you will; but on the other hand, there was all the while a certain trace of condescension. After all, as I see it, the truly great painter knows what he is doing. Poor Rousseau was delightful, but he used to say to Picasso, for example, "We are the two greatest, you in the Egyptian genre, I in the modern genre." Now, it is quite obvious that to Rousseau the modern genre meant Bouguereau, Bonnat, the Artistes Français. He did not succeed in doing what these painters were doing because he was better than they were.

So he made those curious compositions that we know. Whatever you say, he was an unfortunate man who basically did not know what painting was. He had talent, genius, whatever you want to call it; but like all popular painters, he was not fixed in a period. This is what characterizes popular painting: It is not fixed in time. Rousseau's paintings could just as well have been painted fifty years earlier or right now, if a few costumes were changed.

CRÉMIEUX: In your opinion, is Rousseau the exception that proves the rule?

KAHNWEILER: No, not even that; there are so many other popular painters! However, they don't have the genius of Rousseau. He was much greater than the others. As you know, there is now in the Musée d'Art Moderne in Paris a whole room of popular painters, which seems to me to be a mistake. People have developed a taste for this painting since those days. These popular painters exist everywhere. There are more of them in France, which seems to prove that pictorial or plastic ability is better developed in France than elsewhere. These are people who in their youth did not have the necessary instruction and weren't able to continue their study, and who only much later began to paint as amateurs, but with taste and even with talent.

CRÉMIEUX: Isn't it possible to regard cubism as a classical style of painting, an extremely serious and difficult investigation, which is the exact opposite of surrealism with its uninhibited and oneiric painting?

KAHNWEILER: Yes, I think that the cubist theory, if there is one, was

fundamentally classical. As for the painters, themselves, each had his own temperament, so they were not all classical. In my opinion, Juan Gris was certainly a pure classicist; there is not the slightest doubt about that. Neither in what he has written nor in his painting will one find the slightest contradiction. So was Léger; there is a painting by Léger called "Hommage à Louis David," which indicates what it means. Picasso, on the other hand, was not; he may have been a classicist for a brief period, but his baroque temperament, if I may say so—that is, his romantic temperament, for I find the two terms somewhat similar—always got the upper hand. Neither can I regard Braque as a classicist.

CRÉMIEUX: In conclusion, tell me whether you agree with the definition of great painting that we owe to André Masson: "Great painting," he writes, "is painting in which the spaces between the figures are charged with as much energy as the figures that determine them."

KAHNWEILER: I subscribe to it completely; I have always found that definition admirable. As a matter of fact, it also corresponds exactly to the intentions of the cubists. It says that what matters is the whole, the picture itself, and that all of its parts must be equally important.

4.

FRANCIS CRÉMIEUX: If you don't mind, I'd like to go back, not to rue Vignon, but to that rather damp ground-floor apartment in rue de Rome where your canvases had been in storage. What had happened?

DANIEL-HENRY KAHNWEILER: Apparently my paintings were to have been sequestrated as enemy property under the legislation then in effect.

CRÉMIEUX: And were they?

KAHNWEILER: After those laws were passed. During the war an administrator was appointed. As a matter of fact, I was on the best possible terms with this administrator. I paid my rent regularly and I hoped to save the paintings. No one could have imagined that those in charge would be crazy enough to do what was finally done.

CRÉMIEUX: What was done, if you will forgive me for stirring up painful memories?

KAHNWEILER: As I already told you, my wife and I returned to Paris in 1920, on February 22, and I tried, with the help of the painters, to save the paintings. We did what we could. But at that time a law was passed whereby sequestrated German property had to be liquidated. I won't tell you of the endless efforts that the painters made, that I made. These efforts failed in the face of the narrow-minded stupidity not only of the authorities, but also of certain critics or journalists.

CRÉMIEUX: You must tell me about that. What journalists, what critics? And what support did you have?

KAHNWEILER: Support? Hardly any, except for the painters. PAGE 67

CRÉMIEUX: A man like Albert Sarraut, for example, a lover of painting—what was his position?

KAHNWEILER: He did not become interested in painting until later. At that time I did not know Sarraut, and in fact I never knew him well. No, there were people like Olivier Sainsère, whose name you probably don't know, who was a great lover of painting and who was Secretary General to the President of the Republic under Poincaré. He tried hard. There were other people who tried hard. But they couldn't do anything. There was also the absolute hostility of my colleagues.

CRÉMIEUX: Ah, now we're talking about money.

KAHNWEILER: We certainly are, because on the one hand, there were the people in and around rue La Boétie who really hoped to ruin me.

CRÉMIEUX: To buy . . . ?

KAHNWEILER: Oh, no, you're making them much cleverer than they were. No, they simply hoped to ruin cubism. On the other hand, there was a man whose name I mentioned admiringly a while back, Léonce Rosenberg, who was on the side of cubism, but who in his naïveté thought that these sales would bring about its triumph. This was infantile, and it was consistent with the lack of commercial sense that this poor man never ceased to display, since he wound up almost penniless.

CRÉMIEUX: Why did they want to ruin cubism? Cubist paintings were selling at much higher prices in 1921 than in 1908, for example. Cubism was already a good investment, wasn't it?

KAHNWEILER: The paintings weren't yet commanding fabulous prices, but every year the prices were a little higher.

CRÉMIEUX: Did these people want to ruin cubism because they didn't have any, or many, cubist paintings themselves?

KAHNWEILER: That was one reason, and then they didn't like cubism. They were interested in supporting other "investments," and that was that. And yet Léonce Rosenberg believed, as I just told you, that it would be the triumph of cubism. This was absurd, as anyone can tell after a moment's reflection. I don't remember exactly how many paintings were sold, seven or eight hundred, not counting the drawings and all the rest. Now, no market in the world is capable of withstanding such an avalanche. What happened, of course, is that after the first sale the prices steadily dropped.

CRÉMIEUX: How many sales were there?

KAHNWEILER: Five in all: one of my private property and four of what was the gallery.

CRÉMIEUX: Over what period did they take place?

KAHNWEILER: Over about two years, from 1921 to 1923, I think.

CRÉMIEUX: So eight hundred canvases were sold, of which the majority were by Picasso, Braque, Derain, and Vlaminck?

KAHNWEILER: Yes, all the painters I have told you about. Not the majority, all of them. It so happened that I had acquired, through an exchange, a painting by Metzinger, which was there, and a very few other canvases, but for all practical purposes, there were only those painters.

CRÉMIEUX: Forgive me, Monsieur Kahnweiler, if I ask a question that smacks of sensationalism. If you had been able to keep those eight hundred paintings for forty years . . .

KAHNWEILER: Yes . . .

CRÉMIEUX: And if we sold them today, not all together, but one at a time . . .

KAHNWEILER: Yes . . .

CRÉMIEUX: How many billion francs do you think it would represent?

KAHNWEILER: Many billion . . . many billion . . .

CRÉMIEUX: Many billion! You have kept track of those pictures. Were they sold again?

KAHNWEILER: Yes, but many of them are in museums and have stopped changing hands. Some of them have been sold very recently for sixty and seventy million francs.

CRÉMIEUX: So when we say several billion, we're not exaggerating.

KAHNWEILER: But it would not have happened that way. In any case, I would have sold some of them, I would have bought others, and so on. Pictures don't stay put; one doesn't hide them and not sell them when one is an art dealer.

CRÉMIEUX: My next question will be a little naïve, but you know as well as I do that in the mind of the general public, one of the things that distinguishes Picasso and perhaps also Braque—although Braque's production is not as large as Picasso's—is that he is the only man in the world capable of creating at will such monetary wealth. There is no one else in the world who can, either by painting or drawing, instantly create the sum of one million, or three million, or ten million. This is why I asked you the question about the billions of francs. Well, who bought those paintings? How did it happen? Were you present at the sales? You must have been very upset.

KAHNWEILER: No, I was not present. I went to the exhibitions, but I did not attend the sales. As a matter of fact, I had very little money at the time. A German owner was not allowed to buy back his property after it had been sold, though this didn't really matter, since any one of my friends could have bought them for me. In fact, I did have a few

paintings of which I was particularly fond bought for me. Who did buy the paintings? You're going to be surprised. You were wondering just now whether certain of my colleagues hadn't wanted those sales so they could buy cheaply. Not one of them to speak of bought a single painting! Paul Rosenberg, who died very recently, after having transferred his gallery to New York, and who had been buying from Picasso since 1918 or 1919, especially the classical paintings, did not buy a single picture of his, although they went for nothing. As for Léonce Rosenberg, he was already in financial trouble at this time and he bought hardly any either. The people who did buy were primarily young writers and poets. André Breton, Tzara, Eluard, Salacrou—those were the people who bought.

CRÉMIEUX: No foreigners? No foreign museums?

KAHNWEILER: None at all. This is another complete error in perspective. These painters were unknown or almost unknown at that time; they weren't in any museums yet, except for Picasso and Derain. A few Americans bought paintings. For example, there was a wonderful lady named Sarah Lewis who bought quite a few paintings by Gris.

CRÉMIEUX: You're going to make a lot of people sorry that they weren't thirty years old in 1922. They can always have the illusion that they would have bought.

KAHNWEILER: It would be an illusion; they wouldn't have bought a thing. Like those people who think now that, if they had lived in Cézanne's day, they would have bought dozens of Cézannes. They wouldn't have bought a single one.

CRÉMIEUX: So there you were back in Paris, in 1920. When did you open your new gallery?

KAHNWEILER: I rented that gallery in April or May, I think. Of course, I had to make certain changes. I have a letter from Gris, who was convalescing in Touraine at the time, which must be dated early September 1920. He says, "You write me on the stationery of the gallery, how delighted I am, at last!" So the gallery must have been open in September 1920.

CRÉMIEUX: What was its name?

KAHNWEILER: It was called Galerie Simon, after the name of my associate.

CRÉMIEUX: And it was at . . .

KAHNWEILER: 29 bis, rue d'Astorg, in the court. We stayed there until 1957, thirty-seven years.

CRÉMIEUX: Once established in rue d'Astorg, did you resume your old life and did you renew contact with your painters?

KAHNWEILER: Absolutely, and I must say that they had all remained

faithful to me, with the exception of Picasso, who had gone to Paul Rosenberg and who stayed with him at that time. Later this changed.

CRÉMIEUX: When did he come back to you?

KAHNWEILER: Partially, very shortly afterwards. He never had a contract with Paul Rosenberg, but Rosenberg was a rich man and bought a great deal. Starting in 1923, Picasso sold to me again, more and more often, which finally culminated much later in another complete understanding.

CRÉMIEUX: In this gallery did you sell only the work of painters of whose production you were assured?

KAHNWEILER: Yes, as in the past. Just then this group was joined by Laurens, the sculptor.

CRÉMIEUX: For many years now you have had other painters. Will you tell us something about them?

KAHNWEILER: The first one I bought from at that time was Lascaux, who later became my brother-in-law; he married one of my wife's sisters. I met him through Max Jacob. The second was André Masson. Afterwards, others gradually appeared: Suzanne Roger, Kermadec, Beaudin, and later, Rouvre. I hope I'm not forgetting anyone. I also bought from a few other painters, Borès, for example, but that didn't last.

CRÉMIEUX: While a new generation was getting established with you, part of the old generation was leaving.

KAHNWEILER: We took leave of each other—Vlaminck and Derain, on the one hand, and I myself, on the other—around 1923. It was a spiritual as well as a physical divorce. Derain told me that, and so did Vlaminck. They claimed to have suffered so much in that "boutique cubiste," as Derain called it, in rue Vignon. Vlaminck, who had been very much impressed and truly captivated by cubism, later revolted against his own submission. . . . He told me sometime in the twenties, "When I think, Kahnweiler, that in rue Vignon you showed me a piece of paper with a few lines drawn on it in charcoal and a bit of newspaper glued to it, and told me that it was beautiful! . . . And the sad part, Kahnweiler, is that I believed you!" He was talking about one of Picasso's collages.

CRÉMIEUX: New painters came, other painters left. Didn't Braque and Léger sometimes appear in the galleries of other dealers?

KAHNWEILER: Braque went over completely to Paul Rosenberg, for purely financial reasons. Rosenberg offered him more money.

CRÉMIEUX: What about Léger?

KAHNWEILER: Léger too. When Léger came to me one day and told me that Paul Rosenberg was offering him twice as much as I was giving him, I told him sadly, "All right, I'll give you the same"; but three months later, when he came and told me again, "Paul Rosenberg is offering me

twice what you are giving me now," I said, "I think it is a great mistake to overprice that way, and I cannot do it. Go to Paul Rosenberg." He did go to Paul Rosenberg, but because the depression hit soon afterwards, the sales stopped, and Paul Rosenberg never bought anything from him again. While we're on the subject, I want to say that I dealt with another painter who was a friend and a hero: Juan Gris. Paul Rosenberg made him the same propositions, but Gris refused. He came and told me, "This is what Paul Rosenberg is offering me, but of course you know it would be out of the question."

CRÉMIEUX: Isn't there some sort of gentlemen's agreement among art dealers?

KAHNWEILER: You're very naïve! No, art dealers have always tried to steal from each other the painters whose paintings were selling well.

CRÉMIEUX: I thought they called each other on the telephone and, with the understanding that the other would do the same, did not steal painters from each other. Am I being naïve?

KAHNWEILER: Perhaps it may happen that way sometimes, but it never has for me. All I can say is that I've never had that kind of gentlemen's agreement, if it exists, but I don't really think it does.

CRÉMIEUX: Between 1923 and 1929, the time of the Great Depression, were the prices for the production re-established, in spite of the sale of the Kahnweiler collection?

KAHNWEILER: Prices for the production did not suffer at all in the case of a man like Picasso, for the simple reason that his painting was completely different at that period. After 1920 Picasso's classical period developed, that is, a kind of painting that addressed itself to a different audience. The question no longer arose. Braque certainly suffered a little from the sale, Léger a great deal, and Gris certainly suffered too. Generally speaking, Léger and Gris never saw high prices during their lifetime. Gris died very young, but even in the case of Léger, who did not die young, high prices did not come until after his death.

CRÉMIEUX: Tell me, Monsieur Kahnweiler, does the painter ask you to increase the prices you pay him proportionately as his market value rises, or doesn't he need to do that? Is there some sort of sliding scale?

KAHNWEILER: Well, I hope he doesn't need to ask me, or he certainly would. It's a question of understanding.

CRÉMIEUX: What are the general rules that govern relations between dealers and painters?

KAHNWEILER: There aren't any rules. A young jurist has just written a book on contracts between art dealers and painters. I find this book rather naïve, because I have never seen a single case in which, when such an

agreement was violated, there was a trial. It's all a matter of good faith. The only times there were trials were after the deaths of certain painters or dealers—Vollard, for example.

CRÉMIEUX: In other words, even if a canvas that you bought in 1930 is suddenly worth ten times its price in 1931, the painter profits in 1932, for everything has gone up.

KAHNWEILER: Certainly; or even immediately, in 1931, if he has an honest dealer. But personally, for many years now I haven't had any contracts with painters; it has become simply a matter of good faith, simply a good friendly understanding without any contract or anything in writing, not a word.

CRÉMIEUX: You don't even require a certain number of canvases?

KAHNWEILER: If there are dealers who do that, they are criminals who should be shot. That is an abomination.

CRÉMIEUX: So you take the risk that the painter won't give you a single painting for a whole year?

KAHNWEILER: Of course.

CRÉMIEUX: Or for eight months?

KAHNWEILER: Of course. After all, what is the purpose of such an agreement, when it exists? The purpose is so that the painter can work without financial concerns, that's all. If you tell him he has to produce a certain number of canvases, then everything is over. I tell you, I find that idea absolutely criminal.

CRÉMIEUX: I hope the practice is not widespread.

KAHNWEILER: I don't know; contracts for the total production are very rare. I don't believe it is done very often. The most common arrangement is the so-called first sight agreement, in which the painter promises to submit all his paintings or a certain number of paintings to the dealer, who has the right to buy them.

CRÉMIEUX: I may be mistaken, but it seems to me that one of your painters had a contract with Rosenberg for some canvases of certain dimensions, which he never executed.

KAHNWEILER: Do you mean Léonce Rosenberg?

CRÉMIEUX: Yes.

KAHNWEILER: Oh, that was an entirely different matter. It was toward the end of the war. Léonce Rosenberg made that contract when I wasn't there; since his gallery was already on the decline, he did not want to commit himself for large canvases. He made a contract only for canvases of sizes 12 to 40, I believe, that is, for canvases of 61 by 50 centimeters to 100 by 81 centimeters, but it was simply a way of not overcommitting himself.

CRÉMIEUX: Since you don't operate on a "first sight" basis, you have occasion to receive delivery of the production of a painter. How does this work? Does he call you on the phone and say, "Come over, I have some things for you . . ."?

KAHNWEILER: Just about like that, yes. Since I visit the studios rather often, at a certain point the painter says, "Send Robinot." Robinot, the trucker, goes and picks up the recent things, and that's all there is to it.

CRÉMIEUX: You must tell us some of your secrets, Monsieur Kahnweiler.

KAHNWEILER: It's all so simple; there are no secrets, as you see.

CRÉMIEUX: Yes, I have the impression that, with you, everything is simple.

KAHNWEILER: Yes, it really is.

CRÉMIEUX: You are not, perhaps, the typical art dealer?

KAHNWEILER: No, I'm really not; I think my case is quite unusual and won't repeat itself very often.

CRÉMIEUX: Nevertheless, since we're talking, tell me: When the paintings have been delivered to you, do you put them in the basement, or, on the contrary, do you try to sell them immediately through an exhibition or through rearranging the pictures on the walls?

KAHNWEILER: Of course I always show the paintings that have been delivered to me, and if they sell, so much the better. If they don't sell, well, I put them to one side, but I don't hide them. You must realize that the foundation of my activity has always been relations with other countries, the organization of exhibitions in other countries. In fact, in our total volume of business, exports outweigh sales in France by a a very large margin.

CRÉMIEUX: What taxes do you have to pay as an art dealer? Do you have to pay a purchase tax?

KAHNWEILER: No, I don't, but I do have to pay a tax on the volume of business.

CRÉMIEUX: In the case of exports, do you have the advantage of a reduction?

KAHNWEILER: Yes.

CRÉMIEUX: Does the painter whose paintings are exported also get some of the advantage of this reduction?

KAHNWEILER: Obviously not, because he is not the one who is exporting, nor can the painter have what is called an exporter's license.

CRÉMIEUX: Why not? You could be the forwarding agent.

KAHNWEILER: Only tradesmen or industrialists can have one under the present legislation.

CRÉMIEUX: What about your reserves, the enormous files you have in certain rooms in your gallery, the works that stay behind?

KAHNWEILER: Well, they are there. . . . I may sell them two years later, twenty years later, thirty years later, but after all, they are there to be sold. My system has never been to hide things. I don't see any point in it.

CRÉMIEUX: When you like a painting, when you really want to have it in your home, do you buy it for yourself?

KAHNWEILER: I am not a collector; like Saint Peter, I am a fisher of men rather than a fisher of paintings. I do have paintings in my home; you know some of them.

CRÉMIEUX: There are some admirable paintings in this room.

KAHNWEILER: Yes, and you also saw some in Saint-Hilaire. These are paintings that I like very much, but I do not feel any jealousy toward the collector who buys another painting that I like very much. I couldn't hoard them all. So I take as many as my walls can accommodate, but that's all.

CRÉMIEUX: Yes, but the ones you have in your home are there because you want to keep them, aren't they?

KAHNWEILER: Yes, I have a collection that I won't part with.

CRÉMIEUX: When did your international activity begin? You had correspondents in foreign countries even before World War I, but how does this operate, and since when has it been on such a large scale?

KAHNWEILER: I have worked in this direction ever since the first year I started to be an art dealer.

CRÉMIEUX: Didn't you organize the first Picasso exhibition in London?

KAHNWEILER: There was no Picasso exhibition in London at that time. In 1913 there was an exhibition in the Graffton Galleries, but that was a group exhibition, of my painters for the most part, although there were other modern painters of the time.

CRÉMIEUX: Was it your doing?

KAHNWEILER: Yes and no. I worked with people in London, Roger Fry and Clive Bell. The first Picasso exhibition in Germany was my work, actually, at the Thannhauser Gallery in Munich, in 1912. I had already organized dozens of exhibitions before World War I; in addition, I had correspondents to whom I would give a certain number of paintings on consignment, without there being an exhibition. They would try to sell them. For many years, as long as his gallery existed, I was in touch with Alfred Flechtheim. At a certain point he had galleries in Berlin, Düsseldorf, Frankfurt, Cologne, and Vienna. He was an excessively active man, and I used to provide him with paintings.

CRÉMIEUX: All this is unilateral. There are always exhibitions of your painters in foreign countries, but it doesn't seem as if you had exhibitions of foreign painters in Paris.

KAHNWEILER: No, never. This was understood. I am only interested in my painters, and I cannot concern myself with their painters. In any case, their painters would not have much chance of succeeding in Paris. A painter who does not live in Paris has very little chance of being successful there.

CRÉMIEUX: You describe your profession as if it were a very simple, reliable thing. You have few painters, you do not make exchanges, you have dealings abroad, but in spite of this, you are always at the gallery. When you're not at the gallery, you're giving a lecture, and when you're not giving a lecture you may be at a sale. . . .

KAHNWEILER: I never go to sales.

CRÉMIEUX: Who does go to them?

KAHNWEILER: Oh, my associate Jardot, or my sister-in-law Louise Leiris.

CRÉMIEUX: You are extremely urbane and polite to your visitors. I often observed them when I went to rue de Monceau, but I did not dare interrupt you, as I noticed ladies with American or English accents who must have been potential buyers. You seem to have a regular schedule. How do you organize your day?

KAHNWEILER: It is not organized in advance. I arrive at the gallery in the morning. I read my mail, I dictate, and afterwards I have appointments.

CRÉMIEUX: Business appointments?

KAHNWEILER: Yes.

CRÉMIEUX: Are most of your appointments with people who want to buy or to have things appraised?

KAHNWEILER: Oh, no, there are many appointments that are only remotely connected with business. People come to ask me for information for a book or an article they're writing on one thing or another.

CRÉMIEUX: Tell us about a meeting or conversation with a buyer—not a buyer coming for the first time, but one of your good customers. How does it go? What are people like who buy expensive paintings—for they are expensive!

KAHNWEILER: He calls to ask for an appointment, and when he arrives, someone shows him into the room where the pictures are shown, asks him to sit down, and shows him the pictures that he asks to see.

CRÉMIEUX: I assume that you have old customers with whom you have become friends, but you also have customers whom you don't know. How does it go? Do they bargain?

KAHNWEILER: Naturally, there are my old customers, if you will, friends whom I see outside the gallery, with whom I have lunch or dinner. But business relations are very simple. A friend who is a customer or a

customer who is a friend arrives. I know what he is looking for. I tell him, "You'd like to see some new things," let's say by Picasso, for example. One of my assistants shows him into the room where this usually goes on, gives him a seat, and shows him the pictures. If he is interested in a painting, he asks the price. I consult the list and tell him the price. He buys or he doesn't buy. You ask whether there is any bargaining. Well, there isn't. There used to be. Like many of my colleagues, I used to set prices that I could afford to reduce afterwards. I never do that any more. I fix a price that is invariable and that I maintain. Not one cent of reduction. As soon as people know one is using this system, it works smoothly. There is no need to bicker if people know that that is the price. Either they buy or they don't buy.

CRÉMIEUX: And the dealers to whom you sell, don't they bargain either?

KAHNWEILER: No, they know too. We sell an enormous amount to art dealers, but they don't bargain either.

CRÉMIEUX: In that case, everything is simple! I think I have a false impression of the art dealer, or else you are a rare and unique specimen of the art dealer. You've never had some American from Arizona walk into the gallery with a pile of bills, ready to buy anything in order to have a Picasso in his home?

KAHNWEILER: No. People are always telling stories like that. It's never happened to me. I've never had a man walk in with a pile of bills and say, "I want to buy a dozen Picassos." The people who come to my gallery are cautious. At first they buy one painting by a painter; then, if they like it, they come back a year later and buy more. They have always been people who had a clear idea of what they wanted. I've heard the stories about the man who orders a dozen Renoirs or whatever over the telephone. But it's never happened to me.

CRÉMIEUX: I am wondering whether you still enjoy contact with the customer, or whether you avoid it.

KAHNWEILER: I enjoy seeing people I know. But with people I don't know, I'm just as happy if my associate Maurice Jardot or my sister-in-law Louise Leiris takes care of them.

CRÉMIEUX: You said that you do a large part of your total business with foreign countries. So the foreign galleries, which are very fond of Picasso, must wait their turn because the production is not sufficient, isn't that so?

KAHNWEILER: Of course!

CRÉMIEUX: Do you have a small contingent of galleries to whom you distribute equitably, to each in its turn?

KAHNWEILER: You couldn't call it a contingent, but there are galleries with

whom we are constantly dealing, who are friends whom we favor over others when we have new paintings by Picasso. Actually, foreign art dealers are always appearing from all over, and we sell to them.

CRÉMIEUX: How do they know this? Do you write them?

KAHNWEILER: They beg me, "Please let me know when you have new Picassos, and I'll be there." I tell them, and they come.

CRÉMIEUX: Now let's talk about forgeries. You're not going to tell me that you've never been given any forgeries to appraise. . . .

KAHNWEILER: There are innumerable forgeries now. As soon as a certain kind of painting is worth a lot of money, forgeries automatically appear. But here again, I don't have many good stories. A poor gentleman comes in with a painting he has been sold and says, "Look at this; now they tell me that this painting is not authentic"; I tell him, "As a matter of fact, it is not by X," and that's all there is to it. Sometimes the painting is not a forgery. There are some very clever forgeries. On the other hand, there are forgeries that are completely idiotic. Recently I received a photograph of a hideous daub representing a woman in profile, a pastel with a notation at the bottom, "Lola de Ruiz." Since Picasso's name is Ruiz, this gentleman had imagined that this was Picasso's sister, whose name was not de Ruiz, but Ruiz. It was nothing of the sort; it was a daub of absolutely no interest.

CRÉMIEUX: Still, you must have heard about rather many forgeries in the case of Picasso?

KAHNWEILER: Hundreds, hundreds.

CRÉMIEUX: What becomes of these forgeries once they have been recognized as such?

KAHNWEILER: Alas, I am afraid they do not disappear. When they are shown to the painter himself, he has the right to remove or erase his signature; but as long as they're not shown to the painter . . . There would have to be lawsuits.

CRÉMIEUX: Who sues whom? Does the buyer sue the dealer?

KAHNWEILER: The buyer can bring suit in civil court, and in this case the police, in principle, pursue the forger as such in the criminal courts.

CRÉMIEUX: And, in practice, the forgery is not withdrawn from circulation?

KAHNWEILER: The painting is seized and becomes an object held in evidence. At that moment it is withdrawn from circulation. But as long as there is no prosecution, it is not; prosecution is rather rare and does not occur in the most serious cases, I believe.

CRÉMIEUX: Tell me the story about the forgeries of Picasso and his friends.

KAHNWEILER: That's a joke of Picasso's. I told him, "But after all, you

really should lodge a complaint with all these forgeries," and Picasso replied, "You're right, but I can't. I know exactly what will happen: I will be with the examining magistrate, they'll bring in the criminal with handcuffs on, and it will be one of my friends. . ." The fact is that Spaniards have a great talent for forgery, as they do for painting in general, and I am convinced that there are friends of Picasso's who have forged his work. Finally, there is an enormous number of paintings that are not really forgeries, but paintings by other painters, which are wrongly attributed to famous painters. There are works by many of Picasso's friends from the years 1896 and 1899 in Barcelona that pass as Picasso's works now.

CRÉMIEUX: They are not signed.

KAHNWEILER: Sometimes people sign them Picasso or Ruiz. Sometimes, in the case of works that are not signed at all, they say, "This is something that he did not sign"; in this case, there is only one thing to do— submit them to Picasso himself. Generally speaking, these are not very significant things, which do not yet truly bear the imprint of Picasso. Even in that book that appeared in Spanish called *Picasso antes de Picasso* [*Picasso before Picasso*], which is supposed to reproduce Picasso's work in Barcelona, there are a few things that are not his. They have been removed from the French edition.

CRÉMIEUX: When the painter is no longer living, who has the legal authority to determine the authenticity of a work?

KAHNWEILER: Legally speaking, no one.

CRÉMIEUX: No one?

KAHNWEILER: No. But in practice, it is well known that certain persons really do have documentation.

CRÉMIEUX: Are these the experts, the arbiters chosen by the contending parties?

KAHNWEILER: Yes, but generally speaking, these are not people who bear the title of experts, because, as we know, people who are known as experts in connection with customs or the courts are generally Prix de Rome types, who are incapable of giving an expert opinion on anything having to do with modern painting. In practice, it does not happen this way. One goes to someone who is known to be familiar with the works of the painter in question. Zborowski, an art dealer who died young— well, people used to go to him for expert advice on Modigliani; he had been Modigliani's friend and had a great many documents.

5.

FRANCIS CRÉMIEUX: You told us, Monsieur Kahnweiler, how Derain and Vlaminck first came to your gallery. They came to bring the paintings you had bought at the Indépendants. What were they like in 1907?

DANIEL-HENRY KAHNWEILER: Well, first of all, they were great friends. They had virtually lived together for years in Chatou; for example, they had a studio over the Pont de Chatou, where they worked together and did all kinds of crazy things. There is a famous story about a lay figure who had a name; I think his name was Prosper. They staged terrible scenes, with screaming, in their studio—a kind of mock battle with this Prosper, which would end with Prosper getting thrown out the window. Everyone would run down, thinking that someone was really hurt. They were like children. . . .

CRÉMIEUX: Were they married at that time, or were they living as bachelors?

KAHNWEILER: Vlaminck was married, and Derain had mistresses, but he was a bachelor.

CRÉMIEUX: Did they live together?

KAHNWEILER: Oh, no! They only shared the studio. Vlaminck had a little house in Rueil, which he kept for quite a long time.

CRÉMIEUX: And they had visitors. I think I read somewhere an account of a visit Matisse paid to their studio.

KAHNWEILER: That must have been later. They met Matisse around 1906,
and I believe they no longer had that studio over Pont de Chatou.

CRÉMIEUX: You came along in 1907. After you met them, I know you became the co-owner of a boat with Vlaminck.

KAHNWEILER: Two boats, in fact. We had a sailboat, the *Saint Matorel,* and a motorboat, *L'Enchanteur.*

CRÉMIEUX: What became of them?

KAHNWEILER: Poor Vlaminck, in his confusion at the time he thought the Germans were arriving in Paris, in 1914, he sold the boats for the modest sum of three hundred francs. I received one hundred and fifty. He was absolutely honest, I'll say that. To get back to their physical appearance, they didn't look anything like the image we have nowadays of painters of that period. They dressed "à l'américaine," as they used to say, in rather flashy tweed suits, bowler hats, and colorful ties. A little later, Vlaminck made himself a tie out of wood.

CRÉMIEUX: Wood?

KAHNWEILER: A wooden tie that he fastened to his collar. It was blue with yellow dots, if I remember correctly. Apollinaire describes it as "a defensive and offensive weapon." These clothes were ready-made; they came from stores with English names to which they gave a French pronunciation. They bought their clothes at High-Life Tailor, for instance. They were both big, husky men, tall and broad-shouldered, and Gertrude Stein said rather nicely that, when you saw Picasso with Braque, Derain, and Vlaminck, he looked like Napoleon surrounded by his marshals.

CRÉMIEUX: Because Picasso isn't very tall.

KAHNWEILER: He is short. They are all tall. So much for their physical appearance. Of course, there were the shoes, which were yellow with thick soles, the epitome of what was believed at that time to be American.

CRÉMIEUX: So they were not at all like our stereotyped image of the painter in baggy corduroys and a big hat?

KAHNWEILER: No, they weren't like that at all. Picasso was much closer to it, though. Picasso often wore corduroy trousers. Braque, on the other hand, was a complete dandy. In fact, he is still a man of extraordinary elegance. In those days he used to wear very simple blue suits with a special cut, which I never saw on anyone but him. He also had black, square-toed shoes that did not have thick soles, which he said came from Abbeville. Like Max Jacob, he had a black string tie, and he wore all this with a great deal of chic.

CRÉMIEUX: Could you recognize their palettes in the costumes of these painters?

KAHNWEILER: Not really. No, I don't think painters have ever thought

about their painting when they selected their clothes. There really isn't any connection.

CRÉMIEUX: Are you sure? Don't you think that in so far as dressing is an activity involving selection, one can partly analyze a person by examining the way he is dressed?

KAHNWEILER: Yes, I do. I think you're right. . . .

CRÉMIEUX: That's why I asked you the question. Through dandyism, perhaps through a trace of exhibitionism . . .

KAHNWEILER: It wasn't exhibitionism at all, because their dandyism was excessively discreet. With Braque, for example, one really had to be a connoisseur to see that he was elegant. I think most people would have considered him very badly dressed.

CRÉMIEUX: Fifty years later, you're still very impressed by those square-toed shoes. Everyone didn't have them!

KAHNWEILER: Nobody had them. Shoes were excessively pointed in those days, much more pointed than they are now.

CRÉMIEUX: Were there places where they would get together, as there are now among the young painters? Did they meet regularly outside of Montmartre or the Lapin Agile?

KAHNWEILER: There was a café in Montmartre called L'Hermitage where we used to go often. I don't believe it exists any more. It was on boulevard de Clichy, right near Place Pigalle.

CRÉMIEUX: Did they go to Montparnasse before the war or after the war? Who invented Montparnasse?

KAHNWEILER: That's difficult; Montparnasse already existed before the war, you know. There were Germans at the Café du Dôme, which in those days was really the meeting place of all the German painters.

CRÉMIEUX: Did you ever go there?

KAHNWEILER: Never; I never go to cafés. You see, I don't drink. I did go to Montmartre, to L'Hermitage . . . but that was the only time in my life. I have never cared for cafés, and I never go any more.

CRÉMIEUX: Did you prefer to go to cabarets?

KAHNWEILER: I went to the Lapin Agile, as we all did. I used to go to night clubs with Picasso perhaps once a week, but not every night.

CRÉMIEUX: Did you go to the movies much? Didn't the movies have any influence on these painters?

KAHNWEILER: Not really. I went to the movies now and then, and they did, but it really had no importance, it played no role. The only spectacle that did play a role for them, as I shall always maintain, was the circus, but not the theater—they never went to the theater; and when they

reached the Ballets Russes period, fundamentally they did not know the theater. They had to invent everything themselves.

CRÉMIEUX: What about concerts and music?

KAHNWEILER: Not at all.

CRÉMIEUX: So did the arrival of Satie in the world of Picasso and Braque bring about their contact with music, as you see it? Was one of them more of a musician than the other?

KAHNWEILER: They were more interested in Satie than they were in music.

CRÉMIEUX: In your early days as an art dealer, was Vlaminck still taking part in bicycle races? What is this business of bicycle racing?

KAHNWEILER: He really did it. He was still doing a lot of bicycle riding, but he had stopped racing. He had also done some boat racing; he still went rowing on the Seine, but no longer took part in regattas.

CRÉMIEUX: But is it true that during his poorer periods he earned his living playing the violin on the sidewalk outside cafés?

KAHNWEILER: I don't think so. He did play gypsy music in the cafés.

CRÉMIEUX: For money?

KAHNWEILER: Yes, but he never played on the sidewalk.

CRÉMIEUX: Was he already painting?

KAHNWEILER: He started painting very early, around 1901.

CRÉMIEUX: So if he did both things at once, it was really to earn his living?

KAHNWEILER: Absolutely; he had no interest in being a professional musician.

CRÉMIEUX: Let's talk about Derain. What did his parents do?

KAHNWEILER: Derain was the son of a *petit-bourgeois* dairyman in Chatou. His family had a very successful creamery in Place de l'Hôtel de Ville in Chatou, so they were able to give their son a little help, although they disapproved of his career. At first Derain was supposed to go to the École Centrale; he was to have become an engineer. That was what his parents wanted.

CRÉMIEUX: Did he avoid the official teaching of the Beaux-Arts, did he go to one of the independent academies?

KAHNWEILER: Yes, he went to the Académie Carrière.

CRÉMIEUX: What about Vlaminck?

KAHNWEILER: Vlaminck never went to art school.

CRÉMIEUX: You were telling me about Picasso's "marshals," Derain, Vlaminck, and Braque, three big men; but a fourth marshal arrived later who was also tall, Léger.

KAHNWEILER: Ah, yes! Léger was an exquisite creature. Physically he was truly the northerner—red-haired, tall, freckled, exactly as one imagines the man of the north. I did not meet him until 1910. He had previously

done some painting, which he had then almost completely destroyed.

CRÉMIEUX: Really?

KAHNWEILER: He had done paintings that must, in so far as one can judge, have been fauvist; he himself called them impressionist paintings, and it was not until after 1910 that he really became himself. You know how he made his living: as a photographic retoucher, as an architectural draftsman—jobs of that sort.

CRÉMIEUX: Did he also avoid the official teaching of the Beaux-Arts?

KAHNWEILER: He spent several months at the Beaux-Arts; next, he drew at La Grande Chaumière and places like that. Between 1907 and 1910 he went almost every evening to make sketches from the nude. I own some of those drawings, which are very beautiful.

CRÉMIEUX: And what did Léger think of the paintings of Picasso, what did Picasso think of the paintings of Léger, what did Derain think of the paintings of Léger—in other words, how was a certain familiarity established among these painters? Was it compartmentalized?

KAHNWEILER: Picasso had praised that first painting by Léger that was shown at the Indépendants. As for Léger, he certainly thought very highly of Picasso. But there is that remark by Delaunay, which he quoted himself: "But those boys paint with spiderwebs"—in other words, the reproach of the absence of color. Léger's first things were also monochromes. Léger always had a great deal of respect for Picasso, and Picasso certainly respected Léger; Gris, for example, whom we have not talked about yet, admired Picasso enormously, since his career began with a painting called "Hommage à Picasso."

CRÉMIEUX: We must talk about your friend Juan Gris; we are talking about him much too little, and this must be fate working against Gris, because he died much too soon; this is why he is less present in our conversation.

KAHNWEILER: Yes, that is very likely.

CRÉMIEUX: Well, tell us about Gris, who wrote you such beautiful letters, and so regularly, and who was your neighbor in Boulogne, where you emigrated.

KAHNWEILER: That's right, my wife and I found him that little house while they were in Céret in the winter of 1922.

CRÉMIEUX: He was still in rue Ravignan?

KAHNWEILER: Up to then, yes. He lived in rue Ravignan for sixteen years.

CRÉMIEUX: It was, according to his friends, a rather unhealthy place to live.

KAHNWEILER: It was the most unspeakable and unsanitary place you can imagine. I remember Gris' first major illness, an attack of pleurisy.

It had been necessary to make a kind of tent around his bed to protect him. In fact, very shortly thereafter he was moved to the Hôpital Tenon, because it was absolutely impossible for a sick person to live there. I first met him there, probably in 1907, at least by 1908, through Picasso. I used to see him when I went to visit Picasso. His two windows gave onto the square, and one could see him working in his studio.

CRÉMIEUX: How did you become such an intimate friend of Gris? What was it about Gris, perhaps more than the others, that held you?

KAHNWEILER: Who can explain friendship? I can't tell you. He was a man of whom I still think with tenderness, a man admirable in every respect, the purest man and the most faithful friend imaginable. Aside from that, the fact that we were neighbors certainly helped bring us together. We were already friends at the time Gris was living in Montmartre. The letters you mentioned attest to this. They were written, of course, at times of the year when he was not in Paris. When he was there we saw each other, but we wrote often when one of us was away from Paris. In 1922 he moved to Boulogne, at 8 rue de la Mairie, next to us—we lived at 12—and after that we saw each other every day. He came to see us every evening. I often went to his studio during the day to see what he was doing. Josette, who is now his widow, would come to see us while we were having lunch; she would sit on a wooden bench ("*en troisième*," as she used to say) and talk. Suddenly she would scream, "*Mon dieu*, Jean must be in a rage, the peas have certainly turned to coffee beans, and the *haricots* must look like vanilla pods."

CRÉMIEUX: Wasn't Gris calmer than the others?

KAHNWEILER: Not at all. Gris had an extremely explosive temperament. He had terrible rages, which did not last long. There was a certain scene, which the two of them often told me about. Josette and Jean (we called him Jean) loved each other very much, but there were fights. One day Josette was in bed waiting for Jean to bring her *café au lait*. Jean arrived with the saucer, the cup, the *café au lait*, and the *croissant* lying prettily across the cup. He said, "Here is your *café au lait*, Jojo." She answered, "I don't want it." "Yes, you do, my Jojo, you must have your *café au lait*." "No, no, I don't want it, leave me alone." "So you don't want it? *Merde!*" roared Gris, overturning the cup and pouring the hot coffee onto the head of Josette, who, completely inundated with coffee and with the wet croissant on her head, first cried and then laughed with him.

CRÉMIEUX: So it was like that—sudden fits of anger?

KAHNWEILER: Yes.

CRÉMIEUX: Thunderstorms.

KAHNWEILER: That's right!

CRÉMIEUX: In Boulogne you used to meet not only during the week, but also on Sunday, and on Sunday there were many more people.

KAHNWEILER: Yes. I don't know how it happened, probably because it was Boulogne, and we were in the suburbs. We had a garden. Boulogne was pretty in those days; people still had big gardens and garden houses, and it was very pleasant. It became awful because the factories moved in, and we were surrounded with big buildings, apartment houses. By 1940 it had become impossible. A great many friends came to our Sundays. At that time, my two young sisters-in-law were living with us, who later became Madame Louise Leiris and Madame Berthe Lascaux, having married a poet and painter, respectively; both of them used to come to the house on Sundays. Gris loved to dance, and since he did everything very seriously, as we used to say, he used to buy those little booklets that were published in those days and teach himself the new dances, which at that time were the tango and dances of that kind.

CRÉMIEUX: It was Borneman who published those little books, a publisher in rue de Tournon; he also published fishing manuals.

KAHNWEILER: That's right. Gris also had an old-fashioned wind-up phonograph. We used to play the phonograph and dance in the hall in the winter, and in the garden in the summer. Gris used to give lessons to young girls and women, and we made a great many friends that way—all those who became my friends after the First World War. That period was a kind of second youth for me. I don't dance, but in those days, I danced. I never learned, but I danced anyway.

CRÉMIEUX: It seems that when Juan Gris was in Céret, he made a great show of dancing, since he won contests.

KAHNWEILER: Yes, he took it very seriously, and he was a good dancer. To mention some of those who came in those days, there was Michel Leiris, whom I have already mentioned, and Satie, whose work I published then. He became a great friend of the family. I remember him with a great deal of admiration; he was an amazing man.

CRÉMIEUX: What year are we talking about now?

KAHNWEILER: The years between 1921 and 1925 mostly. Satie died in 1925, Gris died in 1927, and his death marked the end of that era.

CRÉMIEUX: Let's stay in that happy period a little longer. There was also Salacrou.

KAHNWEILER: There was Salacrou, there was Raynal, and there was Malraux, and there were their wives. There were many others, my friend Simon, for example. There were the painters: Masson, Suzanne Roger and Beaudin, Kermadec a little later at the time when I knew him,

and the poets Cingria, Limbour, Tual, Artaud, Desnos, and many others.

CRÉMIEUX: In short, your painters soon become close friends, at any rate, the second generation.

KAHNWEILER: I can't imagine any other kind of relationship. It is this, I think, that accounts for the special quality of our business: the fact of its being really trusting, friendly, even familial, if you will. I can't conceive of its being otherwise.

CRÉMIEUX: Is this what you would say to a young man of twenty-two who wanted to become an art dealer? Do you believe this is part of the work?

KAHNWEILER: I don't know whether it would still be possible now to do what I did. The cost of living has become very high. A certain ratio must be maintained between the price at which one can sell a painting, if one wants to sell it at a reasonable price, and the cost of living. I insist on this. I have already quoted Picasso's advice, "For paintings to be worth a lot of money, they must at some point have been sold cheaply." Of this I am convinced. I think nowadays we are inclined to sin in the opposite direction: We charge too much to begin with. Personally, I believe that one should start by selling the paintings very cheaply. On the other hand, if one sells them too cheaply, will one be able to give enough money to a young painter? That's the crux of the matter.

Here is an example that I have given often. Max Jacob, who was a lifelong friend, a very dear friend, had a cousin named Gompel, a very rich man who was the manager and principal stockholder of the Paris–France stores. Max wanted this Monsieur Gompel to buy some paintings and drawings from Picasso. Well, one day in 1904 or 1905, Max brought him to rue Ravignan, and after Picasso had shown him numerous drawings, this Monsieur Gompel said, "How much would you charge for a drawing?" Picasso replied ,"Fifty francs," which was really a reasonable price for a drawing at that time, whereupon Gompel, looking around the studio and seeing numerous drawings on the walls, the sofa, the tables, and everywhere, said to Picasso, "But in that case, you are very rich!" This story amused us very much when we talked about it, but actually it was not as ridiculous as it seemed to be. After all, Gompel was a businessman. He said to himself, if there are two hundred drawings here, that makes ten thousand francs. It was absurd, in the sense that Picasso could not sell them all. When he sold one from time to time, he was very happy. Max was bringing Gompel there so that he would buy one or two. Obviously, from this point of view, it was ridiculous; on the other hand, in those days fifty francs represented fifty dinners. I have eaten in little restaurants for one franc, wine

included. What price would you have to ask nowadays for the drawing of a young painter for it to represent fifty dinners?

CRÉMIEUX: Fifty thousand francs.

KAHNWEILER: Oh, not that much . . . There are still very simple restaurants where you can get a decent meal for four hundred francs.

CRÉMIEUX: They're getting rarer all the time.

KAHNWEILER: True. But let's say twenty-five thousand francs. You see! That's why I think it would be difficult for a young dealer to begin the way I began. And I should tell you that the majority of dealers, even Vollard, started out with different kinds of paintings, things that were easier to sell, whereas I really began with the painters who were mine afterwards, except for those who, for artistic reasons, broke with me or with whom I broke, like Van Dongen, Derain, and Vlaminck. And I don't repudiate what these painters did at that time; I continue to find it excellent.

CRÉMIEUX: When you wrote your friend Reignier that you wanted to become an art dealer, he discouraged you. What did he say?

KAHNWEILER: Well, he had very kindly consulted some "men of learning," that is, people who, according to him (and according to me too), ought to know, people like the architect Plumet or Pascal Fortuny, who was an art critic. He talked to others too, whom I don't remember. All these people had discouraged him, saying that first of all, it was necessary to have a great deal of money, and that if one bought expensive paintings, the money would be very quickly exhausted. If one bought paintings by little-known painters, one would have to wait a very long time to sell them. Next, he told me, one would have to know the market. I would have to defend myself against the other dealers, who would be very hostile and would fight me. And then, he wrote, "It seems there are all sorts of little tricks that one has to know." I came across this letter again about a month ago. I read it with tenderness, thinking of my very dear friend, who died in 1918 of the Spanish flu, but I said to myself, what tricks was he talking about? To this day I still don't know them. I don't know a single trick. I know a way of selling pictures, which is to acquire them and to wait until people come to buy them, but I don't know a single trick.

Getting back to our young art dealer of today, I don't think that at this point he could plunge right in and buy solely the work of young painters. I think that after a while he would find himself at an impasse. Even if he succeeded in selling his paintings by pricing them low, this would not make enough money for the painters; but if he priced them high, I don't think he would sell very many.

CRÉMIEUX: Let's get back to Max Jacob taking Monsieur Gompel to see Picasso. Jacob had stopped working for Monsieur Gompel, hadn't he?

KAHNWEILER: That's right, he did work for a while in boulevard Voltaire, in one of the Paris–France stores.

CRÉMIEUX: He sold fabrics, didn't he? Do you remember?

KAHNWEILER: I don't know exactly what department he was in.

CRÉMIEUX: He must have been unhappy there.

KAHNWEILER: He certainly must have been. I didn't know him until afterwards; that was before my time.

CRÉMIEUX: Did you know him before his conversion to Catholicism?

KAHNWEILER: Yes, I met him in 1907, and the conversion was in 1909 or 1910. It was around then that Christ appeared in his bedroom, after Max had come back from the movies.

CRÉMIEUX: Picasso, who was his sponsor, wanted to give him the name Fiacre as his Christian name.

KAHNWEILER: No, that was a joke; Picasso knew very well that it was an impossible name. Anyway, as you know, the baptism did not take place until 1917, during the First World War.

CRÉMIEUX: But was Picasso really his sponsor?

KAHNWEILER: Picasso was his sponsor, and in the end he took the name Cyprien, as you probably know: Cyprien Max Jacob.

CRÉMIEUX: What was Max Jacob like in those days?

KAHNWEILER: Max Jacob is difficult to describe. What struck one most were those admirable eyes he had, eyes of an extraordinary tenderness, which also contained all the sorrow of Israel. At that time he was already beginning to get bald, and he was smooth-shaven; previously he had had a beard, but I hadn't known him with a beard. He wasn't very tall. He was one of the wittiest and most comical men in the world.

CRÉMIEUX: There were great joking sessions between Max and Picasso. . . .

KAHNWEILER: Oh, my, yes, there were entire nights of fooling around; I remember Max singing "Le Grand frisé" one whole night, with different interpretations. It was a popular song: "Quand je danse avec le grand frisé . . . il a une façon de m'enlacer. . . ." Max sang that one whole night until four in the morning in all kinds of ways, waltzing with a chair.

CRÉMIEUX: Did all these friends live in fairly comfortable circumstances, or were they still under a certain amount of financial pressure?

KAHNWEILER: They weren't all, but Max was. He was very, very poor all his life. It's very simple: Max never had enough money. He earned nothing to speak of from his poetry, his literature. The little he earned

was from his *gouaches*, which at first were made with a bit of tobacco, a bit of saliva, and very little paint, and later became rather carefully done—worked-over *gouaches* showing a certain talent, which Max sold rather easily to friends, for not very much money. He was always poor, and the reason he moved to Saint-Benoît-sur-Loire was partly because he could live there much more cheaply than in Paris.

CRÉMIEUX: But how is it that, since Max was such close friends with Picasso and the other painters, they didn't manage to help him financially?

KAHNWEILER: They did help him, of course, but in the first place, Max would have refused to live off other people, and in the second place, a person can help someone for a few months, but helping someone all his life is another matter.

CRÉMIEUX: He seemed somewhat dedicated to poverty. Did he try to escape it?

KAHNWEILER: I don't think he really did. Actually, there was something of the saint in him, the saint and the martyr.

CRÉMIEUX: You have seen money enter the lives of these painters who had been very poor. Did it bring about changes, outside the possibility of finer clothes, new and more splendid square-toed shoes?

KAHNWEILER: The advent of money took different forms according to the individual. Vlaminck bought houses, first at Valmondois, later at Verneuil-sur-Avre. Derain also bought houses, and then a kind of château in Chambourcy. Picasso acquired several homes, but fundamentally not one of them, not even Derain, and certainly not Picasso, radically altered his life style. Picasso always lived in a state of nostalgia for rue Ravignan. I remember him in rue des Grands Augustins, pointing to the ceiling, which was rather dilapidated, and saying, "Look, it's rue Ravignan, it's exactly like rue Ravignan." Actually, he re-created rue Ravignan wherever he went, its disorder and everything it implied.

CRÉMIEUX: What one knows of the lives, I won't say the private lives, but the domestic lives of these painters, is that basically they have very few needs. They haven't succumbed to bourgeois values on the level of daily life.

KAHNWEILER: None, I think, except Van Dongen, whose profession as a society painter once obliged him to stroll along the allée des Acacias, in the Bois, or on the boardwalk at Deauville. I don't know where these festivities take place nowadays.

CRÉMIEUX: I think he still strolls on the boardwalk in Deauville; that's what the newspapers say.

KAHNWEILER: Ah, you see! He certainly still strolls there in the spring and

in Cannes in the winter, but the others do not—no, not even Derain, who spends his money on very fast and very expensive cars. Braque had a beautiful house built by the architect Perret, in which he has been living for many years now, but aside from this, their lives have not really changed. There is a remark by Picasso on this subject, which may sound disagreeable to certain people who do not understand. A long time ago Picasso told me, "I'd like to live like a poor man with a lot of money." This is really the secret. Picasso wanted to live like a poor man, to continue to live like a poor man, but not to have to worry about tomorrow. This is what he meant—to be free of financial worry.

CRÉMIEUX: Money can change a man, or he can change on his own. These painters, whom you have known for fifty years—at a certain point they changed; certain ones withdrew from you, others remained close to you. Have you seen the influence of events on them, the influence of life? What changes could you describe, to conclude this portrait of your painter friends?

KAHNWEILER: One thing that must be mentioned above all is the wars, the political events. Events of such great gravity have occurred that each has had to take a position. I would not say that anyone changed. I believe that each man revealed himself as he was.

CRÉMIEUX: Yes.

KAHNWEILER: Each one showed himself "as he was in himself at last." It was not eternity that changed him, but the age he lived in.

CRÉMIEUX: Can you explain why these six or seven painters of the first generation did not, it seems, haunt the museums? I am thinking especially of Picasso; he traveled very little.

KAHNWEILER: Oh, not so little; he used to go to museums a lot. He went to Holland, to England, and naturally, to Spain and Italy.

CRÉMIEUX: What about Germany, since he likes its painting so much?

KAHNWEILER: He hasn't been to Germany. He has been to Switzerland and Poland, where there are few museums. I suppose he did not have time to see the museums in Poland.

CRÉMIEUX: But were your conversations with him filled with references to painting, the great painting, which he had perhaps seen only in reproductions?

KAHNWEILER: Oh, no, he had seen it in the Louvre in any case, for after all, there is in Paris a universal museum, so to speak, a museum where it is really possible to study the painting of the Christian world. Picasso also knew the museums of Spain; he knew the Prado. Think of the "Ménines" and remember that at the exhibition of the "Ménines," as interpreted by

him, we showed the photograph of a little sketch that Picasso had done in front of the "Ménines" in Madrid in 1898.

CRÉMIEUX: That's true. But what about the others?

KAHNWEILER: Well, there was Derain. He began his career with a copy from Ghirlandajo in the Louvre, the "Bearing of the Cross."

CRÉMIEUX: Did they buy paintings or try to buy paintings by their colleagues, living or dead?

KAHNWEILER: Among the living they made exchanges; they gave each other gifts. Picasso bought a few paintings by the old masters, especially the impressionists. Vlaminck bought none at all. Matisse did. As you know, Matisse was not one of my painters, but I was on very good terms with him. Braque has a few little things; he has a little Corot, for example. But there is an art that they all collect, and that is Negro art.

CRÉMIEUX: Negro art. But, generally speaking, they did not invest their money primarily in paintings in order to have them before their eyes night and day?

KAHNWEILER: Certainly not; at least they would not have regarded the purchase of a painting as a way of investing money.

CRÉMIEUX: I expressed myself badly—as the satisfaction of a desire? I imagine that if they had been able to buy Cézannes, they would have been happy to have them.

KAHNWEILER: Picasso bought some Cézannes, and Braque acquired one too.

CRÉMIEUX: What is Picasso's collection like? One can talk about a Picasso collection.

KAHNWEILER: Yes, indeed, he has some very fine things. He has quite a few Cézannes, he has works by Renoir and Degas, two by Le Nain, quite a few things.

CRÉMIEUX: All turned to the wall, or hung up?

KAHNWEILER: Well, since he has been at Vauvenargues, for the first time there are things on the walls. There never were before, except in the days of Olga in rue La Boétie, where there were paintings not hung up, but visible, on the furniture or leaning against the wall.

CRÉMIEUX: Have you been to Vauvenargues?

KAHNWEILER: Yes, quite a few times.

CRÉMIEUX: Why, in your opinion, did he buy that big house?

KAHNWEILER: For the same reason as always: to fill it.

CRÉMIEUX: And will he succeed this time?

KAHNWEILER: It is enormous, but he will succeed.

CRÉMIEUX: Do you think that the paintings that were piled up or turned
against the wall will take their places on the walls?

KAHNWEILER: Not all, perhaps. He spoke of painting the walls, not directly, but by means of remounted canvases. "I am going to make Piero della Francescas."

CRÉMIEUX: Does Picasso ever buy back his own paintings?

KAHNWEILER: Rarely. Sometimes he has bought back very old things that were souvenirs because they represented a friend.

CRÉMIEUX: He is a man with a memory. You mentioned his extraordinary eyes, which impressed you when he walked into your gallery for the first time, but there was also the period when his hair fell into his eyes.

KAHNWEILER: Yes, it lasted for a long time, too.

CRÉMIEUX: As long as he had hair?

KAHNWEILER: As long as he had hair. When I met him, he had that very black hair and a lock that practically covered one eye. He also had a period of great elegance, the period when he had just married Olga, who was one of the dancers in the Ballets Russes. At that time, in fact, he moved in society circles and dressed not with a personal elegance, but with an elegance that was recognized by all, in clothes that he bought from the great English tailors. That didn't last long.

CRÉMIEUX: He is still very elegant.

KAHNWEILER: He is always very elegant.

CRÉMIEUX: It is easier to be very elegant on the Côte d'Azur; with a pair of pants and a jersey, it is a matter of color.

KAHNWEILER: Yes, but there he often wears gifts he has received.

CRÉMIEUX: Picasso maintains rather curious bartering relations with certain clothing establishments.

KAHNWEILER: Oh, you mean Sapone, the Italian tailor?

CRÉMIEUX: Yes.

KAHNWEILER: Yes, it's something of a joke. Picasso makes him little drawings, and Sapone makes him some pretty extravagant things.

CRÉMIEUX: Overcoats with white polka dots.

KAHNWEILER: Yes, things made out of women's fabrics, trousers with horizontal instead of vertical stripes, but which he nevertheless wears with a great deal of elegance.

CRÉMIEUX: There was a period when Picasso stopped painting—that may be a bit strong, but he painted very little. Isn't this part of our portrait of Picasso?

KAHNWEILER: There have been quite a few periods when Picasso stopped for a while; but there was one period when he stopped for at least six months. This was at the time of his separation from Olga in 1934.

CRÉMIEUX: You have written that the art of Picasso is fanatically auto-biographical.

KAHNWEILER: I know no art that is autobiographical to such a degree. There is no face painted by Picasso, no woman's face that is not the portrait of the beloved of that period. Never are they simply casual or invented heads: It is always the woman he loves. I have often told about this: There was a period in his life between 1912 and 1914 when, given this requirement, it was impossible to do a portrait. But even at this time, he wanted to bear witness to his love in his paintings. I have a letter from him in which he says something like "I love Eva"—she was the woman who lived with him and who died during the First World War—"I love Eva, and I shall write it on my paintings." In fact, there are paintings from that period on which he has written on a gingerbread heart, "I love Eva."

There are also other paintings from the same period on which he has written, "Ma jolie," which was a song—"Oh, Manon, ma jolie, mon coeur te dit bonjour"—a song that we used to hear in the night clubs in Montmartre in the days when he was courting Eva. So it was also Eva he was thinking of when he put "Ma jolie" on the paintings.

CRÉMIEUX: If Picasso's art is fanatically autobiographical, then social contact with Picasso must have been and must still be, perhaps, greatly affected by his state of mind at the moment. Is he moody, can he be kind sometimes and cruel other times?

KAHNWEILER: I cannot say that he has ever been cruel with me; my God, no, I would never say that, but it is quite obvious that he does not have an even temperament, that he can be depressed, and that he can be, on the contrary, very enthusiastic.

CRÉMIEUX: Do you mind if we go back and talk a little about Apollinaire, whose work you were the first to publish—your companion in the heroic days of cubism, although you had many reservations about his qualities as an art critic?

KAHNWEILER: I regard Apollinaire as the great poet of his time. I thought so then, I think so today, and I was very fond of him. But I am convinced that Apollinaire did not have a physical, sensual relation to painting.

CRÉMIEUX: You have mentioned his erudition. What was he like?

KAHNWEILER: His erudition was very great and rather eccentric; it was an erudition with respect to subjects that many people do not think about. He knew an enormous number of things, and he displayed them very readily.

CRÉMIEUX: Can you give us an example?

KAHNWEILER: I remember that we were living in Auteuil, in rue Théophile Gautier. He was living in rue Gros; anyway, he told about the flood of

1910, when the soldiers came to get him in a boat and saved his life. We often used to take a trolley that stopped at Alma so they could renew its supply of compressed air, which took a good five minutes. You had time in those days! So, we were on the top deck of this trolley, and Apollinaire pointed to the barges that were passing and said, "You see those barges, you see those boats? They have a magnificent name: They are called *bélandres*.

CRÉMIEUX: *Bélandres?*

KAHNWEILER: I hadn't heard the word either. It occurs in one of his poems from that period.

CRÉMIEUX: Did he give you its etymology?

KAHNWEILER: I don't remember, but in any case I checked, and it's true; they really are called *bélandres*, but I don't remember the etymology. He probably told it to me.

CRÉMIEUX: Almost all these men were bachelors. You were ...

KAHNWEILER: I was married, but Apollinaire was having an affair at that time with Marie Laurencin, who lived two steps away from him, in rue La Fontaine.

CRÉMIEUX: Were there many ladies interested in this group?

KAHNWEILER: Do you mean the wives of the painters?

CRÉMIEUX: No, women in general. I am talking about the unmarried painters, I am talking about adventures, gold diggers, and so on.

KAHNWEILER: Do you mean ladies who were interested in them for erotic reasons or for artistic reasons?

CRÉMIEUX: Both.

KAHNWEILER: They were successful with women of course, all of them, especially Gris. He was not just Juan Gris, he was Don Juan Gris. But Gris never made a display of his success with women. He was always the soul of discretion. Gris was very handsome, almost mulatto, with heavy lips, but very handsome.

CRÉMIEUX: So it was really they who were interested in the ladies, then.

KAHNWEILER: Very much.

CRÉMIEUX: And did they put this interest into practice?

KAHNWEILER: Yes, women played an important role, which is only natural.

CRÉMIEUX: Good! Now, I would like to go without any transition from the so-called first generation to the second generation, that is, the painters of the postwar days in 1919. I wish you would talk about them and that you would tell some of the same kinds of things you have told about the older ones. Who was the first painter to join the group of the older ones, André Masson?

KAHNWEILER: No, it was Henri Laurens. When I was in Bern during the First World War, I regularly received the little there was in the way of reviews at that time, and I had seen some of Laurens' work. I had even seen pictures of him. At that time, Léonce Rosenberg was his dealer, and I think that Laurens was my first new painter. As a matter of fact, he was older than the others, not much younger than myself, whereas the others had been born around 1900. Laurens was a man admirable for his optimism, modesty, and kindness. He is the only man I have ever heard say something that I myself would say: "If someone asked me to live my life over again, with all the suffering and everything else, I would not hesitate to say yes." Well, the suffering was terrible, for Laurens had a leg amputated when he was only about twenty years old, some sort of bone disease from which he suffered very often during his life. Fortunately, he lived to a reasonable age in spite of it. Laurens never complained, and yet it was really not until two years before his death that he saw a bit of success. He was poor and he lived modestly, first in La Ruche, then in Montmartre, then in his little house at the Villa Brune. He never complained or showed the least trace of bitterness. Laurens had been an anarchist in the great period.

CRÉMIEUX: The Bonnot group?

KAHNWEILER: Let's not exaggerate; he had known people in the Bonnot group, but he had not taken part in the crimes, of course. Fundamentally, he remained an anarchist in the true sense all his life. He is one of those rare people who refused the Legion of Honor. They asked me to sound him out, as they always do, so the artist won't refuse. I asked Laurens whether it would be agreeable with him. He answered, "Oh, no, Marthon would laugh at me." Marthon was Marthe, his wife, who has since also died.

CRÉMIEUX: Yes, the Legion of Honor is a rather delicate and complicated decision; I don't see the rosette in your . . .

KAHNWEILER: No, because I am something like Laurens, if I may say so.

CRÉMIEUX: Was the daily life or the week-end life of this new group anything like the life of the early cubists?

KAHNWEILER: Yes and no, but there is considerable similarity. For instance, the life of Masson is not so different from the life of Picasso. Masson, too, lived in an absolutely miserable studio in rue Blomet, where, on top of everything else, there was a horrible thing: He lived next door to a factory that ran all day and shook the studio. Everything moved until evening, until the time when the machines stopped running. Here he lived with his wife, for he was married, and with his little daughter, who

was more often with us in Boulogne than with him, since the sanitary conditions were too miserable for a baby.

CRÉMIEUX: What year was it that you met Masson?

KAHNWEILER: It was in 1921, and like Picasso, he was surrounded by poets. There were Georges Limbour, Michel Leiris, Armand Salacrou, Artaud, and there were lesser-known people who have been forgotten, like Roland Tual, who made his living writing scenarios for movies and who died not long ago, poor man. At that time we all regarded him as one of the most gifted, and we awaited his poetry with extraordinary impatience. He never wrote a thing. As a matter of fact, I even bought a manuscript from him sight unseen. He had told me about it. To do him justice, I should add that he returned the money, for he never wrote it.

CRÉMIEUX: But it was Masson who was the unifying link between the two generations, at least in your mind.

KAHNWEILER: The unifying link was Max Jacob, for Max Jacob knew all these young people too. The young poets gathered around him. As for the painters, Masson knew almost all of them in Montmartre, for he had lived in a furnished room in Montmartre before moving to rue Blomet. I also met Lascaux through Max.

CRÉMIEUX: And Masson through Lascaux?

KAHNWEILER: Yes. Masson was Lascaux's friend in Montmartre. Lascaux lived in Place Jean-Baptiste Clément in a ground-floor apartment between a moss garden and a courtyard. This place was so damp that after a while the paintings began to disintegrate. One day when I was visiting Lascaux, I saw two paintings by his friend Masson. He had hung them up so I could see them. As soon as I saw them, I liked them very much.

CRÉMIEUX: Did you participate at all in the social and literary life of this group, for this was on the threshold of surrealism?

KAHNWEILER: Yes, except that at that time they were not yet friends of the orthodox surrealists, whom they met a little later. It was in 1924, at an exhibition of André Masson's work that I organized, that the surrealists Breton, Eluard, and Aragon first saw the work of Masson, which they immediately admired greatly, and it was at this time that they met. The contact was not of long duration, for in 1929 appeared the so-called dissident surrealists, who were the rue Blomet group. Artaud had already parted company with Breton after publishing the review *La Révolution surréaliste*.

CRÉMIEUX: What about Kermadec?

KAHNWEILER: Kermadec moved in an altogether different world from these

people, although he had been a friend of Desnos, and I did not meet him through them. There was an Alsatian painter named Adrion who came to see me rather often, though without the slightest intention of selling me his paintings. He is dead too. His work was not at all the kind I could defend, but the boy was rather amusing, a bit picaresque, and it was he who was the first to mention his friend Kermadec, who had come to show me one or two paintings, around 1924. They were still-life paintings; to give you some idea, I would say they were somewhere between Soutine and Vlaminck, with a lot of paint. As a matter of fact, he had been a very great friend of Soutine. After that, I did not see him again for a long time.

Then one day around 1927, Adrion told me that his friend Kermadec had completely changed his style and that he had made some paintings that were very different—very light, with very little paint, and relatively difficult to read. This is what made me decide to go to see Kermadec in his studio. He lived in rue de Seine on a courtyard, but rather high up, in an apartment that was very curious in that the house was fairly old and that everything was painted white, with all the modern conveniences, exhaust fans and things of that sort, not at all like the others; it was the exact opposite, with very little furniture, but with modern furniture, some of which he had made himself. There were three tennis balls over one door as a trophy. I did not know then that Kermadec was a great tennis player, one of the best in France at that time. Later his son was a champion, and even today Kermadec still referees all the big matches in Paris.

CRÉMIEUX: But did this furniture and this athletic, hygienic cleanliness come from the sale of his paintings?

KAHNWEILER: Not at all. There was an old art dealer in rue La Boétie known as Père Chéron, who had bought a few things from Kermadec. Eventually he had stopped buying, and then he had disappeared. But Madame Kermadec worked: She made sweaters, very pretty ones, and she had a small clientele for this. Kermadec's father, who had been director of the Pointe-à-Pitre boarding school for young ladies in La Guadeloupe, was already retired by then, and probably he was able to give his son some help. Kermadec has a rather Caribbean appearance, a curious, somewhat pear-shaped head. He is not very tall, but very broad-shouldered and very strong.

The paintings that I saw at his place were at the threshold of abstraction, but had not crossed it. They won me over immediately. I must say that there was something almost physical in the attraction this painting had for me then and still has today. I told Kermadec then and there

that I was prepared to buy his entire production. There was a whole series of paintings by him over a period of several years that had an extremely pronounced erotic element. They did not show couples embracing, but women in corsets and stockings, partly undressed women, with an eroticism that was very strong and very beautiful. I remember one of my Swiss friends, whose puritanism made him literally recoil from the *odor di femina* of these paintings the first time he looked at Kermadec's work.

CRÉMIEUX: And after this, shall we say, feminine period ...

KAHNWEILER: Afterwards, there was a period in which landscape played a greater and greater role, as is still the case today. Kermadec has a curious trait, which is that he paints only what is close to him: his wife, his child, objects in his home, what he sees out the window. There is a certain street corner (he lives near the old Station Montsouris in La Ceinture) that he has painted I don't know how many times. Across from his house there are garages; he has painted them. He owns a little house by the sea in the Cotentin, which comes from his wife's family. The landscapes he has painted there have a striking resemblance to the area once one has found the key. At first they seem very difficult to read, but when one sees a photograph of the same country, one is amazed at how accurate they are down to the last gable; nothing is left out.

CRÉMIEUX: But you, the great locksmith of painting, can easily find the keys to unlock them. What you say about Kermadec proves that you must have learned to read him.

KAHNWEILER: One must learn, one must always learn to read painting. I told you at the beginning of our conversations that painting is a form of writing; but all writing is convention, the convention must have been accepted, and people must have been willing to learn to read. This should never be forgotten, but it is quite clear that there is no need for special study; habit alone is sufficient.

CRÉMIEUX: A little while ago you said, in speaking of an Alsatian painter who came to see you, "His painting was not one of the kinds I could defend."

KAHNWEILER: I did not even have to tell him this; he was a good man in his own way, and he knew it.

CRÉMIEUX: What kind of painting can you defend? Because, in spite of your severity, although you have only found a painter once every eight years, all hope is not yet lost. . . .

KAHNWEILER: I find your question rather naïve. It is a little like asking a thermometer why it goes up. A thermometer goes up when it's hot and

goes down when it's cold. In other words, it is simply the way I feel in front of these paintings that guides me. I reason afterwards, but not before, and I have no way of knowing in advance what the painting of tomorrow will be like.

CRÉMIEUX: I don't mean that! When you attack a certain kind of painting, you are very good at giving reasons why you do not like it.

KAHNWEILER: Ah, but in those cases the thermometer has stayed at zero. When it has stayed at zero, then afterwards I come along and explain to myself and to other people why I don't like that kind of painting.

CRÉMIEUX: You must then explain to yourself and to other people why you like a certain other kind of painting and give the broad lines of defense of that painting.

KAHNWEILER: Of course, when I have seen it I can say that, but only for each individual painter; otherwise, it would be trying to predict the future and to say that painting will have to be a certain way.

CRÉMIEUX: Oh, no! It means this: If I, Kahnweiler, must defend a painter or a school of painting that I don't know yet, the broad lines of my defensive organization will be these.

KAHNWEILER: No, it doesn't mean that for me because, you see, I am conceited enough to believe that the painters whom I have defended are really the great ones and that I shall never have to defend any but those who are great. Consequently, for me, the two must coincide.

CRÉMIEUX: You're psychic: I have been trying to lead you into a trap. I was going to ask you some questions about little sects of painters like La Ruche, whom you have certainly known, and I wanted to make you talk about other painters. I see that I am not going to succeed. You're going to say, "But why should I talk about other painters at the risk of hurting their feelings?"

KAHNWEILER: Precisely; I would not want to cause pain to numerous painters whose painting I do not like, but whom I like very much as people. Why should I hurt them, why should I even risk causing them pain?

CRÉMIEUX: I won't press you. Instead, let's talk about the last painter to come into your gallery, the youngest of all, Rouvre. What year did you meet him?

KAHNWEILER: I don't remember the exact year, but it must have been about six or seven years ago, in 1953 or 1954, I think. I couldn't have met him earlier, because this is a boy who has had a rather curious life. He is the son of a painter of the Salon des Artistes Français, and his father did not want him to become a painter. He felt that it was an impossible life—one starved to death, more or less.

CRÉMIEUX: Aren't painters who are the sons of painters rather rare in the history of painting?

KAHNWEILER: Yes, and the father was a true academic painter, apparently. I have never seen his paintings. He finally agreed to let his son enter the Arts Décoratifs, thinking that he would do commercial drawing; but Rouvre decided to become a painter. Then the war came, and Rouvre went to North Africa during the occupation. He worked with architects, especially in Tunisia, doing interior decorating. After that he was in Indochina, also working with architects. By that time he had already married, and it was not until he came back to Paris that I met him through Masson—they were neighbors in Aix. He lived at that Château Noir that Cézanne painted so often. I saw his paintings, and there was the same phenomenon as in the case of Kermadec: His work had an immediate, physical effect on me.

CRÉMIEUX: Nowadays, aren't your painters a little less unified as a group than the cubist painters were?

KAHNWEILER: I'd like to point out that we haven't yet talked about all the painters. We haven't talked about Beaudin, a man for whom I have infinite respect and a great deal of affection.

CRÉMIEUX: Answer my question, and then we'll talk about him.

KAHNWEILER: Certainly.

CRÉMIEUX: Wasn't it a different way of life?

KAHNWEILER: But the others weren't unified either at that age. These are people who are sixty years old. For instance, the Beaudin and Masson ménages were very close when they were starting out in 1921. They lived together in the country, and they were very intimate. Masson was rather friendly with Rouvre too during the short time they lived next to each other. Lascaux was a very good friend of Masson.

CRÉMIEUX: But what about Beaudin?

KAHNWEILER: I met Beaudin through his wife, actually, because I bought first from Suzanne Roger. I can't remember how we had met Suzanne Roger, but Gris had known her too. She had shown him some of her paintings, and Gris liked her work. I had decided to buy her painting before Beaudin's. It is true that Beaudin already had a dealer, the Galerie Percier, with old Level senior, a charming man who had an admirable talent for unearthing new painters.

CRÉMIEUX: Is this the same man you used to buy prints from when you were young?

KAHNWEILER: No, the name sounds the same, but it is spelled differently. The print seller was named Le Véel.

CRÉMIEUX: Was it Level whose calling cards Picasso used to pin to his collages?

KAHNWEILER: Precisely; he had known Picasso for a long time. Level was a remarkable man in his way. He founded that society called La Peau de l'Ours, which you may have heard about. La Peau de l'Ours was a society founded by a group of friends under the direction of Level.

CRÉMIEUX: What year was that?

KAHNWEILER: It must have been a little after 1900. It had been agreed that each member would pay a certain sum per year, that Level would buy paintings with this money, and that for the duration of the society each of the members would have paintings in his home, but that at the end there would be a sale at the Hôtel Drouot, that those who wished could buy back paintings, and that afterwards the sum of money obtained would be divided. That is what happened. It was at this sale that, for the first time, one of Picasso's 1906 paintings, "Les Grands saltimbanques," which is now in America, brought a rather high price—I think it was eleven thousand francs.

CRÉMIEUX: Eleven thousand gold francs?

KAHNWEILER: Yes.

CRÉMIEUX: It was almost a lending library for paintings.

KAHNWEILER: Oh, no, we had to put them somewhere. But primarily, it was a way of speculating on the paintings, because it was a question of reselling them at a certain point and sharing the profit.

CRÉMIEUX: Throughout your "second youth," that is, between 1921 and the Second World War, you never moved toward surrealistic painting.

KAHNWEILER: Not orthodox surrealistic painting, no.

CRÉMIEUX: You circumvented it.

KAHNWEILER: To me the real surrealist painting is Masson and Miró, and also Max Ernst. But I don't like orthodox surrealist painting for a very simple reason. The intentions of this kind of painting were very literary; there was not only the business of encountering incongruous objects and whatever, there were all sorts of intentions, Dali's soft watches and a thousand other things. If one has such intentions in painting, for the public to understand them, one is almost obliged to produce an academic painting or calendar art. This is what happened with the Belgian surrealists or with Dali, for example. This has never seemed like painting to me, but a kind of painted literature, which was outside my province.

CRÉMIEUX: Exactly. And you define Max Ernst much more in terms of his origins.

KAHNWEILER: Yes. In the painting of Max Ernst, I have always felt a very

strong connection with the best in German painting, with certain aspects of the great period around 1500. Also with Caspar David Friedrich, the great German romantic painter. I am not very responsive to this type of painting when it is done at the present time, but even so, I salute it and I have respect for the man.

CRÉMIEUX: During those twenty years between the wars, what was the basis of your new solidity, what characterized the life of the gallery? International contacts, exhibitions in foreign countries? What was the history of the gallery?

KAHNWEILER: Well, some of that sort of thing, yes. There were more foreign exhibitions than before, but even so, I had a hard time of it. The fact has been forgotten today, but immediately after the First World War there was a minor depression, but a depression all the same. I had no stock at all and had to start again from zero. In the sales, I had been able, with the help of a few friends, to buy back twelve, fifteen, perhaps twenty paintings; but what was that in comparison with the hundreds and hundreds of paintings I had lost! Besides, these paintings had depreciated because of the sales. Cubism necessarily suffered. For this very reason, those painters whose entire production I again had—like Léger after a while, Gris almost immediately, and Braque for several years—sold badly. As for Derain and Vlaminck, who sold better, I had already broken with them or they with me, as you will, by 1923 or 1924.

By 1924 or 1925 the gallery was again doing a modest but reasonably active business and was just about on its feet. But then came that awful thing that nobody can imagine today: the world-wide Great Depression, the "seven years of lean cattle," if I may, from 1929 to 1936. People nowadays cannot conceive of the way it was, that horrible sense that everything had lost its value.

CRÉMIEUX: In Wall Street, American financiers sold apples on street corners. In France the depression was less severe, but not in your field, isn't that so?

KAHNWEILER: Not for luxury items, not for paintings. It was incredible: We sold nothing. My sister-in-law Louise Leiris had come into the gallery in 1920 and had worked with me since then. We were alone. Before, we had had an office boy whom I was obliged to dismiss. We would sit in that gallery for whole days without seeing a soul. All this would have been relatively bearable if I had not had the responsibility of the painters. I did not want to desert them. I don't mean the great ones. Picasso didn't need me. Nobody was buying from Picasso, but Picasso could wait. Braque could wait too.

It was then that we invented an organization that we called the "artistic mutual-aid syndicate," which consisted of a group of friends. Each one gave so much per month. The gallery distributed this money to the painters, and at the end of the year each person who had contributed was entitled to so many things by one or another of the painters, according to what he had spent. The gallery deducted a small percentage from this sum in order to keep going, but it also spent a certain sum in order to obtain paintings. This is how we kept the painters alive until about 1936.

CRÉMIEUX: It was a society for the preservation of painters!

KAHNWEILER: That's right.

CRÉMIEUX: And the men who belonged to this syndicate were art lovers?

KAHNWEILER: Yes, art lovers of the highest possible type.

CRÉMIEUX: So in 1936, the time of the Popular Front, a period that in France has been blamed by many as the beginning of a substantial devaluation, your business began to pick up?

KAHNWEILER: Yes.

CRÉMIEUX: In France or with other countries?

KAHNWEILER: Both. But as I have already told you, my business has always been much more an export business than a business within France.

CRÉMIEUX: When you stopped exporting, were you experiencing a reaction to the American depression of 1929?

KAHNWEILER: That was the most important thing, but in France people stopped buying too.

CRÉMIEUX: And you hung in your gallery everything Picasso was doing?

KAHNWEILER: Not then, because I could not buy anything from him, but he lent me some things.

CRÉMIEUX: Well, what did you do, since you had an unwritten agreement?

KAHNWEILER: I had no agreement with Picasso at that time. Picasso had been selling to Paul Rosenberg.

CRÉMIEUX: How long did that go on?

KAHNWEILER: Oh, he sold to Paul Rosenberg again until 1939.

CRÉMIEUX: Still, there was a considerable hiatus.

KAHNWEILER: But he did not sell to Rosenberg alone; he sold to me too, what I could buy with my slender resources. I shall tell you a little anecdote on this subject. As you know, there is a new painter who has come into the gallery, Yves Rouvre, whom I admire very much. When I told Picasso about this, he laughed and said, "Kahnweiler is playing dolls," by which he meant that at my age I no longer needed to take young painters, that I was in a position to stick to those I had. I answered

"You're right, I'm playing dolls. But now I want you to tell me something. If someone like me does not take Rouvre, who will? You know as well as I do that it would be very difficult for a young dealer to begin the way I did. Besides, who is keeping Rouvre alive? It's not I, it's you; it is because of the profits from your paintings that I can afford to take on a young painter."

CRÉMIEUX: What did he say?

KAHNWEILER: He laughed and said, "You're right!"

CRÉMIEUX: Haven't you forgotten some of your painters, Monsieur Kahnweiler?

KAHNWEILER: Yes, I have. You cut me off just as I was going to say a little more about André Beaudin, the man who, as I see it, best understood the great lesson of Juan Gris. Like Gris, he was a classical painter, profoundly sensitive, to be sure, but one who subjected the excesses of passion to a lucid reason, to a desire for order, clarity, purity.

What is curious is that his wife, Suzanne Roger, who shares the same studio with him (Beaudin, "painter of dawn," as he has been called, working in the morning and she in the afternoon), is at the opposite pole from this classical art, and an unmistakable romantic. There is a somber flame burning in her paintings whose autobiographical nature is obvious. The paintings spontaneously reflect her joys and sorrows, with possible emphasis on the latter.

I realize that I have forgotten another painter, for the simple reason that I do not buy his paintings today. I'm talking about Gaston-Louis Roux, a painter whose early work I liked and still like very much. He had something absolutely unique. To give you some idea of the man, I will tell you that in his studio he had only one reproduction of an old painting, the juggler by Hieronymus Bosch, which is in the Musée de Saint Germain. Well, his painting had this satirical or humorous quality, whatever you want to call it, of Bosch, along with an originality that was absolutely solid. This boy worked seriously and passionately all his life, but at a certain point something must have happened that threw him off base. First he took off for two years on what was known as the Dakar–Djibouti mission, led by Marcel Griaule, along with my brother-in-law Michel Leiris, André Schaeffner of the Musée de l'Homme, and others.

CRÉMIEUX: This was around 1934?

KAHNWEILER: Not that late; it must have been earlier, in 1932, something like that. They traveled across Africa in two years, from Dakar to Djibouti, spending the longest time in Ethiopia, where Gaston-Louis Roux made copies of paintings in Ethiopian churches.

CRÉMIEUX: Had he already come into your gallery?

KAHNWEILER: Yes. He had painted precisely those things of his that I like the most. He came back and started painting again, but fundamentally, he never recovered his balance. It seems to me that he must have already lost it by the time he left, and that this departure was a symptom of the disorder. One day he came to see me and said, "Something awful is happening to me, I am at an impasse, I have to start all over again." He began making small paintings that were almost all very innocuous—you could not even say what they were really about. There was a slight influence of Gruber, and yet it wasn't really that. Since that time he has been struggling in this sort of confusion, and one day he told me very honestly, "Look, I would understand perfectly if you stopped buying from me. I know you don't like these things, and I myself am completely uncertain of what I am doing." To my great satisfaction, a short while ago he came to see me and said that he had just painted a large decoration that had been commissioned, which he was going to show me, and that he thought he was onto something. For his sake I hope so with all my heart.

CRÉMIEUX: So there was a period of ten years during which he did not even want to give you canvases?

KAHNWEILER: Not exactly; he did ask me from time to time to come to see his paintings, but with a curious kind of skepticism. First he would come to see me and say, "Look, Kahnweiler, this time I think it's better," and when I went to his studio, as soon as I arrived, he would say, "No, I was wrong to make you come, I haven't got it yet."

CRÉMIEUX: What do you mean by going back to the beginning? The beginning of what?

KAHNWEILER: The beginning, as of a painter who is learning to paint, painting very simple objects and painting them in an almost imitative way. . . .

CRÉMIEUX: And when he showed you his early paintings, the ones you described to me, hadn't he begun to paint a few years before?

KAHNWEILER: Yes, he had worked with Dufy; he had painted and had done paintings a little in the spirit of Dufy. He has never been a surrealist. The group has never accepted him, and he has never wanted to join the group, but still there is a slight influence of surrealism.

CRÉMIEUX: Do you have other examples of this kind of confusion or of a painter who stopped producing?

KAHNWEILER: No, he is the only painter I have known in this situation. It moves me all the more.

CRÉMIEUX: When you said that he had just done a decoration, did you mean a wall decoration?

KAHNWEILER: That's right; it is a very large thing, apparently.

CRÉMIEUX: A fresco?

KAHNWEILER: No, not a fresco. Hardly anyone does frescoes nowadays, for a very simple reason: Nobody commissions them. As you know, a fresco is very difficult to remove from the wall afterwards, and, my God, nobody is assured of maintaining his position. Everyone prefers paintings.

CRÉMIEUX: Do you believe, then, to change the subject, that only official commissions, whether secular or religious, can provide opportunities for fresco painters?

KAHNWEILER: I still don't know any who have done frescoes at this time—at any rate, very, very few, an infinitesimal number. Almost all the large paintings that have been done are canvases.

CRÉMIEUX: Are the Mexicans the only ones who do frescoes?

KAHNWEILER: I don't think they do them either. In the United States I saw some murals by a Mexican, Orozco, which in my opinion were perfectly horrible and caricatural, in a university called Hanover in New Hampshire[1]—well, these were remounted canvases.

CRÉMIEUX: I have seen, as you certainly have, photographs of Mexican frescoes that are in the open air and are not canvases; they are painted on cement or on . . .

KAHNWEILER: Ah, yes! But they will not last long.

CRÉMIEUX: Perhaps nowadays they have silicones . . .

KAHNWEILER: You know that frescoes have almost never been done in the open air, and the Italian frescoes that have survived are inside the buildings, not on the outside.

CRÉMIEUX: The new chemical methods of coating may enable us to preserve them longer.

KAHNWEILER: Yes, but in that case it would be much more practical to do what Léger did: mosaics.

CRÉMIEUX: Mosaics? But you would have to bring back the workers of Ravenna . . .

KAHNWEILER: There are some excellent mosaicists in Paris who are Italian, as a matter of fact. Picasso has made mosaics too, as you know, small portable mosaics. Suzanne Roger has just done some very large mosaics for a school in Ivry.

CRÉMIEUX: Mosaics and also ceramics, probably.

KAHNWEILER: No, only Léger has done both mosaics and ceramics. The others have all confined themselves to mosaics.

CRÉMIEUX: Are there technical difficulties involved in making ceramics, not

[1] Monsieur Kahnweiler is referring to Dartmouth College. [Translator's note.]

flat ceramics but three-dimensional ceramics such as those made at the Musée Léger?

KAHNWEILER: To do that, Léger had to create his own studio at Biot with Roland Brice. Obviously it can be done, but the people at Vallauris, for example, have never made such large pieces.

CRÉMIEUX: I believe it is necessary to bake them at very high temperatures.

KAHNWEILER: In the first place, one has to have an oven that is rather high and rather wide, but one also needs the extraordinary devotion of Léger's students, all those who were close to Léger. It is very moving to see all those boys, like Brice, or Carlos Carnero, living truly in and for the memory of Léger.

CRÉMIEUX: I think Brice told me that he intends, if possible, if he gets commissions, to continue Léger's teaching, but without necessarily reproducing Léger's models.

KAHNWEILER: He could not do that in any case, since Léger wanted most of those things to be unique. It is quite obvious that this studio will have to do something else; but right now it is, as you know, executing the large ceramic sculptures that will be in the garden of the museum, which are, oh, about . . .

CRÉMIEUX: Twenty feet high.

KAHNWEILER: Something like that, yes. Magnificent things, too.

CRÉMIEUX: I think there is a plan for a large ceramic fresco of Charlie Chaplin. Didn't Léger make a preliminary design with Chaplin?

KAHNWEILER: Léger made some kind of Charlie Chaplin toy out of wood, which was very pretty. That's the only thing I know of.

CRÉMIEUX: We'll come back to this. Right now, let's go back to the time before the war in 1939. Tell me about "Guernica," which was done for the 1937 International Exposition.

KAHNWEILER: Well, you know the role the Spanish Civil War played in Picasso's life. Picasso was the most apolitical man I have known. I remember that once a very long time ago I asked him, "Politically speaking, what are you?" He answered, "I am a royalist. In Spain there is a king: I am a royalist." He had never thought about politics at all, but the Franco uprising was an event that wrenched him out of this quietude and made him a defender of peace and liberty.

CRÉMIEUX: And the Republic made him director of the Prado.

KAHNWEILER: Yes, but it was purely honorary, for he never went there.

CRÉMIEUX: Still, he did not refuse.

KAHNWEILER: Certainly not, but the paintings were evacuated. They were even transported to Switzerland eventually, and there was an exhibition

in Geneva in 1939, after the end of the Spanish Civil War.

CRÉMIEUX: The fact that Picasso was so upset by the Spanish Civil War reminded us that he was profoundly Spanish. He was also Spanish through his family, for the family ties of Picasso existed, and he had relatives there.

KAHNWEILER: His parents were dead by then. His father had died long before, and his mother died right around then, but he had his sister and his brother-in-law, who died shortly afterwards. Then there were the nephews and nieces.

CRÉMIEUX: Did he go to Spain much?

KAHNWEILER: Oh, he had been to Spain for the last time around 1933. He had not been back since, no.

CRÉMIEUX: So you bought paintings that were very different from Picasso's painting before the Civil War. How would you analyze the content of these paintings—as a reflection of the war?

KAHNWEILER: There were not many paintings that directly reflected the war. There were only "Guernica" and the series of paintings and drawings that related to it. Picasso never sold these works. They have always remained together with the "Guernica," which at this time is still being held at the Museum of Modern Art in New York, with a whole series of preparatory studies.

CRÉMIEUX: Why do you say these things are being held?

KAHNWEILER: Because Picasso has never sold them. He considers that these works belong to the Republic. But since for the present this republic exists only in the mind, these paintings continue to be held in trust there.

CRÉMIEUX: Along with all the preparatory studies. I thought that "Guernica" had been painted in a very short time.

KAHNWEILER: But there are things leading up to it, there are even things that come afterwards, there is a whole nucleus of works. Around this nucleus, there are other works that correspond to the same state of mind—for example, that series of etchings called "Songe et mensonge de Franco," which deals with the same subjects.

6.

FRANCIS CRÉMIEUX: Monsieur Kahnweiler, how did the outbreak of war affect your business as an art dealer in 1939, and how did things go after the armistice and during the occupation?

DANIEL-HENRY KAHNWEILER: Up to the invasion, my relations with the painters were the same, and my gallery remained open. There were dealers who closed their galleries, and there were even some who left for America.

CRÉMIEUX: Did they take their paintings?

KAHNWEILER: When they were able to.

CRÉMIEUX: Did people continue to buy paintings during the war?

KAHNWEILER: In America?

CRÉMIEUX: No, in France. Was there a fever of speculation or not?

KAHNWEILER: There was still some buying. One could send paintings to America. At that time, I had a representative in America, a man who has done an enormous amount for painting as a whole, but especially for French painting and sculpture. He was a German; his name was Curt Valentin. I sent paintings to him. Paintings were sold in Paris, and I bought them. There was no sudden break at that time. The sudden break occurred, of course, when the Germans invaded France.

CRÉMIEUX: Did the mobilization of 1939 have any of the same consequences for your painters as the mobilization of 1914?

KAHNWEILER: For some of them. Poor Beaudin, for example, served in both wars. He was drafted again. Fortunately, he finally got a job in

camouflage, but for the first few months he had to dig trenches in the north, for which he was really too old. Roux was drafted; all the younger ones were drafted.

CRÉMIEUX: So, when the armistice came, you left along with three million other Parisians, between June 6 and June 12, 1940?

KAHNWEILER: I myself left on the very last day, June 12, 1940. I left with my wife and the older of my sisters-in-law, who was living with us. We went by car, taking with us everything we could.

CRÉMIEUX: Did you leave all the paintings in Paris?

KAHNWEILER: Of course, what else could I do? I should tell you, though, that I had already sent a certain number of paintings to Repaire-l'Abbaye, the country place where I went later. This was a small house I had rented, three kilometers from Saint-Léonard-de-Noblat, twenty-three kilometers from Limoges.

CRÉMIEUX: You picked a good spot, when I think of June 1944; that was really a rather disturbed area.

KAHNWEILER: But I had left there by then, although the place I went later wasn't bad either. Anyway, there were paintings there already, which I had sent by truck at the beginning of the war. At that time, people were afraid that Paris would be bombed, which it wasn't.

CRÉMIEUX: The occupying forces were aware of your German origin although in the meantime you had become a French citizen, hadn't you?

KAHNWEILER: Yes, indeed.

CRÉMIEUX: Those Nazis who specialized in artistic matters knew that you were not particularly fond of Hitlerism. You were a former German, and you belonged to a religion that did not have the odor of sanctity; did they come and investigate you immediately?

KAHNWEILER: Not immediately. The people in charge of cultural matters in Paris were more inclined to be sympathetic . . .

CRÉMIEUX: To modern art?

KAHNWEILER: To modern art and to me, especially to me. But in our eyes, they were nevertheless suspect and dangerous, and when they asked my sister-in-law what had become of me (I'll explain in a moment how she happened to go back), she always said she did not know where I was. They offered to help her, and they said they wanted to protect me. This protection seemed dangerous to her, and rightly so.

CRÉMIEUX: You preferred to protect yourself?

KAHNWEILER: Precisely. As I just told you, I left. The roads were jammed with cars, as you know, but oddly enough—people are funny, they don't know geography—they had all taken the highway, National Highway

No. 20 to Limoges. I went as far as Croix-de-Berny, which took three hours: I left at six o'clock, and we got to Croix-de-Berny at nine. I said to myself, we can't go on like this, and I asked a nice man who lived there, "Do these little roads go into the country?" "Not that one," he said, "but take the one two hundred yards back." I drove up on the sidewalk and backed up to that road. I got to the country, and by taking little roads, by going over the Pont de Sully and through Bourges, I got to Saint-Léonard without meeting cars, much fewer than in peace-time. Every once in a while gendarmes would stop us and ask, "Why aren't you on the highway?" although they understood it was better not to be.

We arrived that night. My brother-in-law Elie Lascaux and his wife had been living there since the beginning of the war. They don't particularly like the country, and they weren't very happy there, and after a while they left that house and went to live in the little town of Saint-Léonard. Anyway, we arrived, as I was saying, at twelve that night. The armistice came a few days later, and friends who were demobilized in the southern zone started to arrive. There were my brother-in-law Michel Leiris, Masson's daughter, Raymond Queneau, and numerous other friends. There was Beaudin, who, in fact, stayed in Saint-Léonard about six months and even worked there.

CRÉMIEUX: What about the gallery in Paris?

KAHNWEILER: The gallery in Paris was closed, of course. Everything was closed at that time, including our house in Boulogne. But eventually, my brother-in-law Leiris arrived with his wife from Landes. We decided that they would go back to Paris, and that my sister-in-law would take charge of the gallery with the help of my other sister-in-law, who went with her, leaving me alone with my wife.

CRÉMIEUX: Was the gallery regarded as Jewish property?

KAHNWEILER: That invention came a little later. Yes, there was the anti-Jewish legislation. The gallery was regarded as Jewish property, for my associate Simon was Jewish too. He had gone to England with friends. So at first the gallery was put under sequestration again, but my sister-in-law declared that she was buying the gallery. She immediately got an anonymous letter, which must have been from someone we knew, for it was composed of letters cut out of the newspaper. It said that she was my sister-in-law and that consequently the sale would not be valid. My sister-in-law, who is a woman of magnificent courage, went to the bureau of Jewish affairs. She told them, "It's true, I am Kahnweiler's sister-in-law, but on the other hand, I am what you call Aryan, and I've been working in this gallery for twenty-one years, since

1920. Who else would buy it?" Strangely enough, this was language that the Germans understood; the sale was ratified, and she was able to take possession of the gallery, which has remained hers ever since.

CRÉMIEUX: The Galerie Louise Leiris.

KAHNWEILER: Precisely.

CRÉMIEUX: Since the paintings were safe from looting, you did not return to Paris before the liberation?

KAHNWEILER: It would never have occurred to me to go back to Paris. I lived in Saint-Léonard-de-Noblat for three years, and I'm going to tell you something that will amaze you: Those three years were happy ones for me and my wife. We were together. I worked every day, in peace. I wrote my book on Juan Gris. She was with me, and we were very, very happy. Of course, our paradise existed in the shadow of the crematory ovens, but fortunately, I escaped those ovens. We knew that we were in constant danger, and my sister-in-law and brother-in-law, who came to see us rather often, kept telling me, "You can't stay here, it will end badly."

In February 1942, my brother-in-law came all the way from Paris to tell me, "All our friends say that you're going to be arrested any day now. You must leave. We have found you a place to hide with friends in Lot-et-Garonne; you must go there." I agreed, I started to pack, but in the end I said, "No, I won't leave; we're happy here. We'll take our chances." I unpacked the bags and we stayed. Of course it ended as you would have foreseen: The Gestapo eventually arrived—in fact, they arrived before my sister-in-law and brother-in-law had left. They searched the house for weapons. There had been an anonymous letter. We even found out later who had written it.

CRÉMIEUX: Was it from the local people? It wasn't from painters?

KAHNWEILER: Oh, no, it was from a girl who was mistress of the head of the Gestapo in Limoges, the daughter of a farmer who was our neighbor and a very nice man. Anyway, they searched the house. They even looked in the well for weapons; of course we didn't have any. The Résistance would not have been crazy enough to hide weapons in the home of a Jew, where there was always the danger of a search. They went away. They came back at four o'clock in the morning shouting, "You lied to us," etc., and ended by looting the house. They stole all the money there was, all the jewelry my wife and sister-in-law had, in short, everything they could take with them, but not the paintings—they weren't interested in those.

CRÉMIEUX: Picasso had the same experience at another time. The Germans

ransacked his house, stole all his linen, and left the paintings. He was not happy; he would have preferred them to take the paintings.

KAHNWEILER: Yes. By then I had already taken the most important paintings out of the Repaire, where we lived, for fear of just such an event, and had stored them in the home of a nice neighbor, a local landowner.

CRÉMIEUX: Didn't certain painters have false impressions about their colleagues? I don't mean travel in Germany; I am thinking of articles....

KAHNWEILER: Well, there were some unfortunate articles by Vlaminck in *Comœdia* against Picasso, yes.

CRÉMIEUX: You weren't involved?

KAHNWEILER: No, not at all.

CRÉMIEUX: Didn't Vlaminck write things about you?

KAHNWEILER: Never. I have absolutely nothing to complain about. He attacked Picasso, whom he detested primarily for artistic reasons, but I was not directly involved.

CRÉMIEUX: So you survived the war and the occupation, and from Lot-et-Garonne . . .

KAHNWEILER: We managed to escape, my wife and I; we left in the evening, we spent the night in Limoges at the home of a niece of my brother-in-law Lascaux, who sheltered us for the night, and we left at four o'clock the next morning for Gascogne. After resting a few hours at Agen at the home of some friends, we arrived in the evening of the next day at the home of the people who had offered to take us in. I don't have to tell you that we lived there under false names. Fortunately, we already had some false papers, which my brother-in-law and sister-in-law had procured for us.

CRÉMIEUX: What was your false name?

KAHNWEILER: Kersaint, Henri-Georges Kersaint.

CRÉMIEUX: With a "Q"?

KAHNWEILER: No, with a "K," because of the initials.

CRÉMIEUX: The monograms on your shirts, and so on?

KAHNWEILER: Exactly; we couldn't forget that. Actually, we had fun filling out those papers. The handwriting was done by Raymond Queneau, who came rather often because his wife, who is Jewish, was also in Saint-Léonard. One Sunday afternoon we filled out the false papers. When the Germans made the search I mentioned, the papers were hidden in a buffer—you know, a buffer that is used to polish shoes.

CRÉMIEUX: Yes.

KAHNWEILER: And one of the Germans picked up the buffer and asked, "What is this?" My wife, who, like her sister, was a woman of admirable

courage, took the buffer out of his hands and said, "It's for polishing shoes," making the appropriate gesture.

CRÉMIEUX: Are those papers still in your possession?

KAHNWEILER: Yes; if they had found them we would have gone right to the concentration camp. So we lived for another year in a little hamlet called Lagupie, between Marmande and La Réole, under false names, as I just told you. We had been taken in, and we were sheltered by some very nice people called Petit whom my sister-in-law and brother-in-law had met in July 1940.

CRÉMIEUX: In this corner, where guerrilla activity was rather violent, did you almost escape the storm by sharing the lot of the other people living in the village?

KAHNWEILER: You can't say we escaped the storm. We escaped the massacres, but there were a great many incidents in the area. One day the Germans surrounded the little hamlet and burned a house, but there was no killing.

CRÉMIEUX: And throughout this period of exile within France, did you correspond with the painters? How did they react, what did they do?

KAHNWEILER: Well, some had left France. Masson, who had gone first to Auvergne, then to Marseille, had left France with his wife, who is of Jewish origin, and after being at sea for about six weeks, he had reached Martinique and from there, finally, America. So it was easy to get news of them until America entered the war. Kermadec had gone to a house in the Cotentin, which he still owns today, and we wrote to each other. I also corresponded with my old friend Max Jacob. All this was only as long as we were in Saint-Léonard.

CRÉMIEUX: Was Max Jacob in Saint-Benoît? What were the circumstances of his arrest?

KAHNWEILER: I heard about it afterwards from the people who were near Max and those who were in Paris; in my opinion, someone must have informed on him. The Germans arrived and took him first to Orléans and next to Drancy. It was there that he died very quickly of pneumonia.

CRÉMIEUX: How did Picasso react? Did he write to you during the occupation of Paris?

KAHNWEILER: No, we did not correspond. No one had my address after we went into hiding. I corresponded with no one except my sister-in-law, but she saw Picasso every day at that time, and I got all the latest news of Picasso, and he of me.

CRÉMIEUX: And did he continue to give his whole production to the gallery?

KAHNWEILER: There was no question of the whole production at that time,

but he did sell paintings to my sister-in-law, of course. Everything had slowed down as much as possible. To be able to keep the gallery going, to keep the younger painters alive, and to buy a few things from Picasso: That was the most we could hope for. He did not sell to anyone else.

CRÉMIEUX: Did the German military personnel and officials who were in Paris buy modern art?

KAHNWEILER: Never from us. I heard about things like that, but it was never from us. Germans came in, painters who came to see the things, but the Germans never bought anything.

CRÉMIEUX: And yet Goering was a great collector.

KAHNWEILER: Ah, but not of those things; he was interested in old painting.

CRÉMIEUX: Were any great French collections that you helped to build seized and sent to Germany?

KAHNWEILER: They were not sent to Germany, but they were stolen one way or another. These things were resold immediately right in Paris. There are people whose names are known who engaged in this, who bought these things and resold them.

CRÉMIEUX: So it was individual theft.

KAHNWEILER: That admirable collection owned by Alphonse Kann—a large part of it was stolen by the Germans.

CRÉMIEUX: Was there a period when the Germans systematically deported to Germany, if I may, the libraries and personal possessions of Jewish intellectuals?

KAHNWEILER: Yes, there was, but in the case of paintings, they couldn't take them to Germany, where they were regarded as decadent, so they sold them. A great many paintings disappeared. Paul Rosenberg lost an enormous number of paintings this way.

CRÉMIEUX: Were your colleagues of foreign or Jewish origin subjected to the same measures as you, that is, sequestration?

KAHNWEILER: There were very few of foreign origin, I think, but of course there were a great many of Jewish origin at that time, many more than there are now.

CRÉMIEUX: Yes, generally speaking, among the names you gave of the great art dealers there is a high proportion of Jews. To what do you attribute this?

KAHNWEILER: I don't attribute it to anything, because the two dealers whom I really admire were not Jews: Durand-Ruel and Vollard. I attribute it to the fact that, as you know, the Jews had been forced because of the social situation to go into business at the beginning of the nineteenth century. Selling pictures was one of their businesses; but I

don't think they have any special gift for it, since the truly great art dealers were not Jewish.

CRÉMIEUX: Let's get back to Paris. In what month of 1944 did you return?

KAHNWEILER: In October, as soon as it was possible, as soon as there was some vague semblance of transportation. As you know, the guerrillas had blown up all the bridges, and the railroad was a mess. . . . My wife, unfortunately, was already ill by then. We left anyway, going through Limoges, where we took my niece Germaine Lascaux, who was with her parents in Saint-Léonard. They felt that she should go to Paris so she could go to better schools than those in the little town of Saint-Léonard. You know how it was as well as I—people crossed the Loire in a little boat. Everything was insanely complicated. We finally reached Paris at two or three o'clock in the morning, with all the difficulties there were then. We found a man who agreed to carry our bags, and we came on foot to the very place we are in now, on quai des Grands Augustins, where my sister-in-law and brother-in-law had rented an apartment on the fifth floor in 1942, and where they had already prepared our room exactly as it had been in Boulogne.

CRÉMIEUX: So activity resumed at the gallery? Did the paintings that were in the provinces return to the walls of rue d'Astorg?

KAHNWEILER: Yes.

CRÉMIEUX: How would you characterize this period of regained freedom and the years that followed the renewal of contact with your old customers? How did it happen?

KAHNWEILER: It happened naturally and amicably, just as one would expect. For example, at an exhibition in the Salon d'Automne—you remember perhaps, they had hung a Picasso room there. . . .

CRÉMIEUX: Oh, yes, there was a scandal.

KAHNWEILER: Well, I ran into my first French collector, Roger Dutilleul, who has since died, alas, at a very advanced age. Roger Dutilleul threw his arms around me and kissed me. I rediscovered the painters, I rediscovered everyone.

CRÉMIEUX: Did any old customers enter in the uniform of the American army?

KAHNWEILER: No, because they were too old, but we saw a great many Americans who came to the gallery. There is one who has remained a very close friend, a professor at Yale University, who was a major at the time and who came to the gallery every week, starting before my return, with chocolate or cigarettes for my sister-in-law. He bought a few small things, for he did not have much money. But it meant a great deal to us. He had dollars, and he bought nearly every week.

CRÉMIEUX: And do you feel that the period immediately following the war, with the generation known as the BOF,[1] was the occasion of a speculative boom in painting? Did you feel a change?

KAHNWEILER: I had that impression, yes, not for the artists whom I was defending, but for certain new painters. As for my painters, the old generation was already commanding high prices, and those of the generation born around 1900, who had not been presented during the occupation, had been somewhat eclipsed by the younger painters who were showing. Those painters certainly achieved a much more rapid success than they would have at another time.

CRÉMIEUX: What changes, in your opinion, did the war of 1939–1945 cause in painting, in the subject matter of painting?

KAHNWEILER: I don't think wars cause changes in painting. In the real painters, of course, one feels it when a war really touches the essential things, which was not the case in 1870–1871, for example. One could feel the war in Picasso's work. Not that he made monsters, as people think. He has always painted the women he loved. At the beginning of the war, throughout the war, it was Dora Maar. All the women he painted at that time resembled her. He did not want to represent her as a monster. But there is something else. Picasso told me himself, "When the Germans arrived in France, I was in Royan, and one day I did a portrait of a woman"—it was Dora Maar—"and when the Germans arrived a few days later, I saw that the head resembled a German helmet." Obviously, he did not make a monster, but even so, the war is in all his paintings. An ivory tower is a beautiful thing, but a painter in whose work a war like the war of 1940–1945 was not felt, not externally but in almost imperceptible ways—well, he would not be a great painter.

CRÉMIEUX: How did the war make itself felt in Picasso's work during those four years? Was there a return, not toward different subjects, but toward certain objects that recurred in his painting?

KAHNWEILER: I don't think so.

CRÉMIEUX: Saucepans, cooking utensils, "women with artichokes," food . . .

KAHNWEILER: What you're saying is very ingenious; I had never thought of that. Perhaps, perhaps . . . In any case, it is a fact. There is the famous painting "Le Buffet du Catalan," which shows that the restaurant where he went to eat occasionally was very important to him. There is "Le Boudin." And there is something else that would seem to prove

[1] Stands for *beurres-oeufs-fromages*, or butter-eggs-cheese. [Translator's note.]

that you are right. Do you know the play that Picasso wrote during the war?

CRÉMIEUX: Yes.

KAHNWEILER: It's called *Le Désir attrapé par la queue*.

CRÉMIEUX: Yes.

KAHNWEILER: Actually, it was read for the first time in the room next to this one.

CRÉMIEUX: You must tell us the names of the actors; one of them won the Nobel Prize, I think.

KAHNWEILER: Yes, and Camus directed it.

CRÉMIEUX: Camus directed, and Michel Leiris had the major role, didn't he?

KAHNWEILER: Yes. There were Sartre, Raymond Queneau, Simone de Beauvoir, Georges Hugnet. Who else? Zanie Aubier, Janine Queneau, and my sister-in-law Louise Leiris.

CRÉMIEUX: It wasn't a very expensive play; there were five or six characters.

KAHNWEILER: Yes. In that play, as Queneau has shown very correctly, one feels the whole occupation. The characters are always talking about hunger, about their feet, their chilblains. The whole play is the occupation. So it is very possible that you are right, and that this is felt in the painting too.

CRÉMIEUX: Didn't the period immediately following the war, the years when there was still rationing, 1945 and 1946, indirectly have a much more material influence on Picasso? For instance, you said that the home of Mourlot, the lithographer, was well-heated. I don't mean to imply that Picasso made lithographs because he was warm there, but isn't there a causal relationship?

KAHNWEILER: Of course he made lithographs because he was warm there—or rather, he found a place where he was warm, and in this place he could make lithographs. Picasso's art is always an art of circumstance. Two years ago he was making linoleum blocks for the simple reason that next to Cannes, in Vallauris, there is a printer who can print them immediately, whereas lithographs and etchings he has to send to Paris. As a matter of fact, Picasso moved into Mourlot's house, and for about six months during the winter of 1945–1946 he made a series of lithographs that marked the beginning of the real lithographic *œuvre* of Picasso, an admirable *œuvre*, which fortunately is far from finished.

CRÉMIEUX: Let's go back to the little disturbance at the time of the opening of the Picasso room in the Salon d'Automne.

KAHNWEILER: Yes, there were a few idiots who caused some paintings to fall down.

CRÉMIEUX: Had he departed from his rule not to take part in the Salons, or was it you who had organized this retrospective exhibition?

KAHNWEILER: No, I had absolutely nothing to do with it. Picasso, having been urged and invited to show, decided that after the liberation he could and should participate in a group exhibition. He also showed his work in an exhibition that took place in the old Musée du Luxembourg, which had already become the Orangerie. It was an exhibition of almost all the painters of that time. He was in that one too.

CRÉMIEUX: He also showed in an exhibition called Arts et Résistance.

KAHNWEILER: Ah, yes, he showed "L'Hommage aux résistants espagnols morts pour la France."

CRÉMIEUX: After the war, you tell me, the BOF's did not buy those paintings, but the people who supplied the army, the people who made the Atlantic Wall, made a lot of money. They could buy expensive paintings.

KAHNWEILER: That's true, but that isn't what they bought.

CRÉMIEUX: But there was a boom in painting, a rise in the market, wasn't there?

KAHNWEILER: There was a rise, but it was almost offset by the decline of the franc. It was only gradually, as the rise became more pronounced, that it came to outweigh the decline of the franc.

CRÉMIEUX: As someone who regularly sells Picassos and Massons and all your other painters, do you feel that the rise in the prices of their paintings and drawings is proportional to the rise in the cost of shoes, that is, to the rise in the cost of living in general?

KAHNWEILER: Obviously it must have been greater, because if it had simply reflected the rise in the cost of living, it would be inexplicable in the case of painters who have become as celebrated as Picasso, Braque, and Gris.

CRÉMIEUX: Is this rise attributable to the emergence of the American market?

KAHNWEILER: To a large extent. But the American market is not unique. There are other countries that have always been big buyers and that have become more so, notably Sweden.

CRÉMIEUX: Does the tax system there too protect the art collector?

KAHNWEILER: No, they don't have that in Sweden, and there are no gifts to museums, or very few. No, it is really people who make collections. The same is true in Switzerland; but in Switzerland I find that the art-collecting movement has slowed down somewhat, in comparison with the impressionist period. There are more impressionist collections in Switzerland, I think, than there are more modern collections.

CRÉMIEUX: Do you think people buy more painting in Sweden because the

nights are longer in winter and people spend more time in their homes?

KAHNWEILER: That is a plausible explanation; yes, perhaps.

CRÉMIEUX: It is true that domestic life in Sweden is much more highly developed than it is in Paris, for example, and that the polar night ...

KAHNWEILER: That's true, that may be one of the reasons. And then there are always men involved, not just nature. There was—there still is, fortunately, an art dealer there named Gosta Olson with a gallery called the Franco–Swedish Gallery. This man has received the Legion of Honor, which he richly deserves. What he has done for French painting is admirable. He was a full-time propagandist; he is really responsible for opening the Swedish market to French painting. He began immediately after the First World War, in 1918–1919.

CRÉMIEUX: Are the museums of the so-called eastern countries, that is, the popular democracies, the Soviet Union—are these countries trying to exchange or complete their collections by buying modern painting?

KAHNWEILER: Not at all, at the moment. As you know, they have preserved the splendid Stchoukine collection and the few other paintings that were in Russia before the First World War. They are shown now, they are visible. But they haven't done anything yet about buying new ones.

CRÉMIEUX: What about the directors of museums in the Nordic countries or Germany or South America—do they come to you to buy paintings?

KAHNWEILER: Very few from South America, for financial reasons: At the present time they cannot afford to buy painting outside their own country. But they come from Germany, of course.

CRÉMIEUX: Are museums your customers?

KAHNWEILER: Yes, museums too.

CRÉMIEUX: Do you make any distinction for museums? Do you give them a discount?

KAHNWEILER: No, no. One accommodates museums by extending credit. When one has decided once and for all to maintain a fixed price, one doesn't change it for a museum either.

CRÉMIEUX: I asked you that because, when a museum buys, the dealer knows there is no speculative motive. It is really a question of historical documentation.

KAHNWEILER: Obviously, in the case of relatively unknown painters, we would do something for the museums. But when the museums are buying highly celebrated paintings, there is no reason; they are no longer furthering any cause, since there are many other people who would be ready to buy these paintings.

CRÉMIEUX: How about the French museums—what do they do when they want to buy paintings?

KAHNWEILER: There are two organizations that buy in France. First, there are the directors of the museums. The paintings are submitted to a board and they are approved or not approved. Then there is a second organization, called the Travaux d'Arts, which buys independently of the museums and later distributes the paintings to the museums in Paris or the provinces.

CRÉMIEUX: Is this a state organization?

KAHNWEILER: Yes, it comes under National Education.

CRÉMIEUX: Does it have much money?

KAHNWEILER: Not much; the budget is tiny. They can only buy things by relatively young, inexpensive painters.

CRÉMIEUX: When museums buy cheaply from young painters, the day comes when they have in their reserves paintings by painters who have become famous.

KAHNWEILER: Fortunately!

CRÉMIEUX: Well, do they sell or buy back?

KAHNWEILER: Oh, no, never.

CRÉMIEUX: They have to keep everything?

KAHNWEILER: As a matter of fact, I think there's a regulation that prohibits them from selling.

CRÉMIEUX: They can't sell, but the big museums can make exchanges between countries, can't they?

KAHNWEILER: No, not at all; I have never seen that. Imagine, in the Louvre there is a Mantegna painting, of which one panel is in Tours. They have never been able to get them together.

CRÉMIEUX: Red tape?

KAHNWEILER: Precisely.

7.

FRANCIS CRÉMIEUX: We must talk, not about the future of painting—I know better than to bring up that subject—but about the future of the painter.

We live in a given society, which is not the only form of society that exists now in the world. How do you see the future of the painter in society? How do you think his role will change in the light of what you know about the present situation of painters in the east as well as the west?

DANIEL-HENRY KAHNWEILER: Well, that depends on the society in question. In a socialist society, the painter will live mainly on what he receives from the state. I have been to East Berlin quite often, and I would say that the painters are quite happy there. It is easy for them to earn a living. The state gives them frequent commissions for public buildings, and it buys paintings and gives them to museums and organizations. So the painters are rather fortunate.

CRÉMIEUX: In general, does the financial situation of the painter seem somewhat better right now in the east than in the west?

KAHNWEILER: I wouldn't say that, because there are very few painters in East Germany.

CRÉMIEUX: Yes, and it is necessary to define the word "painter."

KAHNWEILER: There are very few, because those who do not satisfy the definition of socialist realism have necessarily left. As you know, there is no difficulty in going from East Germany to West Germany. You take the subway to Berlin and there you are.

CRÉMIEUX: Shall we talk about France, which we know more about? According to statistics, there are forty thousand people in France who are professional painters. This does not mean that they live by their painting, but simply that they call themselves painters.

KAHNWEILER: I don't know if all of them really call themselves painters, but in any case they paint. Many of these people have another profession—I know, because I know some of them.

CRÉMIEUX: Do you think this is desirable?

KAHNWEILER: Alas, no, it is not desirable. I think it is one of the reasons that you see so few really young painters nowadays. After all, when I knew Picasso and the rest, they were in their early twenties and they were serious painters. Now you see very few very young painters, and this is certainly the reason. When a person has another profession, he has little time for work, a few hours a day or the weekend. But in order to paint, or rather to learn how to paint, he has to do it.

CRÉMIEUX: Then in your ideal society—I assume that you have an ideal society in mind—what should the relation be between the society, not to say the state or the government, and the painter?

KAHNWEILER: I have never found the solution to that problem. I cannot conceive of the relation existing except on a personal level. How can you expect the state to have taste? The state cannot have taste. It would be a miracle if the people who were in charge of the funds that are set aside to help painters were to have taste. In East Berlin, the system works because there are really very few painters; consequently, they all receive help. Everything goes very well. But what is one going to do about the forty thousand painters of Paris? One can't help them all, especially since, as Degas used to say, it seems necessary to discourage a young painter so that he will stick to it even in adversity and thus prove that he is worthy of painting.

CRÉMIEUX: Do you think it is inevitable that in the future the state will be the principal customer of the painter?

KAHNWEILER: That depends on the evolution of society. But we are moving further and further in the direction of state management, if not collectivization. I am afraid that it will become more and more difficult for painters to make a living. I am afraid that personal fortunes will become smaller and smaller.

CRÉMIEUX: Do you think there is a sort of hierarchy of personal needs? Consider, for example, a society that is still poor in consumer goods. Do you feel that once these goods are made available to all, people will want to buy paintings on an individual basis? Do you think that the

reason people don't buy paintings now is that they want to buy a washing machine or a sewing machine first?

KAHNWEILER: That seems highly probable. You know as well as I do that there are people in Russia who buy paintings.

CRÉMIEUX: Certainly. They are probably people who have a washing machine and a television set and who can afford another luxury.

KAHNWEILER: One can imagine a society in which the painter would have painting as his second profession and as his first profession, but they would be two different kinds of painting. He might make a major part of his living executing official commissions, but that would not prevent him from making paintings for individual consumption, which he would not necessarily sell at high prices. There is no reason why the customers must be very rich.

CRÉMIEUX: Certainly not. If there were real understanding between serious painting and those who give the commissions, it would be conceivable. It worked that way for centuries.

KAHNWEILER: In socialist countries we know that men of letters are very fortunate, because their books are well distributed, which cannot happen with painting.

CRÉMIEUX: No, unless royalties are paid for reproductions, which is done.

KAHNWEILER: Probably. It is done in capitalist countries.

CRÉMIEUX: It is not a dream; it is conceivable that some day circumstances will at last unite the state commission and free painting.

KAHNWEILER: It is quite possible.

CRÉMIEUX: In this society of tomorrow, in which Degas's precept of discouraging painters would be applied, how do you visualize the teaching of art?

KAHNWEILER: I have no objection to state education if civilization truly regains its former unity, but if this does not happen, what is wrong with private education? Léger had an academy, and there are many others: Lhote and Ozenfant have academies, and there is the Académie Ranson where Maurice Denis and the other nabis taught. It is quite conceivable. Most painters nowadays do not come from the Beaux-Arts.

CRÉMIEUX: Among living painters, aren't there a great many professors who teach in public or private schools?

KAHNWEILER: Yes.

CRÉMIEUX: Even if they do not have an academy?

KAHNWEILER: Yes.

CRÉMIEUX: Let's see, there's Gromaire, who teaches at the Arts Décoratifs ...

KAHNWEILER: Yes, and Zadkine teaches somewhere. There's Goerg too—

he may be at the Beaux-Arts; it's possible. There are quite a few painters and also all the Salon d'Automne people like Brianchon now at the Beaux-Arts . . .

CRÉMIEUX: You're always hard on the Beaux-Arts.

KAHNWEILER: My God, I see the results. Every once in a while I see the Prix de Rome show. It's just as bad as ever, with a surface modernity that doesn't change anything.

CRÉMIEUX: But fundamentally, when you say it is bad, you think it is much more the fault of the teaching than the fault of the students. You imply that the students are obliged to do this.

KAHNWEILER: No doubt, no doubt. You know how these things are. To pass an examination, one has to do what the professor likes. . . .

CRÉMIEUX: So they should do away with examinations.

KAHNWEILER: Ah, you are right! The Indépendants have that admirable motto: "Neither jury nor prizes"; that is the only truth.

CRÉMIEUX: It is true that, when one reviews the list of official laureates, it is rather depressing.

KAHNWEILER: In all the arts, as you know; in music it's the same thing.

CRÉMIEUX: Perhaps a little less so in music, isn't it?

KAHNWEILER: I don't think so.

CRÉMIEUX: Ravel went to Rome . . .

KAHNWEILER: Ravel didn't, Debussy did.

CRÉMIEUX: Ibert went to Rome twice.

KAHNWEILER: But after all, he was not a really great musician, was he? Personally I don't see in that whole generation . . . Not Poulenc, not Auric, nobody has been to Rome.

CRÉMIEUX: That's true, nor has Satie.

KAHNWEILER: Especially not Satie. But outside France it's not the same; there are no prizes of that kind for music.

CRÉMIEUX: Before we finish, you must tell me something about foreign painters, about American painting. It seems to me that in North America, which has been heavily influenced by the painting of Europe, there is a need not to create an American school, but a need to paint. There are painters in the U.S.A., and what painters! And they sell, and what painting!

KAHNWEILER: It was the arrival of André Masson in America that started this whole movement. Pollock himself very honestly declared that it was the influence of Masson that manifested itself in his painting at that period. Others followed, but this painting is not painting, but decoration pure and simple. Furthermore, there is nothing new about it, for even the use of sand and all those techniques are not new. The cubists used them.

So did Masson. When this painting abandons itself to chance, it has its precedent in the automatic writing, or rather the automatic drawing, of surrealism. None of this is new. It is the final deliquescence. It has found innumerable disciples in Europe—all the recent exhibitions are composed ninety per cent of paintings of this type.

CRÉMIEUX: But tell me, from the commercial point of view it must be very complicated to ship canvases on which tubes of pure paint have been squeezed. Doesn't the paint melt?

KAHNWEILER: Oh, no, not after the painting has dried.

CRÉMIEUX: What if it gets warm?

KAHNWEILER: Oh, no, no, no, once the painting is dry it doesn't melt; oh, no, it isn't any more dangerous than anything else.

CRÉMIEUX: Do you have information on some foreign school, some art activity or movement in certain countries that seems especially interesting?

KAHNWEILER: Absolutely not, since in all countries abstraction and *tachisme* have spread like a plague, for the very simple reason that this art actually offered the same facility that academic art once offered. It is an academic art, and the best proof is that the state protects it.

CRÉMIEUX: So now there will be the revolt of the sons against the fathers?

KAHNWEILER: I hope so with all my heart. One of these days painters will come along who really paint.

CRÉMIEUX: Do you believe that the dream of men like Léger, the dream of frescoes, the dream of decoration in the streets will be realized? Did you hear about the experiment made by a store on the left bank, which projected huge colored pictures on the street in front of its windows?

KAHNWEILER: No. It sounds interesting, but it seems to me to be outside painting, to belong to decoration, which is a very valid field. You know that Léger himself always said that it seemed to him permissible to do abstract things, that is, things that did not mean anything in large decorations, but that in an easel painting, it seemed impossible.

CRÉMIEUX: According to you, easel painting is not on its way out?

KAHNWEILER: Absolutely not. I don't see why it should be, because it is the embodiment of all that is noble in painting—all the admirable emotion of the painter transmitted to the spectator.

CRÉMIEUX: You don't believe that if the state becomes the most important customer of painting, this may shift painting toward monumental and non-easel works?

KAHNWEILER: Oh, it may happen, but even monumental works are not necessarily abstract. Besides, I don't see why the state could not also

buy paintings of smaller dimensions and put them in offices and government buildings, as it does in Russia and East Germany.

CRÉMIEUX: Do you think that the public—say what you will, it is better informed now than it was forty years ago, precisely because of the dissemination of writing on art and art history—do you think the public will become more discriminating? You hope that the rebellion of the sons against the fathers will take place; you must also take account of the public, which has its say.

KAHNWEILER: No, it has no say.

CRÉMIEUX: You don't believe in the public?

KAHNWEILER: It has absolutely no say. It will come around inevitably; first there will be a few, and then others will come. The good and beautiful will always break through, will always prevail. It may take a long time or a short time, but it will come. Immediate public success is, in my opinion, a rather bad sign for the simple reason—I don't know whether we've already talked about this, we may have—for the simple reason that the capacity to appreciate painting is not given to everyone. This is precisely what is wrong with certain state arts: They base themselves on the very people who have no taste in painting. With music, everyone agrees that it is an art that does not appeal to everyone. People will tell you straightforwardly, "I am not a musician." They never say, "I'm not a painter." And yet, it's the same thing.

CRÉMIEUX: Very true.

KAHNWEILER: It's the same thing. Even the reading of the painting—which we already mentioned and which seems to me an indispensable element, because only through reading does the painting take form in the viewer's consciousness—even this reading is not the important point. The important point is a kind of communion with the painting. But as you know, there are not many people who are capable of this communion, who have this admirable enjoyment in life.

CRÉMIEUX: But you who have probably seen thousands and thousands of visitors go through your galleries; haven't you seen a change in the public?

KAHNWEILER: I don't think so, because the people who come into a gallery, especially ours, where we don't have many exhibitions, but often simply hang up the work of our regular painters, are already predisposed in favor of our painters. They are people who love these painters. The others don't come. As far as the rest of the public is concerned, there is a change in the sense that a certain kind of painting no longer presents any difficulties. The painting that I do not like, *tachisme* and abstraction, presents no difficulties. In the old days, people would laugh or get

angry in front of the paintings of the period, in front of cubism, even in front of fauvism or Matisse. Why? Because they did not see nature the way they thought these painters "saw" it: They did not read the paintings correctly; they had not learned to read them. The paintings made them laugh or made them angry. Nowadays, in front of a painting that represents nothing, there is no reason for outrage.

CRÉMIEUX: The purpose of my question was to try to get a picture of your visitors. I think that even at your gallery, I have met young people, perhaps young painters.

KAHNWEILER: They are almost always young painters.

CRÉMIEUX: Aren't there more of them than there were between the wars?

KAHNWEILER: No, I don't think so; we've always had them. Even in rue Vignon, before the First World War, we had a lot of French and foreign painters. All the people from the Dôme came, even painters who didn't like cubism. They came anyway, to see.

CRÉMIEUX: Listening to you, one would be tempted to conclude that there is nothing new under the sun. You say that nothing has changed and that if something were to change, it would happen very, very slowly.

KAHNWEILER: That's what I think, yes.

CRÉMIEUX: But when you reread the literature and newspapers of the period between 1900 and 1915, you realize that painting did not have the place in daily life that it occupies now.

KAHNWEILER: On that point you are not wrong. It is obvious that many more people go to museums nowadays than before. Probably to galleries too; but in the museums, in the Louvre, it really hits one in the eye. There are ten times as many people. In the old days, when one went to the Louvre in the winter, there were a few bums warming themselves in front of the hot-air vents. There was no one else. Now there are crowds every day, every day.

CRÉMIEUX: That's already a new element.

KAHNWEILER: Certainly.

CRÉMIEUX: The second element, which we have already mentioned, is the fact that accurate reproductions of the masterpieces of world painting have been made available to the nontraveling public.

KAHNWEILER: Yes, Malraux's "musée imaginaire." There are many illustrated books, even in color. This certainly plays a role.

CRÉMIEUX: What about the number of historical studies?

KAHNWEILER: The literature on art has also increased to an incredible extent.

CRÉMIEUX: This literature is not on the *tachistes*; it is on Italian painting, German painting.

KAHNWEILER: Yes, of course.

CRÉMIEUX: This too is a change.

KAHNWEILER: Don't forget another thing: the automobile has had an enormous influence on the visiting of museums. As soon as people got cars, they started to travel. People who would never have traveled otherwise have started going to Italy, Spain, the provinces to see museums, etc. The Château de Pau, which is not so extraordinary in my opinion, is the monument most frequently visited in France right now after Versailles, I think. Why? Because people travel in the Pyrenees.

CRÉMIEUX: So we may conclude that the existence of the machine, far from killing art, brings us closer to art. Am I putting words in your mouth?

KAHNWEILER: Of course not. Anything that enriches human life cannot be bad. A thing like the automobile cannot be bad.

CRÉMIEUX: I am trying to gather certain conclusions. The development of techniques of reproduction such as color photography and the cinema, which one might have feared would harm painting, far from harming it, has served it. This is another change, Monsieur Kahnweiler.

KAHNWEILER: I agree, but it is rather slow. All these changes come gradually. But they exist. I don't think they have had much effect on the selling of art. If you are talking from a cultural point of view, that's another matter.

CRÉMIEUX: Yes, that's what I'm thinking about.

KAHNWEILER: There is an obvious change. The selling end has not changed that much, except that the number of dealers has multiplied to a terrifying extent, as has the number of painters. But besides that, I don't see a great change. Fundamentally, most dealers operate as they did before Durand-Ruel. There was a complete break, a sensational event, which was impressionism and its dealer, Durand-Ruel. That changed everything.

CRÉMIEUX: I am glad that in these closing remarks you have brought us back to the initial subject of our conversations. You are right: Commercially, things remain as they are, but you are a man who sells canvases to a minority of well-to-do customers.

KAHNWEILER: That is absolutely true.

CRÉMIEUX: So it has always been that way. Has there always been a minority of well-to-do people buying the paintings of masters?

KAHNWEILER: Yes, but formerly it was *rich* people who bought paintings, and not people who were merely well off.

CRÉMIEUX: So here too there has been some change.

KAHNWEILER: This too, I tell you, dates from the time of Durand-Ruel. It began with the collectors of the impressionists, who were not rich

people; they were painter friends like Caillebotte or civil servants like Choquet, people who were not rich. The important phenomenon was the disappearance of the patron, or the disappearance of the gentleman who bought Millet's "Angelus" for a million gold francs. And that was after Millet's death.

CRÉMIEUX: You say that basically the selling of art has changed little; but what about the propaganda techniques, which in broadcasting they call the hard-sell method, which consists in playing the same jingle over the radio three, four, or five times a day so people's memories will be saturated with it? Do you think that by means of publicity, by the use of techniques that could just as well be used to sell soap or leather, reputations have been created in a way they never were before? Was this done in your day?

KAHNWEILER: This must have existed always, with slightly different methods. There were reputations in those days among the Artistes Français, or the Salons, you know, which were formidable.

CRÉMIEUX: Social reputations.

KAHNWEILER: Not just social, international. That gentleman whose name was Chabas, I think, who painted shivering ladies wading into lakes at dawn—he was fantastically well known. So was the one who did pink heather, Didier-Pouget, and Henner, who made pale women with red hair. The reputations of these people must have been created by other means, but they were created just as much as certain reputations now. But this sort of thing does not last.

CRÉMIEUX: So according to you, very little has changed. It is simply the method of propaganda that changes, but the cause and effects are the same, and the work is forgotten.

KAHNWEILER: In the case of certain contemporary painters whose fame I believe to be ephemeral, I do not see that hard-sell methods, as you call them, have been used, but rather the classical methods of art selling.

CRÉMIEUX: In your day, did the weeklies or popular reviews have monographs or long articles like those we have seen recently on contemporary painters, in which they are presented in exactly the same way as military heroes, political figures, or movie stars?

KAHNWEILER: Perhaps not, but there were essays on the Salons, for instance, which were much longer than today's articles, and instead of single articles, there would sometimes be a series that lasted a whole week on a Salon, for example, which made it possible to discuss each painter at greater length. When they talked about Didier-Pouget, the man with the pink heather, they would say, "Here is the admirable

Didier-Pouget and his pink heather, so poetic . . .," and so on. But they did not write a sort of monograph, no.

There were painters who were justly famous, and there were, on the other hand, painters whose fame was absolutely unjustified. There was all that, of course. That has always existed, and there have always been people who have bought paintings, and I even think, as I said, that people were much richer and paid much more for paintings at a certain period than they do now. Naturally, I am not talking about very famous artists like Picasso or Braque. Obviously, the best thing that can happen to a painter is to have a long life.

CRÉMIEUX: "He starts to get young," as Picasso says.

KAHNWEILER: His fame continues to grow, whereas when a painter dies young, one must wait for years to see his success. The most striking example of this is Seurat.

CRÉMIEUX: Yes.

KAHNWEILER: How long Seurat remained in obscurity! It is inconceivable when one thinks of what an admirable, great painter he was!

CRÉMIEUX: Is it true that art dealers deliberately buy the works of painters who are entering old age and put them in storage with the intention of bringing them out again after their death and making a profit?

KAHNWEILER: It's conceivable.

CRÉMIEUX: That is one of the tricks your friend Reignier was talking about, which you still don't know how to use.

KAHNWEILER: It isn't even a trick; it would be an investment of capital, if you will. I don't think it impossible, but I doubt it, because it would require very considerable capital to be really able to stock paintings to that extent, especially expensive paintings. I might believe it in the case of a young painter when the paintings aren't expensive, but with an old painter whose paintings cost a lot, it would really take guts, as they say. And it could turn out badly. There is an accusation that has been made against the art dealer who was the greatest of them all: Durand-Ruel. Pissarro, who was a gentleman, really a great gentleman, imagined very often and over a long period of time that Durand-Ruel wanted to make the price of his paintings go down so he could buy them back cheaply.

CRÉMIEUX: Was this untrue?

KAHNWEILER: I find it unlikely, but in Pissarro's correspondence with his son it is a recurrent topic.

CRÉMIEUX: You speak of capital. . . . Without our discussing individuals, where, generally speaking, does the capital of the great art dealers come from? Is it family fortunes, the management of property not belonging

to them, or simply accumulation, as must have been your case, since you started with little ...

KAHNWEILER: Both: Family fortunes in the case of Wildenstein or Paul Rosenberg, whose fathers were already art dealers, had already accumulated money and paintings. And then there is the second case, the silent partner ...

CRÉMIEUX: Ah, does that exist?

KAHNWEILER: It is often done, but it is very dangerous.

CRÉMIEUX: People decide to turn over their money to an art dealer and ask him for a return on their capital.

KAHNWEILER: Exactly, either a return, a kind of dividend, or even some sort of distribution of the immediate profits. This is done, but it is horribly dangerous. Experience has shown that the moment things go badly, these people generally demand their money back, which forces the dealer to sell out for almost nothing in order to reimburse them. It is very dangerous and absolutely unadvisable. There is the case of a man, a collector who was in that situation, perhaps the greatest collector of cubism. His name was Reber; he was German and lived many years in Switzerland. This man had created an admirable collection. He had sixty or eighty Picassos, and just as many works by Braque, Gris, and Léger. An absolutely unique collection. It was he who owned the modern painting that has brought the highest price in the world to date: Cézanne's "Le Garçon au gilet rouge." He had started with that.

CRÉMIEUX: Did he buy it from Cézanne?

KAHNWEILER: No, no, no.

CRÉMIEUX: Did you know Cézanne?

KAHNWEILER: Oh, no, I just had time to know him, but I did not. I didn't know anyone of that generation. I knew Guillaumin by chance, and I knew Odilon Redon, but that's all. I knew neither Renoir nor Monet, both of whom lived another twenty years after I became an art dealer. Even Picasso knew very few of those people. We did not know them; it was another world.

CRÉMIEUX: Let's get back ...

KAHNWEILER: To Reber. Well, he had bought all those things after starting with impressionist paintings. He died about two years ago at the age of seventy-five, so he could not very well have bought directly from Cézanne. He sold those things and bought cubist paintings. He assembled an incredibly beautiful and rich collection. But he had also borrowed money from banks to make this collection. When the Depression came, between 1929 and 1936, the banks asked for their money back. In France, I don't think you can find banks that would advance money on paintings,

although they exist in Switzerland. So, he had bought with that money. Well, he had to sell, all his paintings went for nothing, and when he died he was a bitter, impoverished man and had almost no paintings left.

CRÉMIEUX: Is there no bank, to your knowledge, which is the silent partner of an art dealer?

KAHNWEILER: No, certainly not. I don't think a dealer can obtain credit by offering paintings as security.

CRÉMIEUX: Aside from banks, what about syndicates or big companies?

KAHNWEILER: Not companies.

CRÉMIEUX: Not to your knowledge?

KAHNWEILER: Not to my knowledge. I don't think so. These things are too personal. The silent partner must have confidence in the dealer and even in the merchandise. I don't see how it would be possible otherwise. And as I say, it certainly should be discouraged; it is very dangerous.

CRÉMIEUX: We shall discourage it! What, in your opinion, are the great collections of cubist paintings at the present time, and what are the great collections of impressionist paintings?

KAHNWEILER: I don't know enough about impressionism.

CRÉMIEUX: Well, we'll skip that. . . . What about the cubists, since you probably provided the pictures.

KAHNWEILER: First of all, there are still three very great collections in France: the André Lefèvre collection and the Douglas Cooper collection.

CRÉMIEUX: You consider that a French collection?

KAHNWEILER: He is a "French resident."

CRÉMIEUX: Yes.

KAHNWEILER: As they say at the Foreign Exchange Office.

CRÉMIEUX: Yes, because in the catalogues they write "Douglas Cooper, London."

KAHNWEILER: No, no, he hasn't lived in London for many years. Legally, they are not British goods.

In any case, he has been able to get his paintings out of England and establish himself with them in France. I know nothing about how this is arranged in terms of the English law, but in any case, the collection is in France. Finally, there is the admirable collection of Madame Cuttoli.

There is the collection of Gertrude Stein, which has been reverently preserved by her friend Alice Toklas. In Switzerland there are several collections, notably that of my friend Hermann Rupf, most of which will eventually revert to the museum of Bern.

CRÉMIEUX: How about American collections?

KAHNWEILER: There are so many that it would take too long to list them, especially since the collections change from time to time because many people give paintings to museums. But we have not mentioned all the French collections, notably the oldest, the Roger Dutilleul collection, which still exists in the hands of his nephew, Jean Masurel at Roubaix.

CRÉMIEUX: And also Georges Salles.

KAHNWEILER: Georges Salles does not have what could be called a great collection. He has some very beautiful paintings. There are many people who have a few beautiful paintings. I have cited those who came to mind immediately as very large collections. There are many others. Alfred Richet has a very fine collection, and so does Max Pellequer.

CRÉMIEUX: Is he French?

KAHNWEILER: Yes, the collection is in Paris. Many things by Picasso. He is on very good terms with him. He is his banker.

CRÉMIEUX: Is he a banker by profession?

KAHNWEILER: Yes, he is director of the BNCI.

CRÉMIEUX: Who else?

KAHNWEILER: My God, there are other bankers. There are all kinds, there are quite a few smaller collections. A country where there are some very fine collections also is Sweden. There is a large number of collections containing eight, ten, or twelve first-rank paintings.

CRÉMIEUX: Let's get back to the United States. Although the collections change hands or are bequeathed to museums, give me a few names anyway.

KAHNWEILER: Well, I think immediately of Nelson Rockefeller, who is now governor of the State of New York. He has an admirable collection.

CRÉMIEUX: What about Thannhauser?

KAHNWEILER: He is a dealer who is no longer very active as a dealer. His father was a dealer before him in Munich. He started in Berlin, then moved to Paris, and he has been in New York since the war. He has some extremely fine things.[1] A man who also has a beautiful collection is Rockefeller's rival for the governorship of New York, Harriman.

CRÉMIEUX: Doesn't the Ford family have a collection?

KAHNWEILER: No, not that I know of. On the other hand, Chrysler has a fine collection. He sells rather often and buys other things.

CRÉMIEUX: Yes. Is he a dealer as well as a collector?

KAHNWEILER: Not at all, not in a thousand years. He is immensely rich.

CRÉMIEUX: Does he exchange paintings?

[1] A large part of Justin Thannhauser's collection is on permanent view at the Solomon R. Guggenheim Museum, New York.

KAHNWEILER: He is immensely rich, but he probably gets tired of things and sells them in order to buy others. There was an enormous collection in Pittsburgh, for example, the collection of a certain Thompson, who is an extremely important man in steel.

CRÉMIEUX: Perhaps we should also mention the small but excellent collection of your friend Kramer in Prague.

KAHNWEILER: Ah, yes, we haven't talked about him. He was one of the very first collectors, as you know. He has kept his collection, which is small, but excessively choice and beautiful.

CRÉMIEUX: Have you seen it recently?

KAHNWEILER: I saw it two years ago. He was still alive, but he just died, poor man.

CRÉMIEUX: Did you find it in good condition?

KAHNWEILER: Absolutely. Absolutely. I had heard that the paintings were very dirty; I did not find it true. In any case, it would not have been serious; all one needs to do is clean them with a damp sponge.

CRÉMIEUX: Well, Monsieur Kahnweiler, thank you for your hospitality and for your repeated kindnesses. I hope we can meet again ten years from now and renew the discussion.

KAHNWEILER: I hope so too!

Afterword

Almost ten years have passed since these conversations were recorded. This was done in an informal way, with makeshift materials. Francis Crémieux suggested the idea, and I agreed. At the time we did not foresee any specific use of the material.

The conversations occurred in various places—the quai des Grands Augustins, my apartment in Paris, our country house near Les Étampes, our gallery in rue de Monceau. I have just reread them, and the experience has left me sad and melancholy, like a visit to a cemetery that holds people who were dear to me. So many dead! Not only those who were already gone by 1960, starting with my wife, but also all those who have died since then. Our generation is vanishing from the earth. . . .

After rereading my answers to Francis Crémieux's questions, it seems to me that we have given a fairly accurate picture of my life with my friends. Of course, we hardly touched on the aesthetic base of the revolution that took place in the plastic arts at the beginning of this century, and of which I was a witness. It is true that all my published writings, beginning with *The Rise of Cubism*, which appeared in German in 1920, attempt to establish this base. As I think it over, I also wonder whether in these conversations I have succeeded in communicating the unconquerable joy, the passionate fervor that inspired us during the period between 1907 and 1914, our unshakeable faith in victory. Today this victory is complete. History has assigned a pre-eminent position to the artists of my generation whom I defended. It will not be long before

she recognizes the merits of their juniors, the generation born around 1900.

Nevertheless, the message of these artists remains, alas, partly misunderstood. Their intentions, which inclined toward a complete figuration, were not always grasped, and those who failed to *read* their paintings saw them as mere decorative arrangements. I have broken many a lance against this abstract pseudo-art in the *Conversations* and elsewhere, but in the meantime, these heresies have only multiplied. What a mass of absurd and gratuitous inventions!

"Gadgets" of every description are presented to credulous buyers and terrified critics who want to be up to date and who no longer dare attack anyone for fear of being wrong. Optical or electrical toys, castings from nature, housepainter's samples are presented as works of art. I always feel like asking the people who tout these miserable objects, "Do you really believe that this is the same as a Rembrandt?" For I am convinced that the essence of art is one, and that a Picasso is the same as a Rembrandt, that is, an emotion that the artist has experienced and that he shares with the spectator.

How are we to explain this proliferation of "novelties"? The cause is the need to make something new, for only the "new" attracts attention. It is the "new" that pseudo-art lovers buy, people who think of buying art in terms of bringing off a deal.

Never have real painters consciously decided to do something new—neither the impressionists nor the cubists. It was not their intention to *épater le bourgeois*. The novelty of their achievements was in no sense deliberate. The painting of their elders did not satisfy them, and they were trying to provide what seemed to them to be missing. A far cry from today, when we have a chorus of loudmouths, each trying to shout the others down.

And yet even today, a few courageous voices are beginning to appear. I dare to hope that they will be heard, that everyone will soon see that "the emperor has no clothes on." Sooner or later, I am sure that these ridiculous productions will fall into oblivion and that they will end up molding in the cellars of the museums whose frightened directors have acquired them. There they will join the works of those nineteenth-century academic painters who were so admired in their day and who were also protected by the government, for—has anyone noticed?—governments everywhere are lavishing their favors on these clever pseudo-artists for fear of being wrong, of "missing the boat."

It is time we rid ourselves once and for all of the notion that everything that is produced as a "work of art" in a given period is valuable.

The example of the nineteenth century proves the enormous quantity of rubbish. What is going on today is of considerable sociological interest, but it falls outside the realm of aesthetics.

I have always avoided making predictions, but perhaps now that I am an old man I may be permitted to say how I see the immediate future of the fine arts. Cubism put an end to all imitative art, all illusionist art. Photography has taken over this function of imitation, but painting, far from being reduced to a purely ornamental role, has an even greater responsibility to render the visible world by pictorial means and thus to create, as it has always done, the external world of men.

All the recent work of Picasso—and of Masson too—leads me to think that the plastic arts are rediscovering the *narrative* aspect that the nineteenth century rejected as "anecdotal." Obviously, we are not going to have any more "Cardinals Playing Cards" or similar nonsense, nor will we have a "socialist realism" that competes with the movies, nor a journalistic "pop art," but works pregnant with meaning, which have their origin in the life of the artist himself. An art of this kind could only be autobiographical. "You can say what you like, there's nothing wrong with a painting that tells a story," Picasso said to me a few years ago. The work is enriched by its narrative elements, which are never "little stories" or "anecdotes." "To express the great emotions": this is what Picasso once told me was the purpose of a work of art.

Another thing that encourages me to believe in the future of a "complete art" of this kind is the work of a young painter, the only one our gallery has taken on for a number of years. His name is Sébastien Hadengue. The events of May 1968 are reflected in his paintings in a way that is not at all photographic. This young painter—he is thirty-one—had attended the demonstrations; the pictures they inspired him to paint bear witness to the same enthusiasms, the same anxieties. Curiously enough, works immediately preceding the events already anticipated them.

I am too old to be able to watch the flowering of this new painting that I foresee. I have had the great satisfaction of seeing the triumph of my friends. One thing of which I am certain is that the plastic arts will not degenerate into childish games, but that they will continue to be for mankind that which is most precious. Besides creating man's external world, they will continue to give him the supreme joy of communicating with the great artists, of sharing their emotions. This is what is meant by aesthetic pleasure.

D.-H.K.

Saint-Hilaire, August 1969

Bibliography

The Writings of Daniel-Henry Kahnweiler

Early writings by Kahnweiler, who wrote as *Daniel Henry*, appeared under his pseudonym from 1916 to 1942. These are detailed in bibl. 157,[1] pp. 287–88, nos. 1–23. Since my bibliography in *The Rise of Cubism* (bibl. 4, 1949) and in *Pour Kahnweiler* (1965), which also contains additional documentation by my former assistant, Lucy Lippard, incorporates two chronological listings, it seems inadvisable to repeat that presentation. Therefore, this inventory is a *classified* record consisting of the following: *Major Works, Supplemental Publications, Articles (Magazines and Annuals), Exhibition Catalogues,* and *Festschrift*. These comprehensive citations testify not only to more than fifty years of substantial continuous comment, but also to an international esteem from Stuttgart (bibl. 157) to Tokyo (bibl. 132, 138) of a unique personality in the world of modern art.

<div align="right">

Bernard Karpel

Librarian,

Museum of Modern Art, New York

</div>

The citations are listed chronologically in each section.

Major Works

1. DER WEG ZUM KUBISMUS. Munich, Delphin, 1920. 55 pp., 36 illus. Published under adopted pseudonym: Daniel Henry. Enlarged version

[1] This form refers to the numbered entries that follow in each section.

of bibl. 38. Second edition, 1929 (Leipzig), with new preface and added chapter on Juan Gris. Third edition, 1958; see bibl. 6.

2. JUAN GRIS: SA VIE, SON OEUVRE, SES ÉCRITS. Paris, Gallimard, 1946. 344 pp., 51 illus.

French extracts: *Les Temps modernes*, 1946, vol. 1, no. 4. German extracts: *Du* (Zurich), vol. 12, no. 1, 1952. English translation, 1947.

3. JUAN GRIS: HIS LIFE AND WORK. New York, Curt Valentin, 1947. 177 pp., 113 illus. (col.).

Revised edition, translated and edited by Douglas Cooper. Bibliography. Reviews: *The Burlington Magazine*, Feb. 1948, p. 52. *Horizon*, March 1948, pp. 225–27. *Magazine of Art*, March 1948, p. 112. *Architectural Review*, May 1948, p. 222. *Art Digest*, March 1948, p. 27.

4. THE RISE OF CUBISM. New York, Wittenborn, Schultz, 1949. 48 pp. 23 illus.

Translation of 1920 edition. First English version for the series Documents of Modern Art. Preface by Robert Motherwell. Chronological bibliography on Kahnweiler's writings by B. Karpel. Reviews: *Canadian Art*, vol. 7, no. 1, 1949, pp. 33–34. *Werk*, vol. 37, no. 4, p. 51.

5. LETTERS OF JUAN GRIS: 1913–1927. London, Privately printed, 1956. 221 pp.

Letters collected by Kahnweiler; translated and edited by Douglas Cooper. Edition: 300 copies.

6. DER WEG ZUM KUBISMUS. Stuttgart, Hatje, and Teufen (Switzerland), Niggli, 1958. 131 pp. incl. 78 illus. (col.).

Third German edition, with new preface, 1958. French translation in *Confessions esthétiques*; see bibl. 9.

7. MES GALERIES ET MES PEINTRES: ENTRETIENS AVEC FRANCIS CRÉMIEUX, Paris, Gallimard, 1961. 224 pp.

Includes eight interviews broadcast in May–June by the French Radio-Television (France III de la RTF). Reviews: *L'Œil* (Paris), Dec. 1961, pp. 76–77. Translation issued by The Viking Press, New York, 1971; also bibl. 8.

8. MEINE GALERIEN UND MEINE MALER. Cologne, Dumont Schauberg, 1962. Translation of bibl. 7. Also issued in Czech, Swedish, and Polish.

9. CONFESSIONS ESTHÉTIQUES. Paris, Gallimard, 1963. 244 pp. (Les Essais, CX.)

Seventeen essays, of which two were previously unpublished. German texts translated by Denise Naville. Contents: "Préface" (1962, p. 8). "La Montée du cubisme" (1920; 1958). "Naissance de l'œuvre de l'art" (*inédit*, 1919). "Les Limites de l'histoire de l'art" (1920). "L'Essence de la sculpture" (1919). "Forme et vision" (1919). "Le Veritable

Béarnais" (1950). "Le Sujet chez Picasso" (1951). "Guernica" (1956). "Rhétorique et style dans l'art plastique d'aujourd'hui" (1949). "Faut-il écrire une histoire du goût?" (1946). "À propos d'une conférence de Paul Klee" (1947). "La Place de Georges Seurat" (1947). "La Peinture à Paris: bilan 1945" (1945). "Une lettre inédite de Juan Gris" (1956). "Mallarmé et la peinture" (1948). "L'Art nègre et le cubisme" (1948). "Les Peintres modernes et l'art populaire" (unpublished, 1955).

10. AESTHETISCHE BETRACHTUNGEN. Cologne, Dumont Schauberg, 1968. 119 pp.

Translations or reissues of sixteen essays already published in his 1963 anthology (see bibl. 9), omitting "La Montée du cubisme," previously published by Verlag Gerd Hatje (see bibl. 6).

11. JUAN GRIS—LEBEN UND WERK. Stuttgart, Gerd Hatje, 1968. 349 pp., illus. (col.).

Contains "Vorwort zur Neuauflage" (1968). Editions: Teufen (Switzerland), Niggli. New York, Abrams. London, Thames and Hudson. Paris, Gallimard. Bibliography by B. Karpel includes Kahnweiler references.

12. MY GALLERIES AND PAINTERS. New York, Viking, 1971. 160 pp., illus. Revised and enlarged edition of bibl. 7. Includes new text and illustrations supplied by the author. Chronology. Bibliography by B. Karpel.

Supplemental Publications

13. MAURICE DE VLAMINCK. Leipzig, Klinkhardt and Biermann, 1920. 16 pp., 32 illus.

Published under the pseudonym Daniel Henry in the *Junge Kunst* series. Previously issued as bibl. 46.

14. ANDRÉ DERAIN. Leipzig, Klinkhardt and Biermann, 1920. 16 pp., 32 illus.

Published under the pseudonym Daniel Henry in the *Junge Kunst* series. Also in Dutch, in *Nieuwe Kunst*, Amsterdam, Van Munster, 1924. Previously printed as bibl. 43.

15. JUAN GRIS. Leipzig, Klinkhardt and Biermann, 1929. 16 pp., 32 illus. Published under the pseudonym Daniel Henry. Extracts published in *Cahiers d'Art*, vol. 8, nos. 5–6, 1933, and in *Juan Gris—Fernand Léger* (Zurich, Kunsthaus, Apr. 2–May 25, 1933), a special compilation by Éditions "Cahiers d'Art."

16. Jardot, Maurice, and Martin, Curt. DIE MEISTER FRANZÖSISCHER MALEREI DER GEGENWART. Baden-Baden, Klein, 1948.

Kahnweiler: "Ursprung und Entwicklung des Kubismus," pp. 7–18. (Published on the occasion of an exhibition at Freiburg/Br., Oct. 1947.)

17. LES SCULPTURES DE PICASSO. Paris, Editions du Chêne, 1949. 8 pp., illus.

Introduction and 216 photographs by Brassaï. English edition: London, Phillips, 1949; translation by A. D. H. Sylvester.

18. LES ANNÉES HÉROIQUES DU CUBISME. Paris, Braun, 1950. 15 pp., 47 illus.

"Collection des Maîtres." Text in French, English, and German.

19. PAUL KLEE. Paris, Braun, and New York, Herrmann, 1950. 32 pp., 24 illus.

"Collection Palettes." Text in French, English, and German.

20. Raymond, Marcel, ed. FROM BAUDELAIRE TO SURREALISM. New York, Wittenborn, Schultz, 1950.

Kahnweiler: "Mallarmé and Painting," pp. 357–63. Translated from the French (bibl. 67) for the Documents of Modern Art Series.

21. Bénézit, Emmanuel. DICTIONNAIRE CRITIQUE ET DOCUMENTAIRE DES PEINTRES. Paris, Gründ, 1948–1955 (reprint, 1957).

Kahnweiler: "Juan Gris," vol. 4, pp. 435–36.

21a. Picasso, Pablo. PABLO PICASSO: RADIERUNGEN UND LITHOGRAPHIEN, 1905–1951. Munich, Prestel, 1952.

Preface by Kahnweiler, pp. 7–16. The booklet also served as a catalogue for exhibition at Nuremberg, Basel, Berlin, Freiburg/Br., Hamburg, Munich, and Stuttgart.

22. Bordiajew, N.; Jung, C. G.; and Kahnweiler, D.-H. PABLO PICASSO: WORT UND BEKENNTNIS, DIE GESAMMELTEN ZEUGNISSE UND DICHTUNGEN. Zurich, Verlag der Arche, 1954.

"Acht Gespräche," pp. 100–110, is a translation from Le Point, no. 42, 1952 (bibl. 77).

22a. THE SELECTIVE EYE, No. 1. New York, Random House, 1955. pp. 120–25.

"When the Cubists Were Young," from bibl. 80a.

22b. Stein, Gertrude. PAINTED LACE AND OTHER PIECES [1914–1937]. New Haven, Yale University Press; London, Oxford University Press, 1955.

Introduction by Daniel-Henry Kahnweiler, pp. ix–xviii.

23. Vercors. PICASSO: ŒUVRES DES MUSÉES DE LÉNINGRAD ET DE MOSCOU ET DE QUELQUES COLLECTIONS PARISIENNES. Paris, Éditions Cercle d'Art, 1955.

"Petite histoire des toiles": une entretien entre D.-H. Kahnweiler et Hélène Parmelin, pp. 17–20.

24. Stiftung zur Förderung der hamburgischen Kunstsammlungen. ERWERBUNGEN. Hamburg, 1956.

Kahnweiler: "Pablo Picasso: Clovis Sagot," pp. 18–21.

25. PANORAMA DE L'ART PRÉSENT. Paris, Éditions d'Art et Industrie, 1957.
Kahnweiler: "Une lettre inédite de Juan Gris," p. 9. First published in *Prisme des arts*, no. 3, 1956; reprinted as bibl. 9.

26. PICASSO: KERAMIK. Hannover, Fackelträger, 1957. 127 pp., illus.
Text in German, English, and French.

27. ALMANACH 1958. Paris, Flinker, 1958.
Kahnweiler: "Réponse," p. 56.

28. PICASSO AT VALLAURIS. New York, Reynal, 1959.
Kahnweiler: "The content of Picasso's art," pp. 1–3. Translated from *Verve*, nos. 25–26 (bibl. 75).

29. JAHRESRING 59/60. Stuttgart, Deutsche Verlags Anstalt, 1959.
Kahnweiler: "Gespräche mit Picasso," pp. 85–98, consisting of seventeen conversations (1933–1959), including bibl. 82.

30. ALMANACH 1961. Paris, Flinker, 1961.
Kahnweiler: "Le Problème du bilinguisme" (reply to an inquiry), pp. 24–25.

30a. PIERRE REVERDY, 1889–1960. Paris, *Mercure de France*, 1962
Kahnweiler: "Reverdy et l'art plastique," pp. 169–77.

31. Arbeitsgemeinschaft kultureller Organisationen. FREUDEN UND LEIDEN EINES KUNSTHÄNDLERS. Düsseldorf, 1964.
Kahnweiler: "Mein Leben als Kunsthändler," pp. 23–36.

32. De Micheli, Mario. SCRITTI DI PICASSO. Milan, Feltrinelli, 1964.
Kahnweiler: "Entretiens avec Picasso," pp. 52–82.

33. Stein, Gertrude. AUTOBIOGRAPHIE D'ALICE TOKLAS. Paris, Mazenod, 1965.
Kahnweiler: "Postface," pp. 185–89.

34. Kay, Helen. PICASSO'S WORLD OF CHILDREN. New York, Doubleday, 1965. Introduction by Kahnweiler, pp. 8–10.

35. JUAN GRIS (I Maestri del Colore). Milan, Fabbri, 1966.
Text from bibl. 140.

36. Reinhardt, Hannes, ed. DAS SELBSTGESPRÄCH. Hamburg, Wegner, 1967.
"Daniel-Henry Kahnweiler," pp. 109–130, from a series of German television broadcasts organized by Reinhardt in 1966.

37. Dufour, Pierre. PICASSO, 1950–1968. Geneva, Skira, 1969.
Introduction by Kahnweiler.

Articles (Magazines and Annuals)

(The early writings [1916–1942] were customarily signed by a pseudonym: Daniel Henry.)

38. "Der Kubismus." *Die Weissen Blätter* (Zurich–Leipzig), vol. 3, no. 9, Sept. 1916, pp. 209–222.
Published under the adopted pseudonym: Daniel Henry. Original version of bibl. 1.

39. "Wider den Expressionismus in den bildenden Künsten." *Neues Leben* (Bern), 1917, pp. 354–61.

40. "Hodler und Rodin." *Sozialistischer Kalender* (Bern), 1918.

41. "Die Schweizer Volksmalerei im XIX. Jahrhundert." *Das Kunstblatt* (Berlin), vol. 2, no. 7, July 1918, pp. 223–25.

42. "Vom Sehen und vom Bilden." *Die Weissen Blätter* (Zurich–Leipzig), vol. 6, no. 7, July 1919, pp. 315–22.
French translation in bibl. 9.

43. "André Derain." *Das Kunstblatt* (Berlin), vol. 3, no. 10, Oct. 1919, pp. 288–304. Republished in *Jahrbuch der jungen Kunst*, vol. 1, 1920, and bibl. 14.

44. "Umschau: Merzmalerei ... Expressionismus." *Das Kunstblatt* (Berlin), vol. 3, no. 11, Nov. 1919, p. 351.

45. "Das Wesen der Bildhauerei." *Feuer* (Weimar), vol. 1, nos. 2–3, Nov.–Dec. 1919, pp. 145–56.
French translation in bibl. 9.

46. "Maurice de Vlaminck." *Der Cicerone* (Leipzig), vol. 11, no. 23, Dec. 1919, pp. 757–61.
Also published as bibl. 13.

47. "Werkstätten." *Die Freude* (Oberfranken), vol. 1, 1920, pp. 153–54.

48. "Absichten des Kubismus." *Das Kunstblatt* (Berlin), vol. 4, no. 2, 1920, p. 61.

49. "Die Grenzen der Kunstgeschichte." *Monatshefte für Kunstwissenschaft* (Leipzig), vol. 13, no. 1, Apr. 1920, pp. 91–97.
French translation in bibl. 9.

50. "André Derain." *Der Cicerone* (Leipzig), vol. 12, no. 8, Apr. 1920, pp. 315–17, 319–21, 323–29.

51. "Der Purismus." *Der Cicerone* (Leipzig), vol. 12, no. 9, May 1920, p. 364.
Also published in *Jahrbuch der jungen Kunst*, vol. 1, 1920, p. 159.

52. "Fernand Léger." *Der Cicerone* (Leipzig), vol. 12, no. 19, Oct. 1920, pp. 699–702, 705, 707, 709, 711–13.
Also published in *Jahrbuch der jungen Kunst*, vol. 1, 1920, pp. 301–304.

53. "Ingres: Ideen und Maximen." *Das Kunstblatt* (Berlin), vol. 9, no. 7, Jan. 1925, pp. 18–24.

53a. "Entretien avec Henry Kahnweiler" [par E. Tériade]. *Cahiers d'Art* (Paris), vol. 2, no. 2, 1927, pp. 1–2 (supplement).

54. "Der Tod des Juan Gris." *Der Querschnitt* (Berlin), vol. 7, no. 7, July 1927, p. 558.

55. "Das abenteuerliche Leben des Manuel Martinez Hugué, genannt Manolo." *Der Querschnitt* (Berlin), vol. 9, no. 8, Aug. 1929, pp. 590–91. Also in bibl. 100.

56. "Juan Gris." *Cahiers d'Art*, vol. 8, nos. 5–6, 1933.
Extract from bibl. 15; also published in bibl. 102.

57. "André Masson." *Volontés* (Paris), Nov. 1945.
French translation by Maria Jolas from bibl. 103.

58. "The state of painting in Paris: 1945 Assessment." *Horizon* (London), vol. 12, no. 71, Nov. 1945, pp. 333–41.
Translation by Douglas Cooper. Original French text in bibl. 9.

59. "La Naissance du cubisme." *Les Temps modernes* (Paris), vol. 1, no. 4, Jan. 1946, pp. 625–39.
Extract from bibl. 2. Reprinted in *Art d'Aujourd'hui*, nos. 3–4, 1953, pp. 3–8.

60. "Elie Lascaux." *Centres* (Limoges), no. 3, Feb. 1946, pp. 1, 24–36.
Text dated Dec. 1943.

61. "Faut-il écrire une histoire du goût?" *Critique* (Paris), vol. 1, no. 5, Oct. 1946, pp. 423–29.
Reprinted in bibl. 9.

62. Eugène de Kermadec." *La Revue internationale* (Paris), vol. 2, no. 11, Dec. 1946, pp. 397–403.

63. "À propos d'une conférence de Paul Klee." *Les Temps modernes* (Paris), vol. 2, no. 16, Jan. 1947, pp. 758–64.
Reprinted in bibl. 9. Swedish text in *Konstrevy*, vol. 24, no. 1, 1948.

64. "La Place de Georges Seurat." *Critique* (Paris), vol. 2, nos. 8–9, Jan.–Feb. 1947, pp. 54–59.
Reprinted in bibl. 9.

65. "L'Art nègre et le cubisme." *Présence africaine* (Paris), no. 3, 1948, pp. 367–78.
Reprinted in bibl. 9. German text, bibl. 85; English text, bibl. 66. Danish translation: *Louisiana Revy* (Humlebaek), no. 4, Apr. 1965, pp. 26–28.

66. "Negro Art and Cubism." *Horizon* (London), vol. 18, no. 108, 1948, pp. 412–20.
Translation of bibl. 65.

67. "Mallarmé et la peinture." *Les Lettres* (Paris), vol. 3, no. spec., 1948, pp. 63–68.
Reprinted in bibl. 9, 20 (English translation).

68. "Le Retour de Joan Miró." *Derrière le Miroir* (Paris), nos. 14–15, Nov.–Dec. 1948, p. [3].

69. [Note about the exhibition of the recent works by Picasso at the Maison de la Pensée Française]. *Transition Forty-Nine* (New York), no. 5, 1949, pp. 18–19.

70. "Rhétorique et style dans l'art plastique d'aujourd'hui." *Cahier du Sud* (Marseille), vol. 36, no. 296, 1949, pp. 33–42.
Reprinted in bibl. 9, 80.

71. "Henri Laurens." *Architecture d'Aujourd'hui* (Boulogne s. Seine), vol. 20, no. 24, June 1949, p. 58.
Extract from bibl. 107.

72. "Daniel-Henry Kahnweiler reviews cubism." *The League Quarterly* (New York), vol. 20, no. 4, Summer 1949, pp. 14–15.
Notes by Barbara Balensweig and Virginia Wangberg on Kahnweiler's talk to the Barnet class, Art Students League.

73. "Fernand Léger." *The Burlington Magazine* (London), vol. 92, no. 564, March 1950, pp. 63–69.

74. "Le Véritable Béarnais." *Les Temps modernes* (Paris), vol. 5, no. 53, March 1950, pp. 1707–10.
Text, dated Aug. 1947, originally written for publication in *Artes* (Antwerp), 1948. Reprinted in bibl. 9.

75. "Le Sujet chez Picasso." *Verve* (Paris), vol. 7, nos. 25–26, 1951, pp. 1–21.
In special number: "Picasso à Vallauris, 1949–1951." English edition, bibl. 28. French text reprinted in bibl. 9.

76. "Juan Gris." *Du* (Zurich), vol. 12, no. 1, Jan. 1952, p. 32.
Extracts from bibl. 2; German translation by Ruth Neukomm.

77. "Huit entretiens avec Picasso." *Le Point* (Souillac), vol. 7, no. 42, Oct. 1952, pp. 22–30.
Dated 1933–1952, with preface. German translation: "Acht Gespräche," Zurich, 1954 (bibl. 22). English extracts in bibl. 83.

78. "Henri Laurens, 1885–1954." *College Art Journal* (New York), no. 1, Autumn 1954, pp. 66–67.

79. "Henri Laurens, période 1916–1916." *Museumjournaal* (Nijmegen), no. 1, 1955, pp. 1–4.
Dutch text.

80. "Über die bildende Kunst: Rhetorik und Stil in der bildenden Kunst. Darlegungen zur Diskussion." *Deutsche Universitätszeitung* (Göttingen), vol. 10, 1955, pp. 10–13.
Translation of bibl. 63.

80a. "Du temps que les cubistes étaient jeunes: un entretien au magnéto-

phone" [par Georges Bernier]. *L'Œil* (Paris), no. 1, Jan. 15, 1955, pp. 26–31.

Translation: "The Selective Eye," 1955 (bibl. 22a).

81. "Cubism: the creative years." *Art News Annual* (New York), no. 24, 1955, pp. 99–116, 180–81.

In the XXIV Annual.

82. "Entretiens avec Picasso au sujet des 'Femmes d'Alger.'" *Aujourd'hui* (Boulogne s. Seine), vol. 1, no. 4, Sept. 1955, pp. 12–13.

Extracts published in "Gespräche mit Picasso" in *Jahresring* (bibl. 29).

83. "Entretiens avec Picasso." *Quadrum* (Brussels), no. 2, Nov. 1956, pp. 73–76.

Six memoirs, 1933–1948. English summary, p. 218.

84. "Voice of the artist, 3—Picasso: Ours is the only real painting." *The Observer* (London), Dec. 8, 1957, pp. 8–9.

Extract from "Huit entretiens" (bibl. 77).

85. "Neger Kunst und Kubismus." *Merkur* (Munich), no. 9, 1959.

Translation of bibl. 65.

86. "El pintor" [Juan Gris]. *Arte Vivo* (Valencia), vol. 2, no. 3, May–June 1959, pp. 4–7.

Homage number on the Spanish painter.

87. "Ist die moderne Kunst in einer Sackgasse?" *Die Kultur*, Oct. 1960.

88. "Mein Bild." *Die Zeit* (Hamburg), no. 2, Mar. 1961.

Reply to an inquiry.

89. "André Masson." *Das Kunstwerk* (Baden-Baden), vol. 15, nos. 1–2, July–Aug. 1961, pp. 3, 4, 13.

90. "For Picasso's Eightieth Birthday." *Art News* (New York), vol. 60, no. 6, Oct. 1961, pp. 34–36, 57–58.

Reprint of UCLA catalogue (bibl. 131).

91. "Gespräche mit Picasso." *Du* (Zurich), no. 248, Oct. 1961, pp. 18–21.

92. "Adieu à Georges Braque." *Derrière le Miroir* (Paris), nos. 144–46, May 1964, p. 24.

Homage number.

93. "Interview mit Kahnweiler." *Das Kunstwerk* (Baden-Baden), vol. 19, nos. 5–6, Nov. 1965, pp. 53–56.

At the Hochschulinstitut für Kunst und Werkerziehung, Mainz, Nov. 11, 1965.

94. "Une musée d'art moderne." *Les Lettres françaises* (Paris), Apr. 6, 1966.

Reply to an inquiry.

95. "Les Grands collectionneurs suisses au début du siècle." *Bulletin Skira* (Geneva), no. 5, Apr. 1967.

On the occasion of the Orangerie exhibition, May 1967.

96. "Formt die Kunst das Weltbild des Menschen?" *Mannheimer Morgen*, Oct. 30, 1967.
Radio interview by Dr. Franz L. Pelgen.

97. "L'Art crée le monde." *La Galerie des Arts* (Paris), no. 5, Feb. 1968, p. 9.

98. "Besuch bei Picasso." *Das Kunstwerk* (Baden-Baden), vol. 21, nos. 11–12, Aug.–Sept. 1968, pp. 56–57.
Kahnweiler's description of his first visit to Picasso.

Exhibition Catalogues: Prefaces and Introductions

99. Flechtheim, Alfred, Galerie. *Maurice de Vlaminck*. Berlin, Nov. 1926. (Veröffentlichungen des Kunstarchivs, no. 20.)
Kahnweiler: "Maurice de Vlaminck," pp. 5–6 (dated 1919).

100. Flechtheim, Alfred, Galerie. *Manolo*. Berlin, etc., 1929.
Kahnweiler: "Das abenteuerliche Leben des Manuel Martinez Hugué, gennant Manolo," pp. 3–4, 6, 8; same as bibl. 55. Exhibition also at Galerie Simon (Paris), Galerie Flechtheim (Düsseldorf), Galerie Flechtheim and Kahnweiler (Frankfurt).

101. Flechtheim, Alfred, Galerie. *Elie Lascaux*. Berlin and Düsseldorf, Apr. 6–June 1, 1930.
Preface, p. 8.

102. Zurich. Kunsthaus. *Juan Gris—Fernand Léger*. Apr. 2–May 25, 1933.
Kahnweiler: "Juan Gris," pp. 24–27. Extract from bibl. 15. Also published in *Cahiers d'Art*, vol. 8, nos. 5–6, 1933.

103. Buchholz and Willard Gallery. *André Masson*. New York, Feb. 17–March 14, 1942.
Preface, pp. 1–2; translated by Maria Jolas and published in bibl. 57.

104. Svensk-Franska Konstgalleriet. *Peintres de Paris*. Stockholm, 1946.
Preface, pp. 5–6.

105. Weber, Achille, Galerie. *Vingt ans d'activité des Éditions Skira*. Paris, Dec. 7–31, 1948.
Kahnweiler: "André Masson, illustrateur," p. 20.

106. San Francisco. Museum of Art. *Picasso, Gris, Miró: the Spanish Masters of Twentieth-Century Painting*. San Francisco, Sept. 17–Oct. 17, 1948.
Kahnweiler: "Juan Gris," pp. 67–73. Exhibition also at Portland Art Museum (Oregon), Oct. 26–Nov. 28.

107. Brussels. Palais des Beaux-Arts. *Henri Laurens*. Brussels, March 1949.
Preface, pp. 1–8. Extract in *Architecture d'Aujourd'hui* (Boulogne s. Seine),

vol. 20, no. 24, 1949. (English translation, London, 1957, and New York, 1958; Swedish translation, Stockholm, 1952.)

108. Svensk-Franska Konstgalleriet. *Henri Laurens*. Stockholm, Feb.–March 1952.
Preface, pp. 3–6; translation of bibl. 107.

109. Basel. Kunstmuseum. *Pablo Picasso: Radierungen und Lithographien*. [1952.]
Exhibition also in Nuremberg, Berlin, Freiburg/Br., Hamburg, Munich, and Stuttgart. Bibl. 21a, with preface by Kahnweiler, served as common catalogue.

110. Düsseldorf. Kunstsammlungen. [*Die Keramik der Maler Picasso und Léger.*] Düsseldorf, 1953.
Prefatory essay by Kahnweiler.

111. Bern. Kunsthalle. *André Beaudin*. Bern, Feb. 7–March 8, 1953.
Preface, pp. 3–5.

112. Lyon. Musée. *Picasso*. Lyon, Festival de Lyon—Charbonbonnières, 1953.
Kahnweiler: "Picasso et le cubisme," pp. 9–11.

113. Valentin, Curt, Gallery. *André Masson*. New York, Apr. 7–May 2, 1953.
Preface, pp. 5–8, 10–11.

114. [Masson Circulating Exhibition.] *Das Graphische Werk von André Masson: Radierungen und Lithographien, 1924–1952*. [1954.]
Preface, pp. 5–7. Exhibition also shown at Düsseldorf, Cologne, Freiburg/Br., Wiesbaden, Bremen, and Wuppertal.

115. Berggruen et Cie, Galerie. *Picasso: dessins, 1903–1907*. Paris, May–June, 1954.
Preface, pp. 1–2. Exhibition in collaboration with Galerie Leiris.

116. Blanc, Lucien, Galerie. *Beaudin à Roux: tous mes peintres*. Aix-en-Provence, 1955.
Preface by Kahnweiler.

117. Saidenberg Gallery. *Pablo Picasso: 58 dessins, 1953–1954*. New York, Dec. 5, 1955–Jan. 23, 1956.
Preface, pp. 2–3.

118. Amsterdam. Stedelijk Museum. *Picasso: "Guernica," avec 60 études et variantes*. Amsterdam, July–Sept. 1956.
Preface, pp. 3–8. Also shown at Palais des Beaux-Arts, Brussels, May–June. Text in French and Dutch. Reprinted as "Guernica" in bibl. 9.

119. Venice. Esposizione Biennale. *28. Catalogo*. Venice, Alfieri, 1956.
Kahnweiler: "Juan Gris," pp. 250–53.

120. Fine Arts Associates. *Picasso Sculptures*, Part I. New York, Jan. 15– Feb. 9, 1957.
Kahnweiler: "The Sculptures by Picasso," pp. 1–4. Extract from bibl. 17.

121. Leiris, Louise, Galerie. *Picasso: peintures, 1955–1956*. Paris, March– Apr. 1957.
Kahnweiler: "Pour saluer Pablo Picasso," pp. 1–2.

122. Marlborough Fine Art. *Henri Laurens, 1885–1954: Sculpture and Drawings*. London. Sept.–Oct. 1957.
Preface, pp. 1–3; translated from bibl. 107.

123. Chalette, Galerie. *Manolo*. New York, Oct. 7–Nov. 2, 1957.
Foreword by Kahnweiler, pp. 1–2, 5. Paris, April 1957. Translated from the original French text.

124. Leiris, Louise, Galerie. *L'Atelier de Juan Gris: peintures, 1926–1927*. Paris, Oct. 23–Nov. 23, 1957.
Preface, pp. 1–2.

125. Sala Gaspar. *Picasso: pintura, escultura, dibujo, cerámica, mosaico*. Barcelona, Oct. 30–Nov. 29, 1957.
Preface, pp. 4–5.

126. Auckland. City Art Gallery. *Picasso: an Exhibition of Lithographs and Aquatints, 1945–1957*. Auckland, New Zealand, 1958.
Preface, pp. 1–3. Biographical notes on Kahnweiler, p. 3. Also shown at Wellington, Melbourne, and elsewhere.

127. Fine Arts Associates. *Henri Laurens: Sculptures*. New York, Apr. 22– May 17, 1958.
Preface, pp. 3–5; translated from bibl. 107.

128. Marlborough Fine Art. *Juan Gris, 1887–1927*. London, 1958.
Preface, pp. 7–8. (Text on Kahnweiler by John Russell.)

129. Madrid. Museo Nacional de Arte Contemporaneo. *Obra gráfica de Pablo Picasso*. Madrid, Jan.–Feb. 1961.
Preface by Kahnweiler.

130. Haifa. Museum. *L'Œuvre gravé de Pablo Picasso*. [Israel, Spring– Summer 1961.]
Preface, pp. 1–2. Also shown in Jerusalem, Tel-Aviv, and Ein Harod. Text in French and Hebrew.

131. Los Angeles. University of California. *Bonne fête, Monsieur Picasso, from Southern California collectors*. Los Angeles, UCLA Art Galleries, Oct. 25–Nov. 12, 1961.
Kahnweiler: "Pablo Picasso," pp. 2–5. Also published in *Art News* (bibl. 90).

132. Tokyo. Art Friend Association. [*L'Œuvre gravé de Pablo Picasso. Text en japonais.*] Tokyo, 1961.

Preface by Kahnweiler. (Also an article on Kahnweiler by Teiichi Rijikata.)

133. Lyon. Musée. *Picasso: gravures-céramiques.* Lyon, Apr.–May 1962.

Preface, pp. 1–5.

134. Marlborough Fine Art. *André Masson: Recent Works.* London, Nov. 1962.

Introduction by Kahnweiler, p. 2.

135. Dortmund. Museum am Ostwall. *Manolo: Plastik und Zeichnungen.* Dortmund, Apr. 5–May 5, 1963.

Kahnweiler: "Der Bildhauer Manolo" [4 pp.]. Extracts: "Manolo: Sculpture and Drawings" (Buffalo, N.Y., James Goodman Gallery, Oct. 11–Nov. 4, 196?).

136. Hamburg. Museum für Kunst und Gewerbe. *Pablo Picasso.* Hamburg, Jan.–March 1964.

Kahnweiler text extracted from "Picasso: Keramik" (bibl. 26).

137. Berlin. Akademie der Künste. *André Masson.* Berlin, May 3–24, 1964.

Kahnweiler: "Die Jugend von André Masson," pp. 7–10.

138. Tokyo. Museum of Modern Art. *Picasso.* (Japanese text.) Tokyo, May 23–July 5, 1964.

Preface, pp. 10–11, 13–14 (in Japanese). Exhibition organized by the Mainichi newspapers; also shown at Kyoto and Nagoya. Supplemental brochure, "A Report on Pablo Picasso Exhibition—Japan 1964," includes photographs of Kahnweiler at the opening. Introduction also in bibl. 141.

139. Amsterdam. Stedelijk Museum. *André Masson.* Amsterdam, June 12–July 19, 1964.

Introduction by Kahnweiler.

140. Dortmund. Museum am Ostwall. *Juan Gris.* Dortmund, Oct.–Nov. 1965.

Exhibited also at Wallraf Richartz Museum, Cologne, Jan.–Feb. 1966.

Text reprinted in "Juan Gris" (I Maestri del Colore) (bibl. 35).

141. Tel Aviv. Museum. *Picasso.* Tel Aviv, Jan. 1966.

Preface, 7 pp., reprinted from Tokyo catalogue (bibl. 138).

142. Dresden. Staatliche Kunstsammlungen. *Pablo Picasso: œuvre gravé,* May–Sept. 1966.

Preface by Kahnweiler. Also shown in Prague, 1965, and Warsaw, Jan.–Feb. 1966.

143. Knoedler, Galerie. *Picasso: dessins et aquarelles.* Paris, Oct. 25–Dec. 1966.

Preface by Kahnweiler.

144. Baden-Baden. Staatliche Kunsthalle. *Fernand Léger.* Baden-Baden, 1967.
Preface by Kahnweiler.

145. Berlin. Haus am Waldsee. *Henri Laurens.* Berlin, 1967.
Kahnweiler: "Eröffnungsrede: Henri Laurens."

146. Kramare, Vincence, Galerie. *André Masson.* Prague, 1967.
Preface by Kahnweiler.

147. Saidenberg Gallery. *Juan Gris.* New York, May–June, 1967.
Preface by Kahnweiler.

148. Marseilles. Musée Cantini. *Paul Klee.* Marseille, July–Sept. 1967.
Preface by Kahnweiler: "Paul Klee, curieux homme."

149. Franke, Günther, Galerie. *Henri Laurens.* Munich, Aug.–Sept. 1967.
Preface by Kahnweiler.

150. Il Milione, Galleria. *Juan Gris.* Milan, March 1968.
Preface by Kahnweiler. Shown in April at Galleria La Nuova Pesa, Rome.

151. Paris. Grand Palais. *Les Indépendants.* [Exposition . . . Le Carré des anciens.] Paris, March–Apr. 1968.
Kahnweiler: "Salut aux Indépendants."

152. Valréas. Château des Simiane. *Pablo Picasso: gravures.* Summer 1968.
Preface by Kahnweiler. Also shown at the Bucharest Museum, Oct. 1968.

153. Baden-Baden. Kunsthalle. *Picasso: œuvres récentes.* Baden-Baden, July 1968.
Preface by Kahnweiler. Also exhibited at Museum am Ostwall, Dortmund, Oct. 1968.

154. Albrecht-Dürer-Gesellschaft. *Picasso—Cranach.* Nuremberg, Sept. 1968.
Preface by Kahnweiler: "Picasso—Cranach."

155. Augsburg. Städtische Kunstsammlung. *Picasso: œuvre gravé.* Augsburg, Oct. 1968.
Preface by Kahnweiler.

156. Theo, Galería. *Manolo.* Madrid, Oct. 1968.
Preface by Kahnweiler.

Festschrift

157. *Pour Daniel-Henry Kahnweiler.* Direction: Werner Spies. New York, Wittenborn, and Stuttgart, Gerd Hatje, 1965.

Comprehensive contributions; illustrations and graphics; documents and bibliography, pp. 287–95, by Lucy R. Lippard. (Revision and extension of 1949 list by Bernard Karpel.) Nos. 1–23 originally published under the pseudonym Daniel Henry. Nos. 97–112 are references *about* Kahnweiler. Limited edition includes 200 copies with suite of signed graphics.

Translation of Letters in Illustration Section

To Henry Kahnweiler
You, Henry, were the first to publish me;
I must remember that in singing your praises.
May you be celebrated in the paintings and verses
Of the *triple étage* where dwell the witches three!

Guillaume Apollinaire
November 28, 1910

242, Boulevard Raspail
December 18, 1912

My dear friend

This letter confirms our agreement covering a period of three years beginning December 2, 1912.

During this period I agree to sell nothing to anyone except you. The only exceptions to this agreement are the old paintings and drawings that I still have. I shall have the right to accept commissions for portraits and large decorations intended for a particular location. It is understood that the right of reproduction to all the paintings that I sell you belongs to you. I promise to sell you at fixed prices my entire production of paintings, sculptures, drawings, and prints, keeping for myself a maximum of five paintings a year. In addition, I shall have the right to keep that number of drawings which I shall judge necessary for my work. You will leave it to me to decide whether a painting is finished. It is understood that during these three years I shall not have the right to sell the paintings and drawings which I keep for myself.

During these three years you agree to buy at fixed prices my entire production of paintings and gouaches, as well as at least twenty drawings a year. Here are the prices which we have agreed on for the duration of our agreement:

drawings	100 francs
gouaches	200 ”

paintings up to and including #6	250	francs
#8, 10, 12, 15, 20	500	"
#25	1000	"
#30, 40, 50	1500	"
from #60 up	3000	"

prices of sculptures and prints to be discussed

<div align="center">

Yours,

Picasso

</div>

**Bibli-
ography**

Index

Reber, Franz von, 133
Redon, Odilon, 133
Reignier, Eugène, 25, 26, 50, 53, 88, 132
Reinach, Salomon, 31
Reinhardt, Hannes, 15
Réjane (Gabrielle Réju), 26
Rembrandt, 31
Renoir, Pierre Auguste, 30, 92, 133
Reverdy, Pierre, 48, 49
Reynolds, Joshua, 28
Richet, Alfred, 135
Rockefeller, Nelson, 135
Roger, Suzanne, 14, 15, 71, 86, 101, 105, 107
Rolland, Romain, 51
Rosenberg, Léonce, 31, 53, 68, 70, 73, 96
Rosenberg, Paul, 31, 70, 71–72, 104, 116, 133
Rousseau, Henri, 65
Rouveyre, André, 49
Rouvre, Yves, 14, 15, 71, 100, 101, 104, 105
Roux, Gaston-Louis, 105–106, 111
Roybet, Ferdinand, 31
Rupf, Hermann, 9, 37, 51, 52, 134
Russell, John, 15

Sade, Marquis de, 49
Sagot, Clovis, 38
Sainsère, Olivier, 68
Salacrou, Armand, 15, 70, 86, 97
Salles, Georges, 62, 135
Salmon, André, 40, 44
Sarraut, Albert, 68
Satie, Erik, 11, 54, 83, 86, 126
Schaeffner, André, 105
Seurat, Georges Pierre, 25, 132

Signac, Paul, 13, 31
Simon, André, 14, 86, 112
Sisley, Alfred, 30
Soutine, Chaim, 98
Stchoukine, Serge, 9, 37, 121
Stein, Gertrude, 11, 81, 134

Tardieu, 22, 24
Thannhauser, Justin, 135
Thompson, G. David, 136
Toklas, Alice, 134
Toulouse-Lautrec, Henri de, 13, 30
Tual, Roland, 97
Tzara, Tristan, 52, 70

Uhde, William, 13, 37–38

Valadon, Suzanne, 54
Valentin, Curt, 110
Van Dongen, Kees, 13, 36, 45, 47, 88, 91
Van Gogh, Vincent, 25
Vauxcelles, Louis, 40, 41–42
Vermeer van Delft, Jan, 29
Villon, Jacques, 47
Vlaminck, Maurice de, 8, 9, 10, 13, 15, 35–36, 40, 44, 45, 46, 53, 69, 71, 80, 81, 83, 90, 92, 98, 103, 114
Vollard, Ambroise, 31, 32–33, 35, 38, 49, 60, 73, 88, 116
Vuillard, Jean Edouard, 13, 29

Wertheimer, 28, 29, 30
Wildenstein, George, 133

Zadkine, Ossip, 125
Zborowski, 79
Zinoviev, Grigori, 52
Zola, Emile, 23